Nicholas Hilliard's
Art of Limning

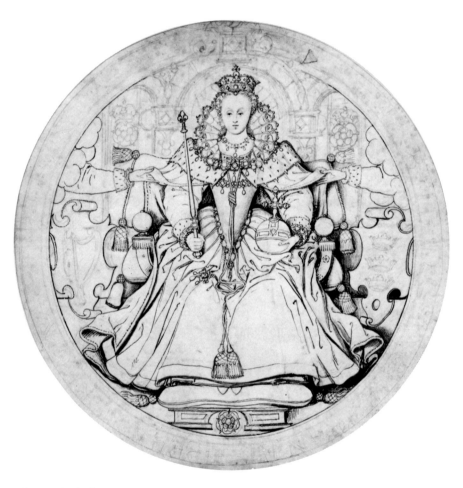

Queen Elizabeth I (late 1590s?). Design for a late Great Seal of the Queen; pen and ink and wash over pencil sketch. 5″. (British Museum)

Nicholas Hilliard's
Art of Limning

A New Edition of
A Treatise Concerning the Arte of Limning

Writ by N Hilliard

Transcription by Arthur F. Kinney
Commentary and Apparatus by Linda Bradley Salamon
Foreword by Sir John Pope-Hennessy

NORTHEASTERN UNIVERSITY PRESS
BOSTON • 1983

Designer, Jean LeGwin

Northeastern University Press

© 1983 Arthur F. Kinney and Linda B. Salamon

Library of Congress Cataloging in Publication Data

Hilliard, Nicholas, 1537 (ca.)–1619.
Nicholas Hilliard's Art of limning.
Bibliography: p.
Includes index.
1. Miniature painting—Early works to 1800.
I. Kinney, Arthur F., 1933– . II. Salamon, Linda
Bradley. III. Title. IV. Title: Art of limning.
ND1329.8.H54 1983 751.42′2 82-24627
ISBN 0-930350-31-6

Manufactured in the United States of America
87 86 85 84 83 5 4 3 2 1

To Mr. Hilliard: upon occasion of a picture he made of my Ladie Rich.

> If Michaell the archpainter now did live,
> Because that Michael he, an angell hight,
> As partiall for his fellow angels, might
> To Raphaelle's skill much prayse and honour give.
> But if in secret I his judgment shrive,
> It would confesse that no man knew aright
> To give to stones and pearles true die and light,
> Till first youre art with orient nature strive.
> But thinke not yet you did that arte devise;
> Nay, thanke my Ladie that such skill you have:
> For often sprinckling her black sparckling eyes
> Her lips and breast taught you The [art you gave]
> To diamonds, rubies, pearls, The worth of which
> Doth make the jewell which you paynt seeme Rich.

—HENRY CONSTABLE, C. 1590

Contents

.

Illustrations

Foreword

This is not simply the first American edition of Hilliard's *Arte of Limning*, but the first meticulous reprint of the text undertaken since it was published by the Walpole Society in 1912. The volumes of the Walpole Society, rich as they are in source material, are not readily accessible; this book makes available for the first time to a wide public the sole discussion of the art of portraiture by any portrait painter in the sixteenth century.

In the seventy years that have intervened since the text was printed, our view of Hilliard as an artist has been radically revised. That this is so has been due to the work of a number of students, centered mainly in the Victoria and Albert Museum in London, which offers incomparable facilities for study of Hilliard and his work. They have included the late Carl Winter (under whom I had the good fortune to work when I first joined the staff of the museum and who opened my eyes to the greatness of Hilliard as an artist), Graham Reynolds (the organizer of a splendid exhibition in 1947 to celebrate the fourth centenary of the artist's birth, a second edition of whose catalogue was issued in 1971), and Erna Auerbach (the author of an impeccably well documented monograph). I myself made two forays into this far-from-congested field, with an article on *The Arte of Limning* and its relation to mannerist treatises on painting, and with a lecture, long out of print, in which I attempted to trace, from the evidence of style, the contacts that documents later proved Hilliard to have had with France.

The aggregate results of all this work is that we now see Hilliard in a European, not just a provincial, context and that his miniatures, despite their scale, have come to be accepted as major works of art in their own right, commanding consideration not as a minor adjunct of Elizabethan literature, but as portraits of incomparable subtlety. *The Arte of Limning* will interest students of art theory, for in it Hilliard was staking out the claims of painting

as a gentlemanly art—claims that had been advanced in Italy three generations earlier by Castiglione in *Il Libro del Cortegiano*. Its quintessential fascination, however, rests in those passages in which Hilliard explains his attitude to portraiture, his admiration for "the comlynes and beauty of the face . . . which giveth us such pleasinge, and feedeth soe wonderful ower afection, mor then all the worlds treassure," and his efforts to "as it [were] catch thosse lovely graces wittye smilings, and thosse stolne glances which sudainely like light[n]ing passe and another Countenance taketh place." Would that other great portrait painters had described, with such vividness and honesty, the psychology of portraiture.

JOHN POPE-HENNESSY

Acknowledgments

We take pleasure in making the miniature painting and, especially, the thought of Nicholas Hilliard readily accessible to an American audience. Such an undertaking is possible only through the generosity of many kind associates of ours and admirers of Hilliard. Support for initial study of Hilliard's treatise in manuscript was provided by the Bunting Institute of Radcliffe College and by the Penrose Fund of the American Philosophical Society. The staff of the Edinburgh University Library, keeper of the single extant manuscript of *The Arte of Limning,* has been repeatedly and unfailingly courteous. In preparation of the present text we received invaluable advice and assistance from G. Blakemore Evans, William Bond, David Vaisey, Laetitia Yeandle, and Doris Suits; Alastair Fowler has been a good friend to the enterprise. Finally, we are permanently indebted for support and encouragement to Washington University and the University of Massachusetts, Amherst, and to our editor *nonpareil,* Deborah Kops.

The photograph of a page of the Hilliard manuscript on page 14 is reproduced with the permission of the University of Edinburgh Library. Photographs of Hilliard miniatures are reproduced by courtesy of the Trustees of the British Museum (Frontispiece and Plate 20); of the National Portrait Gallery, London (Plates 1, 10, 11, 12, and cover); of the National Maritime Museum, London (Plate 23); of the Syndics of the Fitzwilliam Museum, Cambridge (Plate 8); of the Bodleian Library, Oxford, for the portrait of Sir Thomas Bodley (Plate 22); of Lady Anne Bentinck (Plate, p. 64); and of the Victoria and Albert Museum (Plates 2, 3, 4, 5, 6, 7, 9, 13, 14, 15, 16, 17, 18, 19, 21, and the Plate on p. 2).

A. F. K.
Amherst, Massachusetts

L. B. S.
St. Louis, Missouri

Chronology

Kenilworth; Federigo Zuccaro visits England, draws Elizabeth and Leicester

1576 *Hilliard marries Alice Brandon, daughter of his former master;* first English theater built in Southwark by Richard Burbage

1576–78 *Hilliard travels to France, joins suite of Duc d'Alençon; meets Pilon, Gaultier, Ronsard*

1578 *Hilliard takes lease on Gutter Lane house and shop; his first child born*

1579 Spenser's *Shepheardes Calendar* published

1580–95 *Hilliard's mature art at peak*

1581 *Rowland Lockey apprenticed to Hilliard;* Drake knighted; George Gower appointed Serjeant Painter

1584 *Hilliard commissioned to design and produce Second Great Seal for Elizabeth*

1586 Sidney dies of wounds following Battle of Zutphen; Shakespeare arrives in London

1588 Spanish Armada defeated; Gower paints *Armada* portrait of Elizabeth

1590 Sidney's *Countesse of Pembrokes Arcadia,* Spenser's *Faerie Queene, Books I, II,* and *III* printed

1592 Sir Henry Lee entertains Elizabeth at Ditchley; Gheeraerts paints *Ditchley* portrait

1593 Shakespeare's *Venus and Adonis* printed

1595 Sidney's *An Apologie for Poetrie* printed

1598 William Cecil, Lord Burghley, dies; Robert Cecil succeeds as Principal Secretary; Philip II of Spain dies; Globe Theatre built in Southwark

c. 1598–99 *"A Treatise on the Arte of Limning" written*

1599 *Letter patent grants Hilliard annual annuity of £ 40;* Spenser dies

1601 *Hilliard in severe financial distress; further letters patent granted;* Robert Devereux, Earl of Essex, beheaded following unsuccessful rebellion

1603 Elizabeth I dies; James I succeeds

1608 *Hilliard remarries(?) to Susan Gysard of goldsmith's family*

1613 *Laurence Hilliard assumes shop; Nicholas Hilliard moves to parish of St. Martin-in-the-Fields*

Nicholas Hilliard's
Art of Limning

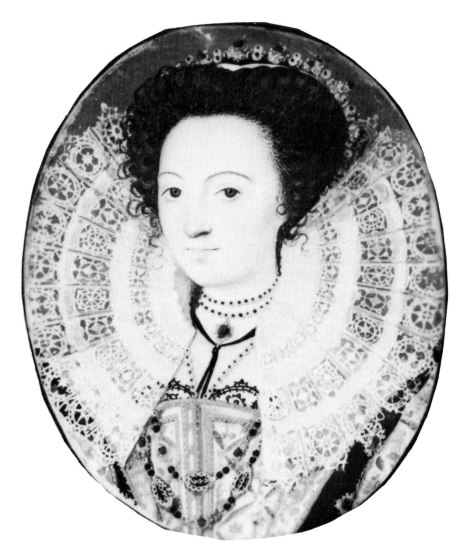

Unknown Lady (late 1590s). 2″ × 1¾″. (Victoria and Albert Museum)

Introduction

Arthur F. Kinney

I

Nicholas Hilliard, in many ways, figures his age. Son of the distinguished Richard Hilliard—goldsmith, bailiff, and high sheriff of Exeter—he took up his father's craft but apprenticed himself to Robert Brandon, goldsmith and city chamberlain of London, and married Brandon's daughter Alice. Ambitious and yearning for a place at Elizabeth's splendid court, he pursued a career common to the Tudor merchant and tradesman. In his long life he succeeded at both. He established his own business, being made a freeman of the Goldsmiths' Company in London in 1569. By 1580, he was painting the Queen and winning a series of appointments from the Crown. But Nicholas Hilliard's life was as rich and multifaceted as the tiny jewels he carved, and his capacious energies and enthusiasms as continually restless as most Elizabethans whose activities shape our understanding of that glorious age. He speculated for a period in a gold rush in Scotland;[1] he may have had an interest in alchemy (there are many references to burning gems in the treatise that follows); and, generous to a fault with family and friends, he found himself in debtors' prison at Ludgate at the age of seventy.[2] He seems, too, to have spent much of his time with his family, raising seven children (an eighth child was stillborn) in an economy severely inflationary and depressive by turns.

Whatever forces laid claim to Nicholas Hilliard's attention, however, painting always remained the steadying center of his life. When a boy of thirteen, he painted a charming if awkward self-portrait; as a young man, he

took his bride with him to France where he may have studied the portraiture of Jean Clouet; and in his later years, as a mature and established miniaturist, he wrote, at the urging of a medical student at Oxford named Richard Haydocke, his essay on the art and craft of painting. Here his enthusiasm is at times unrestrained. "Rare beautys are," he writes in the treatise transcribed here, "more commonly found in this yle of england than else where." Throughout his years, his tiny and exquisite pictures and carving show us that while he could confess "his ffault in speche" to Robert Cecil,[3] he maintained the craftsman's pragmatic line and the jeweler's colorful dreams.

And Hilliard's reputation as painter was great then as now. "A hand, or eye By *Hilliard* drawne, is worth an history," the poet John Donne writes at the beginning of "The Storme,"[4] while their contemporary Henry Peacham, never one given much to compliment, compares Hilliard to Michelangelo in *The Art of Drawing* (sig. B3). For Sir John Harington, godson of the Queen, a reference to Apelles in Book 33 of his translation of Ariosto's *Orlando Furioso* calls forth this extended note in 1591:

> Yet may I say thus much without parciallitie for the honour of my country, as myne authour hath done for the honour of his, that we have with us at this day one that for limming (which I take to be the verie perfection of that art) is comparable with any other country. And for the prayse that I told you of *Parrhasius* for taking the true lynes of the face, I thinke our countryman (I meane M[r]. *Hilliard*) is inferiour to none that lives at this day, as among other things of his doing my selfe have seen him in white and blacke in foure lynes only set downe the feature of the Queenes Majesties countenaunce that it was even thereby to be knowne, and he is so perfect therein (as I have heard others tell) that he can set it downe by the Idea he hath without any paterne, which (for all *Appelles* priviledge) was more (I beleeve) than he could have done for *Alexander*.[5]

Nor was Elizabeth I remiss in admiration. She sat for Hilliard, as he tells us himself in his treatise; she asked him to paint her jewels and sculpt her medals—the Armada Jewel and the "Dangers Averted" medal of 1588 are attributed to him; and for designing the second Great Seal of England, which she used to notarize her state documents, she awarded him for a period of twenty-one years the lease to the manor of Poyle in Middlesex and other estates then, in 1589, valued at £40.[6] Elizabeth's successor to the throne, James I, went fur-

ther: Even as Hilliard's student Isaac Oliver captured the ladies of the Stuart court with his *chiaroscuro* art, the King named Hilliard his official portraitist by issuing this patent:

> Whereas our well-beloued seruant, Nicholas Hilliard, gentleman, our principal drawer of small portraits, and embosser of our medals in gold, in respect of his extraordinary skill in drawing, grauing, and imprinting, &c., we haue granted unto him our special licence for twelue years, to inuent, make, graue and imprint any pictures of our image, of our Royal Family, with power to take a constable and search for any pictures, plates, or works, printed, sold, or set vp.[7]

For a miniature of the King or member of the gentry, Hilliard earned, generally, three pounds;[8] the fee was higher if the portrait was full-length in oil (a picture "in great"), or if more than one person sat as subjects. These paintings, honored then, have been cherished ever since: In 1914 one of Hilliard's portraits of Elizabeth auctioned at Christie's in London fetched £336; two years ago Sotheby's sold a Hilliard miniature for £7,000 ($15,000). His reputation as the first significant native painter in England is secure.

2

> PAINTING is an arte, which with proportionable lines, and colours answerable to the life, by obseruing the Perspectiue light, doeth so imitate the nature of corporall thinges, that it not onely representeth the thicknesse and roundnesse thereof vpon a flat, but also their actions and gestures, expressing moreouer diuers affections and passions of the minde.

So writes Giovanni Paolo Lomazzo in his *Trattato dell'Arte della Pittura, Scultura et Architettura* (Milan, 1584), as translated in 1598 in England by Richard Haydocke of Winchester and New College, Oxford (sig. B1). Haydocke may well have given Hilliard not only the necessary encouragement—the brilliant artist who was rude in speech—but an orderly model of the many points he would need to cover, for Hilliard draws on Lomazzo for his presentation of proportion, perspective, light, color, and the need for a psychological realism (discussed by Lomazzo in his second book as "actions and

gestures"). Yet Hilliard had other sources at his hand in the fifteenth-century *Tractatus de Coloribus Illuminatorum seu Pictorum* and, more certainly, in an anonymous *Arte of Limning* printed in London by Richard Tottel in 1573. This second work, on the different colors used in manuscript illumination and the manner by which to apply them, collates closely with the middle portion of Hilliard's treatise dealing with color (beginning on page 28 in the present edition), although Hilliard adds more detail and is generally more sophisticated in his treatment.

Such use of sources was part of the respectable Tudor tradition of imitation, but there is also much in Hilliard's treatise that is original. His insistence that limning be limited to the upper class and gentry and his sad story of John Bosham, his praise of Holbein and his muted criticism of Dürer, his advice on the relationship of painters to their subjects, his choric commentary on the delicacy of line and the vulnerability of paint, and his complaint that foreign artists receive better treatment than the native Englishman—all of this is pure Hilliard. So is his sense of the utility of miniatures, his plea for patronage of the arts, his praise of England, his theory of full light and no shadow, and, of course, the repeated allusions to gems and the analogies between the primary colors of paint and the rich hues of precious stones. Hilliard's essay is thus instructive, personal, sometimes casual, and always immediate. Yet the importance of the work remains considerable, giving us some valuable information about his life, defining his style and clarifying his technique, and setting forth the first English theory of painting by combining Continental and native art theory and practice. "The finall ende of *images* is the vnderstanding," Lomazzo writes (in Haydocke's translation) on sig. 2P6v, "but the *eie* is the immediate, according to that of *Aristotle, there is nothing in the vnderstanding, which was not first in the sense;* and must needes be, that before these images can come to our vnderstanding, they bee first in the eie: that is, they must first be seene." When we appreciate how Hilliard makes seeing and understanding unite for the painter and viewer alike, when we see how the emphasis on surface values in his miniatures is that natural product of his conviction that they are to be held close, as personal keepsakes—analogous to his charming stories of the Queen, of Hatton, and of Sidney which he holds close in his memory—we sense, finally, not only the wealth of Hilliard's knowledge of his work but the deep joy he takes in it. "Nicholas Hilliardus," he letters proudly in gold around the rim of his self-portrait, "aurifaber sculptor et celebris Illuminator serenissimae reginae elizabethae."[9]

So we should be poorer without Hilliard's essay, itself an illumination of

a very special and unique kind. His contemporaries and immediate successors knew that, too, and subsequent treatises on art draw heavily on the text transcribed here. A rough draft of *Miniatura or the Art of Limning* (about 1646) by Edward Norgate (Bodleian Library MS Tanner 326)[10] and an earlier, shorter draft (British Museum [BM] MS Harleian 6000) are based in part, and openly, on Hilliard's essay.[11] And we can add other manuscripts of the seventeenth century that, through Norgate, derive from Hilliard: BM Add MS 23080 (an imperfect transcript of Harleian 6000); a manuscript dedicated by Daniel King (BM Add 12461); BM Add 34120 which has as colophon "Michael Uffington fecit"; Harleian 6376 (also at the British Library), presumably a 1664 copy of Harleian 6000; a later manuscript at Victoria and Albert Museum, London, following Harleian 6000; and a transcript (dated 1657) of Tanner 326 at the Royal Society of London.[12] Although Henry Peacham's four books on painting—*Art of drawing with the pen and limning in water colours* (1606) expanded as *Graphice* (1612) and retitled *The gentlemans exercise* (no date given) and, finally, included in *The Compleat Gentleman* (1622)—occasionally mention Hilliard, he uses Lomazzo as his chief source. Yet it is the Hilliard text, through Harleian 6000, that models for the other books of the period, including *Polygraphice* (probably by William Salmon, MD, 1672), *Graphice* by William Sanderson (1658), and *Ars Pictoria* by Alexander Browne (1660, 1675). Still, the chief use of Hilliard as source is in the anonymous *Mr. Garrat, Master in that Art, and Painter, to Her Sacred Majesty Queen Elizabeth, of Famous Memory*, printed about 1664.[13] Attributed (in the title) to the royal portrait painter Marcus Gheeraerts, this little volume reprints Hilliard word for word without crediting him, omitting only the personal remarks and stories, as if to cover up the source. That such a hoax could be perpetrated suggests that by the last quarter of the seventeenth century Hilliard's direction and judgments had become commonplace and his position in history comfortably (if anonymously) assured.

3

Even so, we are astonishingly lucky to have Hilliard's treatise today—"a document of the greatest importance," according to Erna Auerbach (p. 198)—for it was never published in his lifetime, and only a meager handful of such literary manuscripts of his period survive. We have personal papers and correspondence, patents and judicial records in abundance, yet in an art so public

and popular as the drama, for example, we have of Marlowe's only a single page of his *Massacre at Paris* and that attribution has been contested; an autograph copy of only one work by Ben Jonson (a man who took care to preserve his material), and this not a play but *The Masque of Queens;* and two manuscript leaves of *Sir Thomas Moore* (sic) attributed to—but not likely by—Shakespeare. And the copy of Hilliard's treatise that has come down to us is without title or date, without the name of the author, and in the hand of an unidentified and careless copyist who wrote it out hurriedly, presumably some years after Hilliard's death in 1619.

Yet Hilliard's *Arte of Limning*—the title awarded the manuscript by George Vertue, who owned it in the eighteenth century—can be dated rather closely and established convincingly as the painter's work. We know from the treatise itself that it was written after the death of Christopher Hatton (referred to as "sometimes" or "former") in 1591 and before the death of Queen Elizabeth in 1603. Since it is unlikely Hilliard had already begun it when urged to write an essay on limning by Haydocke in the preface to his 1598 translation of Lomazzo, but equally likely that this is what finally prompted Hilliard to write his treatise, we can date the original work sometime around 1600.

References within the essay itself also help guarantee the work as Hilliard's. The personal accounts of Queen Elizabeth, her Lord Chancellor Christopher Hatton, and her leading courtier Sir Philip Sidney seem authentic and involve people Hilliard knew. The long digression on the analogy of colors and precious stones reads like the work of a jeweler or goldsmith, which Hilliard was, and the scattered ideas, observations, and practices—such as the refusal to use shadows in miniature portraits—are characteristic of Hilliard's painting. The essay, moreover, has the authentic tone of Hilliard when we match it with his extant signed letters; the treatise has the same swift flow of words, at times slackening, often rambling, and it is, as Hilliard can be, at times awkward in expression and inaccurate in syntax. Even the emphasis in the essay on a strong forehead line as the basis for beginning a portrait confirms Hilliard's authorship and stamps the treatise with his indelible character and belief. There is somewhat less certainty over the technical appendix, for the anecdotal and rambling style of the essay is replaced in the appendix by a set of instructions at once more straightforward and condensed. Hilliard's name attached to one recipe in later manuscripts suggests that that alone might have been considered his shortly after the treatise was copied out—or that the entire work (from which the recipe was taken) is his. Yet here, too, the organization and ideas, though in a separate appendix in a separate copyist's

hand, readily and consistently conform to the main treatise in such particular points as preparing the surface of a card for painting and not making a color too brown; here, too, we may nominate Hilliard as the probable author.[14]

4

What remains a mystery, cloaked by the intervening years, are the names of the two copyists who produced the sole manuscript we now have. The copyist of the treatise dates and places his work "the 18 of March 1624 Londres [London]" at the bottom of his last page of transcription, and the character of his handwriting bears him out. He is sometimes hasty in his work, he repeats some words without crossing them out, omits or deletes others, and inserts some that he first overlooked: clearly the essay was copied from an earlier manuscript and not dictated (dictation being, by then, a common practice). The copyist's writing is reasonably clear; he uses a mixture of secretary and italic hands, especially in the lowercase *r*. He may have written much of the essay at only a few sittings, for as he proceeds his lines grow farther apart, he puts fewer words on the line, and his careless errors increase, indicating that he is growing weary at the task; but then, just past the halfway point, he becomes more careful, and punctuating and paragraphing increase. The copyist who wrote out the appended note on colors has a later—a mid-seventeenth-century—hand, and his writing, like his material, is more dense: He is given to frequent abbreviation (*pfect, coull*[3]) and his rounder scrawl is more crabbed and jammed to the line and on the page. Both copyists share a certain untidiness.

But who they were, why they copied Hilliard's essay, and what they used it for, we do not know and probably have little chance of ever knowing. The manuscript—a total of eighteen folio sheets, with vertical chain lines and a distinctive (but unidentified) watermark, measuring eleven by nine inches, each folio containing catchwords by the copyist and pagination in pencil by the University Library at Edinburgh—can be traced only after the second quarter of the eighteenth century when George Vertue purchased it to use in his projected history of painters and painting. Vertue signed his name, added the title, and, presumably for his own reference, penciled in some of the marginal annotations in his own Augustan handwriting. But Vertue died in 1757, before writing his intended book, and in the following year Horace Walpole bought the

manuscript along with the rest of Vertue's collection from Vertue's widow to use as a basis for his *Anecdotes of Painting;* in that work, Walpole turns to the Hilliard essay for comments on Holbein and Bosham as well as on Hilliard himself. The manuscript remained in the possession of the Walpole family until the estate was auctioned by George Robins in 1842; the manuscript was bought then by Patrick Fraser Tytler and subsequently sold to the well-known Scottish antiquary, bibliophile, and editor of Scottish ballads David Laing (1793–1878), who bequeathed it to the University Library at Edinburgh.[15] There it is catalogued as La.III.174, in the third of four boxes of Laing's materials, the box reserved for separately bound volumes; it is covered in maroon linen over boards, with a leather spine reading in gold leaf ART OF LIMNING—HILLIARD and quarter-bound in leather by the library. Walpole's bookplate and the names of Tytler and Laing, the latter written in pencil and retraced, are on the inside front cover. A half-page bound into the volume between the tenth and eleventh leaves contains a series of speculations on the date of the manuscript; the note is in an eighteenth-century hand, perhaps Walpole's. Other treatises now preserved with the one by Hilliard include a fourteenth-century treatise on astronomical subjects in Latin with diagrams; *Theoria Motuum Coelestium,* according to the hypotheses of Ptolemy, Copernicus, and Tycho Brahe, by Duncan Liddel, 1599; *Perugia,* an important work on the history of pawnbroking, bound in boards covered with leather and brass knobs and printed probably in the fifteenth century; a lecture on optics published in Edinburgh in 1684; and *Alberti Dueri Alphabetum perfectius Efformatum,* with figures and explanations, printed in the sixteenth century.

Surprisingly, a work as unique and significant as Hilliard's *Arte of Limning* has been transcribed only twice. The first transcription was by Philip Norman for Volume I of the Walpole Society (1911–12), circulated only to members of the Society; it was illustrated with five Hilliard miniatures in rotogravure.[16] The second transcription was the 1981 edition produced by the Mid-Northumberland Arts Group.[17] The present transcription is a literal one made from photostats of the manuscript supplied exclusively to the editor from the University Library at Edinburgh more than a decade ago and then read back against the original in Edinburgh. The old spelling, colloquial phrasing, dialectical forms, and punctuation have been preserved, not only out of a sense of history but to provide a sense of that splendid, expansive age in which Hilliard lived, painted, and wrote. But his observations and advice, like his style, know no age. Hilliard's treatise remains an essay for all times, a work for all seasons.

Notes

1. With his fellow limners Arnold van Brounckhurst and Cornelis DeVosse, in 1572; Elizabeth I herself seems to have expressed some guarded interest in the adventure. Hilliard was again speculating in 1610, advocating the suit of William Laborer, goldsmith, who vowed he could mend highways for half the usual cost. There is a good possibility that Hilliard planned to enter partnership with Laborer. See Graham Reynolds, *Nicholas Hilliard and Isaac Oliver* (London, 1947; 1971), 14–15.

2. Recent research has uncovered a mutilated document in the Public Records Office which shows that Hilliard stood as security for one John Langford for a debt of £20 that was not met—and that Hilliard then had considerable difficulty covering. Hilliard was imprisoned when William Pereman, yeoman usher of the chamber, complained of Hilliard's debts but did not appear to testify; Hilliard, imprisoned, then brought a complaint of his own before the Court of Requests. See Court of Requests *Proceedings* (Req. 2), bundle 393, no. 64; transcribed by Noel Blakiston, *Notes and Queries,* 192:6 (22 March 1947), 123–24. Hilliard died two years later, in 1619, at the age of 72.

3. Winter, *Elizabethan Miniatures,* 20.

4. *John Donne: The Satires, Epigrams, and Verse Letters,* ed. W. Millgate (Oxford, 1967), 55.

5. *Ludovico Ariosto's "Orlando Furioso," trans. Sir John Harington (1591),* ed. Robert McNulty (Oxford, 1972), 385.

6. Reynolds, *Hilliard and Oliver,* 10.

7. Erna Auerbach, *Nicholas Hilliard* (London, 1961), 40.

8. Eventually, Elizabeth I awarded Hilliard a pension of £40 per annum, but this was not enough (see Hilliard letter to Robert Cecil, 28 July 1601; Salisbury MS 87/25). Hilliard was in especially bad straits after repairing a house in Gutter Lane, London, at the cost of £200, which, he writes Cecil, might cause him to depart from England for a year or two. In the same letter, he offers his son for some position of service. See Reynolds, *Hilliard and Oliver,* 10.

9. Plate X; painted in 1577 when Hilliard was thirty and now at the Victoria and Albert Museum, London (Salting Collection). See the earlier speculations of Philip Norman, *Publications of the Walpole Society,* vol. 1 (Oxford, 1911–12), 53.

10. Transcribed and edited by Martin Hardie (Oxford, 1919).

11. The passage in the appendix to Hilliard's treatise beginning "Cheristone and Ivory are both to bee burned so ground" is copied exactly into Harleian 6000 with this subsequent note: "This was the manner of our late Mr Nicholas Hilliard in making his Sattens"; see Norman, *Publications,* 10. Norman was the first to establish the relationship of the Edinburgh treatise with Tanner 326 and Harleian 6000 and publish his results, although Hardie had also made the same identification. See Norman, *Publications,* 8–11; Hardie, Introduction, passim.

12. There are also several later, eighteenth-century manuscripts. The most com-

prehensive discussion remains Hardie's, pp. xi–xxiii, to which all subsequent editors and commentators on Hilliard have been indebted.

13. Most of these works cite Hilliard. Presently, the best discussions are by Auerbach, *Nicholas Hilliard*, 219–23, and by John Pope-Hennessy, "Nicholas Hilliard and Mannerist Art Theory," *Journal of the Warburg and Courtauld Institutes*, 6 (1943), 89–100. Roy Strong has several brief popular appreciations on Hilliard that touch upon these matters. Again, Norman was the first to identify some of these works, but he apparently was unaware of *Graphice, The gentlemans exercise,* and *Mr. Garrat,* which I have examined at the Bodleian Library. The last was brought to my attention by Dr. D. H. Craig; my own appreciation of Hilliard was considerably enhanced in discussions with Mr. John Buxton.

14. Auerbach also makes this point, with much the same evidence, in her chapter on Hilliard's treatise. But Hardie remains dubious; see his p. xxviii.

15. This history of the Edinburgh manuscript is noted in the manuscript itself and has been confirmed for me by the Keeper and his staff. I am grateful to Dr. J. T. D. Hall, Keeper of Special Collections, and Marjorie Robertson, Assistant Librarian, for their many kindnesses during my three visits to Edinburgh to examine, transcribe, and check details regarding this manuscript.

16. A portion of the manuscript, transcribed around 1863 for Sir George Scharf, "virtual founder of the National Portrait Gallery" according to Norman, was published in *Burlington Magazine,* viii, and quoted by Helen Farquhar in *Numismatic Chronicle,* 4th ser., 8 (1908), and *British Numismatic Journal,* 4 (1908), thus bringing the work to Norman's attention. See Norman, *Publications,* 12–13. The present transcription differs from that by Norman in a number of ways, in part because the copyist's *o, e,* and *a* are often similar. Such incidental variants can become substantial, as, say, in the case of Norman's *wherfor,* here *wherof,* or *those,* here *these.* Norman repunctuated the text, often changing the sense by recombining clauses and phrases, but declined to acknowledge the common Tudor practice of using double initial consonants (*ff*) to note a capital (*F*). His use of abbreviations, especially regarding the tilde, is inconsistent. The present literal transcription hopes to correct in particular these and related matters.

17. Thornton, R. K. R., and T. G. S. Cain. *A Treatise Concerning the Arte of Limning.* Ashington, England, 1981.

Folio 4v of the Edinburgh manuscript of Hilliard's *Arte of Limning*.

A Treatise Concerning the Arte of Limning

writ by
N Hilliard

*at the request of R. Haydocke
who publisht in English a translation of
Paulo Lomazzo on Painting 1598.*

[fol. 1] ⟨Of Precepts & directions for the⟩ arte of paintinge I will saye littel in so much as *Paulo Lomatzo* ⟨& others hath excellently & learnedly spo⟩ken therof, as is well knowen to the learned & better sorte ⟨who are conversant with those a⟩uhtors, But only intending to teache the arte of limning, and the ⟨True method leading ther⟩unto, as also to shewe who are fittest to be practisers ⟨thereof, for whom only⟩ let it suffice that I intend my whole discourse that way:

⟨Amongst the ant⟩ient *Romans* in time past forbad that any should ⟨be taught the ar⟩te of *Painting* save gentelmen only, I conjecture they Did it ⟨upon judgment of th⟩is ground, as thinking that noe man using the same to get his living ⟨by, if he was a needy⟩ Artificer, could have the patience or leasure to performe any ⟨exact true & rare⟩ peece of worke, but men Ingeniously borne, and of sufficient means ⟨not subject to⟩ [those] comon cares of the world for food and garment, moved with ⟨emulation and desier⟩ therof, would doe their

⟨G. Vertue⟩*

Lomatzo: Giovanni Paolo Lomazzo, author of *Trattato dell' arte della pittura* (1584); also Lomatius, Lomatio
auhtors: authors
limning: illuminating, miniature painting

noe: no

desier: desire
theier: their

*An explanation of the marginal notes appears on page 51.

lenght: length

deface: see Leonardo da Vinci, *Treatise on Painting,* II, 34–34v
pece: piece

weare: were

mad: made

bocher: botcher; *nowe adaies:* nowadays

secreat: secret
perseaved: perceived

beining: being

voloms: volumes

forraine: foreign

⟨*Ecclesiasticus*⟩

aughter: author
guifts: gifts

utermost best not respecting the ⟨profitt o⟩r the lenght of time nor permit any unworthy worke to be pubblished under their name to comon view, but deface it againe rather and never leave till some excelent pece of Arte were by him or them performed worthy of some comendations, by *Reason* wherof it was no wonder that the most excelent nation and the greatest witts of the world then brought forth the most rare workes in painting that ever weare, it must needs be granted then for ever, and like as one good workman then mad an other, so one bocher nowe adaies maketh many, and they increasse so fast that good workmen give over to usse their best skill, for all m⟨en⟩ cary one price, Now therfor I wish it weare so that none should medle with limning but gentelmen alone, for that it is a kind of gentill painting of lesse subjection then any other for one may leave when hee will his coullers nor his work taketh any harme by it, Morover it is secreat a man may usse it and scarsly be perseaved of his owne folke it is sweet and cleanly to usse, and it is a thing apart from all other *Painting* or *drawing* and tendeth not to comon mens usse, either for furnishing of Howsses, or any patterns for tapistries, or *Building,* or any other worke what soever, and yet it excelleth all other *Painting* what so ever, in sondry points, in giving the true lustur to pearle and precious stone, and worketh the metals *Gold* or *Silver* with themselfes which so enricheth and innobleth the worke that it seemeth to be the thinge it se[l]fe even the worke of god and not of man, beining fittest for the deck[ing] of princes bookes or to put in Jewells of gould and for the [imitation] of the purest flowers and most beautifull creaturs in the finest a[nd] purest coullers which are chargable and is for the service of noble persons very meet in small voloms in privat maner for theem to have the Portraits and pictures of themselves [fol. 1v] their peers, or any other forraine ⟨ ⟩ them, And this is a worke which of ⟨ ⟩ owne pressence for the most part of the ⟨ ⟩venient that they be gentelmen of g⟨ ⟩ of abbillity or mad by princes fee, a ⟨ ⟩ to give such seemly atendance one Pr⟨ ⟩ *Royall* presence, Seest thou not that th⟨ ⟩ in theire bussines stand before Prince ⟨ ⟩mon peeople, But god the aughter of Wisdo⟨ ⟩ all good guifts and goodnes, he

16

giveth Gaentilit 〈 〉 rayseth man to reputation by divers mean
〈 〉 he called *Basaleel, And Ahohas* by name and 〈 〉 wiss-
dome, skill, and understanding, without any te〈 〉 of his owne
guift and grace receved 〈 〉 himself to be cuninge in all fine and
curious 〈 〉 silke, in painting, in setting of precious stones in gould
〈 〉 the text sayeth he filled them with the sperit of god to 〈 〉
such works, being men before brought up but in 〈 〉 of brickes in
captivitye they and their Ancestors 〈 〉 generations: Heer is a kind
of true gentility when god caleth and doubtles though gentlemen be
the metest for this gentill caling or practize, yet not all but naturall
aptnes is to be chossen and prefered, for not every gentelman is so
gentel sperited as som others are, Let us therfore honore and pref-
ferre the election of god in all vocations and degrees, and suerly he is
a very wisse man that can find out the naturall Inclination of his
childeren, in due time, and soe applie him that waye which nature
most inclineth him, if it be good or may be made good, as it may be
ussed though in childhood abussed, and as for an naturall aptnes of
or to painting after the liffe thosse surly which have such a guift of
god ought to rejoyce with humble thankfulnes, and to be very wary
and temperat in diet and other government, least it be sone taken
from them againe by some sudaine mischance, or by their evell cous-
tomes, their sight, or stedines of hand decay, then this exortation
give I more that he be diligent, yea ever diligent, and put his whole
uttermost and best endeavors to exceell all other, for a stronge man
that putteth not forth his strenght, is often foyled by weaker, and the
most perfect and cuningest must doe the same diligence, or rather
more, to effect and performe his worke, then hee did at the first in
larninge, for it can not be sayd that a man be he never so cunning by
teaching or naturall Inclination, yet it will growe out of him as haire
out of the head, or fall from him whether he will or no, but with
great labour, and this comfort shall he have then, above others, even
an heaven of Joy in his hart to behould his own well doings remain-
ing to his credit for ever, yea if Men of worth did knowe what de-
light it [fol. 2] breedeth, how it removeth mallancoly, avodeth evell
occasions, putteth passions of sorrowe or greefe awaye, cureth rage,

Basaleel, And Ahohas:
Bezalel and Oholiab;
see Exodus 31:1–11,
cited in John Case's
commendatory letter to
Haydocke's translation
of Lomazzo

metest: meetest, most
suitable

surly: surely

least: lest; *sone:* soon
sudaine: sudden

then: than

avodeth: avoideth

and shortneth the time, they would never leave till they had attained in some good meassur, A more then comfort maie he have, both praysse and even honor in the sight of men living, and fame for ever after, And *Princes* comonly give them competent meanes, by which not the workmen soe much as themselves ar eternized, and famously remembred as the nuresses of vertue and Arts, wherfore it is truly written *Honos alit artes,* and many noble and honorable perssons have bine practizers themselves of the art of painting, as *Lomatius* very learnedly and truly hath in order repeated and some have counted themselves the greater therby as the famous and victorious *Roman Quintus Fabius* added it as an honnore unto his tytle to be called *Quintus Fabius Pictor./.* And *Pamitius* recokoning up the famous barons and worthy perssons which weear attendant on the emperour *Marcus Aurelius,* remembreth, and shortly amonge them this principal *Painter:* nevertheles if a man be so indued by nature and live in time of trouble, and under a savage goverment, wherin arts be not esteemed, and him selfe but of small meanes. Woe be unto him as unto an untimly *Birth:* for of mine owne knowlege it hath mad poure men poorer, as among others many, the most rare *Englishe Drawer* of Story works in black and white *John Bossam,* for one of his Skill worthy to have bene *Sergant Painter* to any king or *Emperour,* whose work in that kind are comperable with the best whatsoever in cloathe in distemper cullors for whit and black, whoe being very poore, and belyke wanting to buy faier cullors, wrought therfore for the most part in whit and black, and growing yet poorer by charge of childeren &c., gave painting cleane over: But being a very faier conditioned zealous and godly persson, grewe into a love of gods devine service upon the liberty of the gosspell at the coming in of quene *Elizabeth,* and became a reading *Minister,* only unfortunat becasse he was english borne, for even the strangers would otherwisse have set him upp, Heer must I needs incert a word or two in honore and praisse of the renowned and mighty *King Henry the eight* a *Prince* of exquisit Jugement:. and *Royall* bounty, soe that of cuning Stranger even the best resorted unto him, and removed from other courts to his Amongst whom came the most excelent painter

Honos alit artes: Honor sustains the arts (Cicero, *Tusculan Disputations*)
bine: been

weear: were

indued: endowed

Story works: narrative paintings
John Bossam: John Bosham

distemper: tempera paints

reading Minister: minor cleric permitted to read the lesson at morning and evening prayers but not to deliver sermons

strangers: foreigners

cuning: skillful

and limner *Haunce Holbean,* the greatest Master truly in both thosse arts after the liffe that ever was, so cuning in both to gether, and the neatest, and the[r]withall a good inventor soe compleat for all three, as I never hard of any better then hee yet had the *King* in wages for *Limning* divers others, but *Holbeans* maner of *Limning* I have ever Imitated, and howld it for the best, by Reason that of truth all the rare siences especially the arts of *Carving, Painting, Gouldsmiths, Imbroderers,* together with the most of all the liberall siences came first unto us from the Strangers, and generally they are the best, and most in number, I hard Kimsard the great french poet on a time say, that the Ilands indeed seldome bring forth any cunning Man, but when they doe, it is in high perfection so then I [fol. 2v] hope there maie come out of this ower land such a one, this being the greatest and most famous Iland of *Europe:* the most excelent *Albert Dure* was borne in *Germany,* a part of the greatest Mayneland in *Europe,* which breedeth or might breed more then a hundred workmen for us one, this *Albert* being as exquisite and perfect a *Painter,* and Master in the art of *Graving* on *Copper* as ever was since the world begane, (that by many works exstant appeareth) and which also hath written the best and most rulles of and for panting and graving hetherunto of any maister untill *Paulo Lamatio,* which *Rulles* of *Albert* for the most part ar hard to be remembred, and tedious to be foloued of *Painters,* being so ful of divisons, but very fittable for carvers and masons, for architects and fortifications, and all which drawing is the enterance the very high waye and foundation, he dowtlesse had opinion that not in hast or short time his better showld arisse, wherfor as it hath bene unto me credabelly Reported, he resserved some plats of his owne graving for printing, which he gave unto the city of *Norenbourgh* wherof he was a worth[y] counselor which he kept fo[r] a time, r[e]quiring of them by his will and testament that thosse plats should not be printed, untill one hundred yeares after his [death] weare fully expired and past that he might then arisse againe after a houndred years to his greater fame, if in the meane time he wear not excelled by any other, which plats ar yet reserved unprinted to his great credit and which in due time to his greater fame will doubtles

Haunce Holbean: Hans Holbein (1497/8–1543)

hard: heard

Carving: sculpting

Kimsard: Ronsard

ALBERT DUER *Dure:* Albrecht Dürer (1471–1528)

⟨Lammazo⟩

Norenbourgh: Nuremberg

19

(Goltzius)
Goltzius: Hendrick
Goltzius (1558–1617),
Flemish mannerist en-
graver and painter
Lucas of Leyden:
Lucas van Leyden
(1489–1553), Flemish
painter and engraver
influenced by Dürer
bouck: book

be devolged, yet hath ther beene divers excelent persons of that na-
tion and of *Italy,* france, and the lowe countries also, wherof *Hen-
drick Goltzius,* aproched *Albertus* very neer, most admirably imitat-
ing him, and *Lucas* of *Leyden* also, in their severall handling the
graver, which he hath done in sertaine peces to showe what he could
doe if he list, but he afecteth an other maner of line, which is swifter
acording to his spirit, and doubtles very excelent, and most folowed,
that Man is worthy to be remembred in bouck to posterity, which
excelleth all men in that age, in that matter, wherof he is professer,
Albertus Dure was both inventor and graver, as few of the rest of
the gravers are, a double honnor to him, nowe the reasson why the
rules of *Alberte,* serve mor the carver then the *Painter* is becausse he
discribeth and devideth the propeortion of parts of men, like as of
pillors or such other things, by measures of inches in lenght, breadth,
thiknes, and circumference, which measures serve not, nor can howld
in painting, for as *Lamatzo* truly speaketh in the eleventh chapter of
Opticio, you cannot measure any part of the pictures by his true *su-
perficious,* Because painting perspective, and forshortning [fol. 3] of
lines, with due shadoing acording to the rule of the eye, by falshood
to express truth in very cunning of line, and true observation of
shadoing, especially in human shapes, as the figure, lieth, boweth, or
standeth, and is situated, or is, and aptly shalbe placed to deceave
the eye, for perspective, to define it brefly, is an art taken from, or
by, the efect or Jugment of the eye, for a man to express anything in
shortned lines, and shadowes, to deseave bothe the understanding

cassed: caused; *cissero:*
Cicero (*Academica
Priora,* II.20)

and the eye, this cassed the famous and eloquent *cissero* to say, O
how many things doe painters see in highning or lightning, and shad-
owing, which wee deserne not, and heer I enter myne opinion con-
serning the question, whether of the two arts is the most worthy,

tow: two

leafe: page

Painting, or *Carveing,* I say if they be tow arts, painting is the wor-
thier, as in the last leafe I hope I shall prove suficiently, againe I will
Doe Cuning *Albert* no wronge, but Right, dowbtles he was the most

vieue: view

exquisite man that ever leaft us lines to vieue for true delination, the
most perfect shadower that ever graved in metall, for true shadowes,
and one of the best and truest in his perspective, but yet it must be

thought or rather heeld for sertaine by reason that he was no great traveller, that he never sawe thosse faier creatures that the Italions had seene, as *Rousso, Raphel,* and *Lambertus Swanius* &c./ for besides a certaine true proportion, some of thirs doe excell his in kind of beautifulnes, and sperit in the linament and Jesture, with delicacye of feature, and limes [of] hands and feet, surpassing all other portractures of the duch whatsoever, yea even nature it self, except in very few which rare beautys are even as the diamons are found amongst the savage indians, more commonly found in this yle of england then else where, such surely as art ever must give place unto I saye not for the face only, but every part, for even the hand, and fooet, excelleth all pictures, that yet I ever sawe/ This moved a sertaine *Pope* to say that england was Rightly called *Anglia* of *Angely* as the country of *Angels,* god grant it, and now to the matter for precepts for Observations, ore directions to the art of limning, which you requier, as breefly and as plainly as I can, Concerning the best waye and meanes to practice and ataine to skill in *Limning,* in a word befor I exhorted such to temperance, I meane sleepe not much, wacth not much, eat not much, sit not long, usse not violent excersize in sports, nor earnest for your recreation/ but dancing or bowling, or littel of either,/ then the fierst and cheefest precepts which I give, is cleanlynes, and therfor fittest for gentlemen, that the praticer of *Limning* be presizly pure and klenly in all his doings, as in grinding his coulers in place wher ther is neither dust nor smoake, the watter wel chossen or distilled most pure, as the watter distilled frome the watter of some clear spring, or frome black cherize which is the Cleanest [fol. 3v] that ever I could find, and keepeth longest sweet and cleare, the goum to be *Goume Aarabeeke,* of the whitest and briclest broken into whit pouder, one a faire and cleane grinding stone and whit suger candy in like sort to be keept dry in boxes of *Ivory* the grinding stone of fine *Cristall, Serpentine, Jasper,* or *Hard Porfory,* at the least let your aparell be silke, such as sheadeth lest Dust or haires weare nothing straight beware you tuch not your worke with your fingers, or any hard thing, but with a cleane pencel brush it, or with a whit feather, neither breath one it, especially in

⟨Italy⟩
Rousso: Giovanni Rosso ("Il Rosso Fiorentino," 1494–1541), mannerist decorator of Fontainebleau; *Raphel:* Raphael
Lambertus Swanius: Lambert Zutman (called "Suavius"), c. 1510-1567, engraver and architect

⟨England beautifull cratures.⟩

wacth: waketh

fierst: first

Goume Aarabeeke: gum arabic, a binding medium from Senegal or Morocco

briclest: most brittle; *one:* on

pencel: thin paintbrush

dandrawe: dandruff

sparkling: spraying

⟨Rule 2′⟩

on[e] only light: recommended by Lomazzo, IV, xx, on the authority of Michelangelo

dieper: deeper (larger)

OF
PAINTING

empresse: impress

prayesse: praise

⟨+⟩

discoure: discourse

could weather, take heed of the dandrawe of the head sheading from the haire, and of speaking over your worke for sparkling, for the least sparkling of spettel, will never be holpen if it light in the face or any part of the naked, the second *Rulle* is much like the first and conserning the light and place wher you worke in, let your light be no[r]thward, somwhat toward the east which comonly is without sune, *Shininge in.* on[e] only light great and faire let it be, and without impeachment, or reflections, of walls, or trees, a free sky light the dieper the window and farer, the better, and no by window, but a cleare story, in a place wher neither dust, smoak, noisse, nor steanche may ofend, a good painter hath tender sences, quiet and apt, and the culers them sellves may not endure some ayers, especially in the sulfirous ayre of seacole, and the guilding of *Gowldsmithes,* sweet odors comforteth the braine and openeth the understanding, augmenting the delight in *Limning, Discret* talke or reading, quiet merth or musike ofendeth not, but shortneth the time, and quickneth the sperit both in the drawer, and he which is drawne, also in any wisse avoyd anger, shut out questioners or busi fingers, all theesse things may be hadd, and this authority may best be ussed by gentelmen, therfor in truth the *Art* fitteth for them, now knowe that all *Painting* imitateth nature or the life in every thinge, it resembleth so fare forth as the *Painters* memory or skill can serve him to expresse, in all or any maner of story worke, embleme empresse, or other device whatsoever, but of all things the perfection is to imitate the face of man kind, or the hardest part of it, and which carieth most prayesse and comendations, and which indeed one should not atempt untill he weare metly good in story worke, soe neare and so weel after the life, as that not only the party, in all liknes for favor and complection is or may be very well resembled but even his best graces and countenance notabelly expressed, for ther is no person but hath variety of looks, and countenance, as well ilbecoming as pleassing or delighting, wherof it is not amis to say somwhat in briffe tuching this point, leaving the better handling therof to better wits, wherin the best shall find infinite arguments, right pleasa[nt] [fol. 4] to discoure uppon and herof it cometh that men commonly

22

say of some drawer, he maketh very like, but better yet for them
then the party is in deed, and of some other they also say he maketh
very faier, but worsse favored in the comlynes and beauty of the
face, therfor which giveth us such pleasinge, and feedeth soe wonder-
ful ower afection, mor then all the worlds treassure, it consisteth in
three points, the first, and least is the faire and beautiful couler or
complection which even a far of, as neare is pleassing greatly all be-
houlders, the next and greater part is the good proportion somtime
called favore, wherof ouer devine part uppon nearer vi[e]w, by an
admirable instin[c]t or nature, Jugeth generally both in wisse, and
foolish, yong, or owld, learned, and simpel, and knoweth by nature
without rule or reasson for it, whoe is well proportioned or well fa-
vored, &c. but the third part &c, greatest of all is the grace in coun-
tenance, by which the afections apeare, which can neither be weel
ussed nor well Juged of but of the wisser sort, and this princepall
part of the beauty a good painter hath skill of and should diligently
noet, wherfor it behoveth that he be in hart wisse, as it will hardly
faill that he shalbe amorous, (and therfore fittest for gent:) for whoe
seeth an exelent precious stone, or diserneth an exelent peece of mu-
sike with skill indeede and is not moved above others with an amo-
rous Joye and contentment then the vulger, howbeit gent or *vulgar*
wee are all generally commanded to turne away ouer eyes frome
beauty of humayne shape, least it inflame the mind, howe then the
curious drawer wach, and as it [were] catch thosse lovely graces wit-
tye smilings, and thosse stolne glances which sudainely like
light[n]ing passe and another Countenance taketh place except hee
behould, and very well noate, and Conceit to lyke, soe that he can
hardly take them truly, and expresse them well, without an affection-
ate good Jugment, and without blasting his younge and simpel hart,
although (in pleassing admiration) he be very serious, bussied, so
hard a matter he hath in hand, calling thosse graces one by one to
theire due places, notinge howe in smilling howe the eye changeth
and naroweth, houlding the sight just between the lides as a center,
howe the mouth alittel extendeth, both ends of the line upwards, the
Cheekes rayse themselves to the eyewards, the nosterels play and are

⟨1⟩
a far of: afar off
⟨2⟩
ouer: our

⟨3⟩

noet: note
gent: gentlemen

bussied: beside

⟨+⟩

alittel: a little

23

more open, the vaines in the tempel appeare more and the cullour by degrees increaseth, the necke commonly erecteth it selfe, the eye browes make the straighter arches, and the forhead casteth it selfe in to a plaine as it wear for peace and love to walke uppon, in like sort countenances of wroth, of feare, or of sorowe, have their severall alterance of the face, and fare according to the mind is affected, maybe many faces, some lovly, some loathsom, some grave and wisse, some foolish and wanton, some proude and audatious, some poore and couardly, wherfor it would be longe to handel evry severall countenance, I leave it therfore, althoug[h] I could, but tuching or pleassing comly grace I have sayd somwhat, becausse a sad and heavy countenance [fol. 4v] in picture is sine of some eivel, I leave all the rest to the drawer, to noet by the same example, and let him *Read Lamatzo,* his second bouck of actions and Jeastures wher he shall find good observations/ wisdome comprehendeth all things it entereth into all arts, it goeth through them, and considereth of them, it turneth back againe and devideth them, it placeth them in order and observeth their severall graces, So Chiefly the drawer should observe the eys in his pictures, making them so like one to another, as nature doeth, giving life to his worke, for the eye is the life of the picture, and be sure likewisse that the sircel of the sight be perfect round, (for so much therof as appeareth.) the senter truly placed in the midest therof, the reflection of the light which apeareth like a whit spek, must be placed according to the light, this seemeth but a slight thing, how beit the most fayleth therin and noet this as the position is, or the drawer placed acording to art, the furthest eye from the drawer must be a littel hig[h]er then the hethermost becausse of the perspective if the drawer sit any deall hig[h]er then the party drawne, but if lower, then the further eye must be a littel lower, if leavel then to be of one hight, so shall the worke by weel placing and trure doing of the eye have great life, for of all the features in the face of a picture, the eye showeth most life, the nosse the most favor, and the mouth the most liknes, although liknes is contained in every part, even in evry feature, and in the cheekes, chinne, and forhead with the compasse of the face, but yet cheefly in the mouth, wherfor as I

sine: sign; *eivel:* evil

sircel: circle

⟨Position⟩
⟨life favor and liknes⟩
⟨+⟩
weel: well; *trure:* truer
LIFE FAVOR AND LIKNES

24

have formerly sayd that the goodnes or ilnes of the living face consis-
teth in three things

1 ⎰ *Complection* ⎱
2 ⎨ *Proportion* ⎬ *Being the favore*
3 ⎱ Countenan[c]e ⎰

So remember the goodnes of a picture after the liffe,/ standeth cheefly
also uppon three points

1 ⎰ *Liffe* ⎱ *Eye*
2 ⎨ *favor* ⎬ which chiefly consist in thesse three features *nose*
3 ⎱ *Liknes* ⎰ *mouth*

favor and liknes are both one in some sence, as one would say of a
picture after the liffe, that it hath the very favore of the party or the
very liknes of the party, both is one thinge, but when one sayeth it is
a welfavored picture, and a well like picture, theese differ, so meane
I that the nosse giveth cheefe favor, for one shall never see an Ill fa-
vored face, that hath a weel propo[r]tioned nosse I find also that
many drawers after the life for want of true Ruell or Jugment often
times fayles more in true proportion, then they that without patterne
drawe out of thier owne head, even through the ill setting of the
party drawne, which is also [fol. 5] the drauers fault, that marketh
not when the party removeth, though it be never so littele for if he
one a sudaine remove a great dealle, then you marke it easely, and
recall him to his first lyne, but the littele moving, leadeth you to a
great error, if you perceive it not quickly, soe that they somtime
make the eyes at one position or standing, the nosse at ane other, the
mouth at an other, the eare at an other, I a[d]monish you of that
fault both Sitter and drawer, which is the greatest cause of leesinge
the liknes in pictures, Marke weel I saye, therfore when your worke
is removed never so littel recall him to his right waye or place or
proceed not, And to prevent this error, your marke shalbe your first
line which you drawe, but that must be most truly drawne, for that
lyne must be a scalle to all the rest/ and let that your first lyne be the
forehead stroake, as for exampel ⁺ Soe then you shall proceed by
that scalle or scantlinge to doe all proportionablye to that bignes, as
if the forehead be but so longe, then the rest of that lyne to the

Ruell: rule

one: on; *sudaine:* sud-
den

OBSERVATION

leesinge: losing

⁺ (

scalle: scale

scantlinge: prescribed
rule or dimensions

25

Chine is but twice so long, as thus,ˣ and so proceed still, weel marking when you loosse that line, that is to say, when that lyne is not to you, to your seeing, as when you first sawe it, and drue it for then your mark is remembred, which you shall best knowe and perceive by the distance betwene the eye and that lyne, which also you must mark howe it was when you drewe that lyne, howe neare it or howe fare/. *Albert Dure* giveth this rulle/ that comonly all faces howld one measure and true proportion (how differing so ever they be of favor) that the forhead is of the lenght of the nose, and the nose as long as frome the nose to the chinne, if it differ in this it is Deformety, (by this rule) howebeit I have knowne to howld in Right good favors in some feewe, but if I should for example name any it must be such an on[e] as most never kneue, or else it can not well be graunted, therfore I wilbe bould to remember me of one namly Sir *C.H.*: some times lorde *Cha[n]cellor of England* a man generally knowne and respected of all men amongst the best favours, and to be one of the goodlyest personages of england, yet had he a very low forhead, not answerable to that good proportion of a third part of his face, and one the contrary part, Infinit number of face ther are which howld that proportion, which *Albert Duer* commendeth, and yet ar but Il favored, or unpleasant faces to behowld (so god in nature hath for diference ordained it) but very rarly doth nature or hardly can Art make a good favor that shall not howld that true porportion./. wherfor he was a rare man, and had as Rare fortune which differed therin, for if any of the three it may [fol. 5v] differ without disgrace to favore, the forhead maye differ Rather in lenght and may be the longst, and hinder no favour, which comonly is seene in the most wisse and noble minded one and ancient folke, wher the forhead ever waxeth higher and higher, and also doeth the nose (to keepe even with it) growe a litel longher, or at the least decline at the toppe, but the lower part shortneth, all men see a marvelious change in the face of mankind frome a child to an owld mane, but fewe can tell howe in parts it is wrought so to change by the efect of time first therfore you shall understand that a child of three years owld hath an eye as bige as a man, at the least the sircle of the sight if not the ball the

26

nose of no lenght answerable either to the forhead or distance from
the nose downe wards, *Ergo Alberts* porprotion howldeth not in
childeren (wherof I knowe he was not ignorant) neither howldeth it
in owld folke, for the forhead waxeth higher, the nose longer, and so
consequently the mouthe, and chine, somtime for want of teethe
shorter, as in men shaven most easaly is deserned, more then in other
becausse of theire beards, then *Albert* meant that such proprotion
howldeth but at rippe years, as frome fourteene to forty or fifty, or
therabouts/ I would willingly give many observations tuching propor-
tion fit to be knowne, but the bouck is great already, wherfor I omit
them porposly yet one would more in remembrance of an excelent
man nam[e]ly *Sir Philip Sidn[e]y*, that noble and most valiant knight ⟨*Sir P Sidney*⟩
that great scoller, and excelent *Poet*, great lover of all vertu and cun- ⟨+⟩
inge, he once Demanded of me the question, whether it weare possi-
ble in one scantling, as in the lenght of six inches of a littel or short
man, and also of a mighty bige and taulle man in the same scantling,
and that one might weel and apparently see which was the taule
man, and which the littel, the picture being Just of one lenght, I
showed him that it was easely decerned if it weare cuningly drawne
with true observations for ower eye is cuninge, and is learned with-
out rulle by long usse, as littel lads speake their vulger tonge without
gramour Rulls, but I gave him rules and suficient reason to noet and
observe, as that the littel man['s head is] comonly as great as the
tawle man, then of nececity the rest of the body must be the lesse in
that same scantling, a littel man comonly hath also comonly short
legs, and thieghs in comparison to his bulke of body or head, but *thieghs:* thighs
though the head be as great as the [fol. 6] tall mans, yet shall his
forme and face and countena[n]ce be fare otherwise, easey enough to
diserne, the talle man hath comonly low showld[e]rs, long shankes,
thieg[h]s, armes hands and feet wherwith ouer eye is so comonly
aquainted that without rule to us knowne, it knoweth it straight, but
if an ile painter come which will make a childs head as littel for his *ile:* ill
body as a tall mans a childe is but fower times the lenght of his face,
and a mans tene tymes and more, or his eye as littel for his face as a
mans, or his nose as great, I will not take upon me to knowe his tall

27

man from a dwarfe, there is notwith standinge much faire worke wherin such grosse error is, and much disproportion and false perspective/ but neatnes and well coulloring the worke oft times soe graceth the matter, that common eys never note it, but men do beleeve it to be exquesit and perfect becausse of the neatnes, but knowe it you for a truth that the cheefest mastery and skill consisteth in the true proportion and line, and a tall mans picture exactly drawne but in the lenght of sixe Inches, shall shewe to be a taller mans picture, then a littel mans picture drawne at the lenght of fowre and twenty inches, or in his owne full height, if his true shape be observed, and so of horsses and other beasts and cattell the like, *Lamatzo* confirmeth this, by naming some man to be sixe heads, some of tenne, some of twelve, other authors the like, forget not therfore that the principal parte of painting or drawing after the life, consiste[t]h in the truth of the lyne, as one sayeth in a place, that he hath seene the picture of her majestie in fower lynes very like, meaning by fower lynes but the playne lynes, as he might as well have sayd in one lyne, but best in plaine lines without shadowing, for the lyne with out shadowe showeth all to a good Jugment, but the shadowe without lyne showeth nothing, as fo[r] exampel, though the shadowe of a man against a whit wall showeth like a man, yet is it not the shadowe, but the lyne of the shadowe, which is so true, that it resembleth excelently well, as drawe but that lyne about the shadowe with a coall, and when the shadowe is gone it will resembel better then before, and may if it be a faire face, have sweet countenance even in the lyne, for the line only giveth the countenance, but both lyne and colour giveth the lively liknes, and shadows showe the roundnes, and the effect or defect of the light wherin the picture was drawne/ this makes me to remember the wourds also [fol. 6v] and reasoning of her Majestie, when first I came in her highnes presence to drawe, whoe after showing me howe shee noti[c]ed great difference of shadowing in the works, and diversity of Drawers of sundry nations, and that the *Italians* who had the name to be cunningest, and to drawe best, shadowed not, Requiring of me the reason of it, seeing that best to showe ones selfe, nedeth no shadow of place but rather the oppen

〈Q. Elizabeth.〉

man against a whit wall: from Pliny, *Historia Naturalis,* via Armenini and Lomazzo

coall: charcoal

〈Q. Elizabeth〉

Italians: probable reference to Federigo Zuccaro, who visited England c. 1575 and painted court figures with little modeling

light./ to which I graunted, & afirmed that shadowes in pictures weare indeed caused by the shadow of the place, or coming in of the light as only one waye into the place at some small or high windowe which many workmen covet to worke in for ease, to their sight, and to give unto them a grosser lyne, and a more aparant lyne to be deserned, and maketh the worke imborse well, and shewe very wel afar of, which to *Liming* work nedeth not, because it is to be veewed of nesesity in hand neare unto the eye, heer her Majestie conseved the reason, and therfor chosse her place to sit in for that perposse in the open ally of a goodly garden, where no tree was neere, nor anye shadowe at all, save that as the heaven is lighter then the earthe, soe must that littel shadowe that was from the earthe, this her Majestie curiouse d[e]maūnd hath greatly bettered my Jugment besids divers other like questions in Art by her most excelent Majestie which to speake or writ of, weare fitter for some better clarke, this matter only of the light, let me perfect, that noe wisse man longer remaine in error of praysing much shadowes in pictures after the life, especially small pictures which ar to be viued in hand, great pictures placed high ore farr of, Requier hard shadowes, or become the better the nearer in story worke better then pictures of the life, for beauty and good favor is like cleare truth, which is not shamed with the light, nor neede to bee obscured, so a picture a littel shadowed maye be bourne withall for the rounding of it, but so greatly smūtted or darkned, as some usse disgrace it, and is like truth ill towld, if a very weel favored woman stan[d] in place wher is great shadowe, yet showeth shee lovly, not because of the shadow, but becausse of her sweet favor consisting in the lyne or proportion, even that littel which the light scarsly sheweth, greatly pleaseth, moving the desier to see more, *Ergo* more would see more but if she be not very fayre together with her good proportion [fol. 7] As if to palle, too red, or frekled &ce, then shadowe to shewe her in, doeth her a favore, wherfore I conclud great shadowe is a good signe in a pictur after the life of an ill cause and sheweth plainly that either the drawer had no good sight to diserne his shadowes, except they weare grosse, or had a bad light to drawe in, to high or to lowe, or to littel, or else

imborse: emboss
veewed: viewed

⟨x⟩

LIGHT
clarke: clerk

viued: viewed
ore farr of: or far off

palle: pale

29

the party drawne needeth and choose thosse shadowes for the causes above sayd, or it was perhaps for some speciall device or affection of the stander to be drawne in so standing, knowe this also that to shadowe (sweetly as wee weell calle it) and round well, is a fare greater cuning then shadowing hard or dark, for to round a worke well canot be without some shadowe, but so to shadowe as if it weare not at all shadowed, is best shadowed, for a round ball is a round ball in the oppen light, where the light cometh every way, as weel as in a seller, wher it cometh in at a littel gratt, but every thing in his true kind is to be allowed of, as is required of necesity in the story or device, that is wher the matter consisteth more in a strange light, then in the liknes of the party so drawne, as if one must be drawne or painted blowing the coalle in the darke to light a candel, wee must then shadowe accordingly, making no light, but that which comes frome the coale untill the candel be lighted, so when the action in the story or the device in the picture requireth it, then I highly comend it and discomend theire obsurdyty which omit it, as if one should make the troupe of *Judas* going to seeke *christ* in the garden by night with torches and lanthornes or any fier works, or asaultinge a city by night, and should make a cleare sky and faire day both one them and all the landship, weare it never so well painted, it weare not to the purposse or matter, but rediccalious and false, for ther the matter consisteth, chi[e]fly one the trayterous act Done by night, and such provision, as they had for light, more then in any liknes of the lyfe in any of theire pictures/ wherfor hee gave then a signe, saying whome I Kisse, that is he least they should not see, if hee had but pointed at him, or discribed him, *Paulo Lamatzo* maintaineth mine oppinion (more then any other that ever I hard) in his bouck, saing what is shadowe, but the defect of light/ nowe a word or toe [fol. 7v] of *Coullors*, for which ar fit for limning, and which ar not/ all ill smelling coullers all ill tasting as *Orpament, verdigres, verditer, Pinck, Lapgrene, Litmonsy,* or any unsweet coulers ar naught for *Limning*/ usse none of them if you may chusse, if *Masticot, Ceder grene, galleston, powncky, greene, Indy Blewe,* and *ultermarine,* may be gotten, theese and most other cullers ought to be



weel: well; *seller:* cellar
gratt: grate

christ in the garden:
example briefly offered
by Lomazzo, IV, vii

landship: landscape
weare: were

hard: heard

toe: two; *ar:* are
COULLERS



30

grinded (except the *Litmouse* or *Pansy greene,* which is a sape
greene) but wash it first, the finest frome the coursest drosse, and
then softly grind it againe, weel cleansing your stone to every severall
collore, nowe to speake of the number of cullers, some authors say-
eth, ther are but toe cullers, which are black and whit, because in-
deed in whit and black all things are or maye be in a maner very
well Discribed, as apeareth in the well graven portraiture of *Albert
Dure, Hendrick Goltzius,* and others, and indeed all painting is per-
formed by ligh[t]ing and shadowing which may be termed whit and
black, for light and darknes, in what coullor soever it be/ therfor first
I will speake of whit and black, whether th[e]y be the only coullours,
or no coullers at all (as many others say) for my part I thinke them
worthiest to be first placed being the most ussed/ of whits, *Whitlead*
the best pict out and grinded, and dried one a chalke stone in
trenches made in the stone for that purpose, and afterwards grinded
againe, after a dayes grinding with *Gume Arabeck,* and wash it, it
becometh a good whit for *limning,* and by the washing to sorts ar
mad, *Iter Serusa,* which is made fine, ussed in the same sort and in
the making you shall make three sorts therof/ the first and finest
which will glisten, I call sattin whit/ the next in finnes is good for
linning &ce/ the last and coursest being once againe grinded, is best
to be ussed for the flesh couller properly called cornations, which in
no sort ought to have any glistning/ that with a very littel Red lead
only aded maketh the fairest carnations, if the party be a littel paller,
lesse Read lead and a littel masticot amonge, if yet browner, more of
each and a littel oker *De Ruse* withall/ other whits may be made of
divers things as of the bones of a *Lambe,* and of yong burnt, also of
some [fol. 8] sheels, as ege shells, and oyster sheels, but thosse whits
are to be ussed for other porposses, fitter then for *limning.*/ ther is
also an excelent whit to be made of quicksilver./ which draweth a
very fine lyne/ this whit the women painters usse./ noet also the sat-
tine seruce grinded with oyle of whit popy, whitneth upp pearles in
oyle coullors most excelently, and it serveth not as the linseed oyle
doeth, but it is long in dryinge, this is an experience of mine owne
finding out/. The best blacke is velvet blacke, which is *Ivory* burnt in

sape: sap

WHITS
pict: picked; *one:* on

Gume Arabeck: gum arabic
to: two; *ar mad:* are made
1
2 *finnes:* fineness
[3]

masticot: massicot, a lead monoxide such as potash or soda

sheels: shells; *ege:* egg

seruce: ceruse, a white lead

BLACKES

31

luted: sealed with clay as a protection against fire; *lutting:* clay *nealle:* bake by firing

power: pour

thine: thin

one: on

caller: color; *vylde:* re-viled

⟨xx⟩
⟨His own practice.⟩

fayer: fair

Murrey: mulberry color, purple-red

a Crucible and luted that Ayre enter not, Mixe therfore your lutting with a littel salt, and let it nealle redd hot a quarter of an hower, then lett it coole, and grind it with *Gume watter* only, and washe it, in this maner, power watter to it by littel and littel, still stirringe it, and when it is as thine as Inke or thinner, let yt settele a wholle afternoone, and poure from it the uppermost, which is but the *Gume* and fowlnes, good to put amonge Inke, the rest let drye, and keepe it in a paper or boxe, and usse it as aforsaid, with soft grinding it againe, or tempering, but one the grinding stone with watter, adding *Gume* in powder to it againe at discretion, For you shall by ussing it, perceive if it have too littel gume, for then it worketh ill, and dryeth to fast, if you put too much gume, then it wilbe some what bright lyke oyle caller, which is vylde in lymning/ Take this for a generall rule, that *Lymning* must excell all *Painting* in that point, in that it must give evry thing his proper lustre as weel as his true cullor light and shadowe./ Other blackes are made in lyke maner, as of *Chery stones, Datestones, Peachstones,* and common *Charkecole, willowe-colle,* or any thinge that burneth blacke, these burnt and grinded as aforesaid, but they need no washinge/ Noate also that velvet blacke after it is drye in the Shell, it worketh never more soe weell, as at the first grinding or tempering, wherfore for principall workes, and even for the Centor of the eye, being but a littel tytle, I use alwayes to temper a lyttle one my grinding stone, having it alwayes in powder ready grinded, washt, and dryed for store, Soe use I to have most of my other cullors, that I may easely temper them with my finger in a shell, adding *Gume* at d[i]scretion/ soe have I them allwayes cleane and fayer and easyer to worke./ Thus a limner should doe, but for sparing time and cost, [fol. 8v] some usse to worke out of theire ould Shells of cullors, thoughe they be naught and dusty/

Now besides whittes and blacks, there are but five other principall cullors, which are cullors of perfection in themselves, not participatinge with any other, nor can be made of any other mixed cullors, and of them five, are neverthelesse dyvers kinds, so as with them are made by mixture *Murrey, Redd, Blewe, greene,* and *yellow*/.

32

First murreye for *Limning* must be a lake of himselfe of a murrey cullore, which kind of Lake is best made at *Venice*, and neatly good in *Antwerpen*, If you be driven of other lake with adding a littel blewe to it, to make your morrey it can never be so good. / This lake is to be grinded but with gume *Arrabecke* watter only, although when it is over drye in the shell, yt hardly relenteth to worke weel againe, then grind more./. Redd for *Liming*, the best is lake of *India*, which breaketh of a Scarlet or staniel cullor, dyvers othe[r] lakes ther are, some which will shadowe one uppon an other they are so blacke/ and all thosse blacke lacks generally must be grinded with some sugercandye among the gume, and some altogether with suger, they cannot be to much grinded nor need any washinge, longe standinge open in the sūne marreth your lakes, and allmost all collors, so over baking them, hardninge, or drying them that they will never worke well/ vermelion is an other redd, and is to be grinded and washt, Redd lead to be but washt only, the finest of it to *Limnige* twoo sorts of it./. for *Limning* the darkest and highest Blewe is *Ultermaryne* of *Venice* of the best, I have payed iiis viiid a Carret which is but fower graines, xil xs the ounce, and the worst which is but badd will cost iis vid the Carret viil xs the ounce/ In steed wherof wee use smalt of the best, blewe byces of divers sorts, some paler then other, some of seaven or sixe degrees one above another/ Theise may be grinded, but better broken lyke *Ammel* in a stone morter of flint, excelent smouthe, with a pestel of Flint o[r] *Aggat* well stirred till it be fine, with gume watter only, and washed, soe have you many sorts, and all good, shadowinge blews are *Litmouse* and *Indy Blewe*, and flory, theese need no washing, nor litmouse any grinding, but steeped in lee of sope ashes/ use gume at discretion as aforsaid./. Greene the best for liming is Ceder greene, In steed wherof wee take *verditer*, *Pinke* is also a nedfull greene in [fol. 9] *Lantscippe*, and mixed with *Byce* ashes makes an other faire deepe greene, so likwise your pincke mixed with masticot and serusa as you see cause for light greens/ All theese neede washing and not grinding, and all common greens, as common *sapgreene, flower De luce* greene, or pauncy

MURREYS
1
lake: one of an important class of purplish-red pigments, giving a semitransparent appearance, prepared by precipitation of lac (resin) or cochineal with salts of aluminum or tin
yt: it
REDDS
2
staniel: color of kestrel, a red-brown hawk
lacks: lakes

Redd lead: minium in Latin, red lead is the pigment from which the term *miniature* may have derived
BLEWES
3
s: shillings; d: pence
l: pounds

byces: byce or malachite, often found in conjunction with blue carbonate of copper

smouthe: smooth
Aggat: agate

Litmouse: litmus
flory: blue or woad indigo
lee: lees; *sope:* soap

GREENS
4
verditer: verdigris or green byce, a carbonate of copper such as azurite or malachite

sapgreene: pigment made from buckthorn berries; *pauncy:* pansy

33

greene neede neither grinding nor washing, but steepinge in watter, or in lee which is better./.

Yeallowe the best are masticotts, wherof there are d[i]vers sorts, some paller then some, yeallowe *Oker* for want of better is one also, and these washt and not grinded doe best, and must have a littel suger amonge the *Gume* in tempering them/ Shadowing yeallowes are the stones found in the oxe gall, grinded with gume watter and not washt, and yeallows made of whit roses brused with a littel *Al-lumm* and strayned, and neither grinded nor washt, nor nedeth gume, one maye shifte with faire oker de *Rouse,* and safaran watter for want of the other, first shadowe uppon masticote with yealowe Oker, and with oker de *Rouse,* for shadowinge cullors which are browne, or blackishe, or heire cullor, which are as necesary as any other cullors, you have earth of cullen, *Umber, Spalte,* and *oker Rouse,* and *Soote* may also be ussed in story worke, gume watter use only unto these./. a word I praye you tuchinge the making of those beautifull rubies or other stones, how you soe arteficially doe them, that being never so littel they seme precious Stones naturall, cleere and perspicious, soe that (by your favor) is no parte of limming/ wherfore requier it not, it appertaineth merly to ane other arte/ And though I use it in my limming, it is but as a mayson or Joyner, when he hath done his worke, and cane also paynt or guilde his freeses and needfull parts therof/ Now that you have true waye for order-inge your coullors, understand that in drawing after the life, you must not change your light, but end your worke in the same light you begone in, if you posibley maye,/ knowe also that *Parchment* is the only good and best thinge to lim̄e one, but it must be virgine Parchment, such as never bore haire, but younge things found in the dames bellye/ some calle it *Vellym,* some *Abertive* derived frome the word *Abhortive,* for untimly birthe, It must be most finly drest, as smothe as any sattine, and pasted with starch well strained one past-bourd well burnished, that it maye be pure without speckes or Staynes, very smoothe and white./. Then must you laye your carna-tion flowing, and not thine driven as ane oyle cullore, and when you begine your picture choose your carnations too fayre, for in working

YEALLOWES
5
Oker: ocher

heire: hair

Umber: earth of Co-logne (cullen); partly manganese oxide, now called Vandyke brown, native to Derbyshire or imported from the Levant; *Spalte:* Ant-werp brown, derived from asphalt or min-eral pitch

cane: can; *freeses:* friezes

⟨xx⟩
⟨Parchment or vellum.⟩

one: on

CARNATIONS

thine: thin
carnations: flesh tints

34

you may make [fol. 9v] it as browne as you will, but, being chosen
to browne, you shall never worke it fayer enough./ for *Limming* is
but a shadowing of the same cullor your grownd is of, and soe gen-
erally all ground cullor in lim̄ing Must be layd flowing, not toe full
flowing, neither for cockling your carde &c. but some what flowing
that it dry not befor your Pensill, untill you have done, least it seeme
patched and roughe/ also when you drawe uppon the said complec-
tion a Carnation ground culler, be verye well advised what lines you
drawe, and drawe them very lightly with some of the same carnation
and a littel lake amonge very thinly mixtioned, or with thine lake
alone with a very smalle pensile, that it scarce at first maye be dis-
cerned, till you be sure you bee in the right waye, for afterwards ther
is no alteration when the lyne is apparant, or very hardly./ Therfore
in your shadowing usse also the same discretion to shadowe, but by
littel and littel at the first, for littel not regarding what the ignorant
say, Which wilbe alwayes teaching, for there be faults which must be
done of porposse, being faults which may be amended, for feare you
comit faults which cannot be amended./. For the face made never so
littel to redd, or to browne in limning is never to be amended, the
face to leane, the forehead to lowe, or haire to darke, is not, or very
hardly to be amended, but the botching or mending wilbe perceived
wher one hath taken away any caler one the face, for the carnation
will never be of the same cullor againe, nor will Joyne so smoothe,
wher any other cullor hath bene layde./. make the forheade to highe
at the first, therfore to be sure you maye mend it, and be not hastye
to lesson it at every mans worde, but proceede with Jugement./ I
have ever noted that the better and wiser sort will have a great pa-
tience, and marke the proceedinges of the Workman, and never find
fault till albe fynished, If they find a fault, they doe but saye, I thinke
it is to much thus or thus, referring it to better Jugement, but the
Ignoranter and basser sort, will not only be bould precisly to say, but
vemently sweare that it is thus or soe, and sweare soe contrarely,
that this volume would not containe the rediculious absurd speeches
which I have hard uppon such occasions/ Theis teachers and bould
speakers are commonly servants of rude understandinge, which

fayer: fair

toe: too; *cockling:* wrinkling, puckering

Pensill: pencil, thin brush

pensile: pencil

one: on

⟨Criticisms of his sitters.⟩

35

flater: flatter
bowld: bold
mane: man

robe: rob

partly would flater, and partly shewe but howe bowld they may be to speake thire opinions,/ my Counsel is that a mane should not be moved to anger for the matter, but proceede with his worke in order, and pittie thyer Ignorance, [fol. 10] being sure they will never robe men of their cuning, but of their worke peradventure if they can/ for commonly wher the Witte is small, the consience is lesse, when your cullors are drye in the shell, you are to temper them with your ringe finger very cleane when you will usse therof, adding a littel gume if it temper not well and flowingly, but beware of to much, if any cullor crack to much in the shell, temper therwith a littele sugar candye, but a very littel least it make it shine, want of guming it causeth the cullor tempere like *Lome* or *Claye* &c and drawes no fine line, if a cullor will not take by Reason that some sweatye hand or fattye finger hath touched your parchment therabout, temper with that cullor

tast: taste

of: off

a very littel eare waxe, but even to give it but a tast as it weare, the same is good likewyse if any cullor pill of to temper the Cullor you amend it with all, and it will pill no more./ liqued goolde and Sillver must not be tempered with the finger, but only with the penssel, and with as littel gume as will but bind it, that it wype not of with every touch, and with a pretty littel toothe of some Ferret or Stote, or other

Stote: stoat, ermine

willde littele beast,/ you maye burnish your goold or silver here or there as neede requireth, as your silver when you make your *Diamonds* first burnished/ then drawne uppon with black in Squares

DIAMONS AND PEARLE
AND OTHER STONES

lyke the diamond cutt, other stones must be glased uppon the Silver with their proper cullors with some varnish &ce./. The pearles loyed

loyed: alloyed

with a whit mixed with a littel black, a littel Indy blewe, and a littel masticot, but very littel in comparison of the whit, not the hundred parte./. That being dry, give the light of your Pearle with silver some what more to the light side then the shadowe side, and as Round

delayed: mixed

and full as you cane, then take good whit delayed with a littel *Masticot,* and underneath at the shadowe side give it a Compassing stroke which showes the reflection that a Pearle hath then without that a smale Shadowe of Seacole undermost of all./. *Paulo Lamatius* in the last chapter of his fowerth bouck very truly (but absurd) sheweth

36

that every thing must be shadowed in his kind, which discretion is not given to every painter after the liffe, but they will shadowe a faire face with a browne shadowe, and following the story works which Shadowes the whole face with one shadowe for hast[e]./. Shadowing in *Lymning* must not be driven with the flat of the pensel as in Oyle worke, [fol. 10v] distemper or washing, but with the pointe of the *Pencell* by littel light touches with cullor very thine, and like hatches as wee call it with the pen, though the shadowe be never so great, it must be all so done by littel touches, and touch not to longe in one place, least it glisten, but let it dry ane howre or to, then dipen it againe./. Wherfore hatching with the pene in Imitation of some fine well graven portrature of *Albertus Dure* small peeces, is first to be practised and used, b[e]fore one begine to Limne, and not to learne to lime at all, till one canne Imitate the Print so well, as one shall not knowe the one from the other, that he maye be able to handle the pensill point in like sort, This is the true order and princi-pall Secret in *Limning*, which that it maye be the better remembred, I end with it./.

SHADOWING

peeces: works

And nowe I thinke it fitt also to speake somwhat of precious stones, which wilbe meet for gentelmen to understand and some gould-smithes wilbe glad to see it for their better Instruction/ I saye for cer-tayne truth, that ther are besides whit, and black, but fyve perfect cullors in the world which I prove by the fyve principall precious stones (bearing cullor) and which are all bright and transparent stones, as followeth, Theise are the fyve stones / *Ammatist orient for Murrey, Rubie* for red, *Saphire* for blewe, *Emrod* for greene, and hard *Orient Topies* for yellowe/ more ther are not which are soe very hard and orient as these fyve./. Nowe is proved, that the absolute Orient & hardest transparent precious stones of proper and unmixed cullors, are only fyve / viz

Ammatist: amethyst; *orient:* iridescent, lus-trous
Emrod: emerald
Topies: topaz

Annatist	*Murrey*	theese fyve only cullors in grosse
Rubye	*Redd*	cullors with theire different mixtures,
Saphier	*Blewe*	make more of many kinds, every all
Emarod	*Greene*	maner of cullors as you list to have

37

Topias *Yeallowe* them, by tempering them together
orientall which weare long to repeate in writ-
ing./.

RAINBOWE

And as for m[i]xture of cullors, if you will see fine varyetie, behold the *Rainbowe,* and therin shall you find an excellent mixture of all the transparent cullors, for there is nothing but mixt cullors./. As first Murrey by mixture growing into or unto blewe./. Blewe growing into greene, Greene growing into yellow/ yellow into redd, red againe into murrey, Murrey into a purpel being mixed with the skey cullor, This exampel [fol. 11] of the *Rainbowe* sheweth the naturall mixture of cullors, and a sweete and agreeable varietie in their mixtures, for they vary, and agree in such a kindly beautifull order, as all the art of the worlde cannot amend it by mixture or other order, nor well in Arte compare by imitation with the same./. But the fyve precious Stones resemble unto us the true beautie of each perfect cullor in his full perfection without mixture in perfect hard bodies and very trans-parent./ As first of Murrey./. In the *Annatist orient* have you only perfect Murrey without mixture, it is an hard Stone, and on of the principall precious Stones, there are divers more kinds of *Annatists,* as *Annatist Almane,* & *Annatists* of sundry other countrys, colde Re-gions, all which are of divers other cullors./. I would speake only of theese fyve which I have nominated, but least men should be de-ceived or mistaken. I am forced to name and mention the other baser stones of all the cullors, as of *Annatist Almane,* some are purple, some violett, some Carnation, some peach cullor, and some a browne smoakye cullor like watter wherin Soote hath layen, and of all theise cullors their is great variety of each some paller then other, theise are as I sayd before all mixed cullors, and softe Stones in each of the fyve kinds of stones, as I will hereafter shewe you./. Take this therfore for a generall Rulle, that the most precious stones the hard-est deerest and rarest to fynde, are those fyve only which I have named, and which have theire proper cullors only in them/ and that of more substance and beauty transpareant and pure, not of a thicke or troubled matter, but clere and yet not pale, wherfore as I have formerly spoken of the *Annatist Orient,* it is a hard stone and right

skey: sky

kindly: natural
⟨+⟩

⟨*Annatist Orient*⟩
on: one

precious, delighting the hart exceedingly to behould, but all the other repeated mixt cullors are softe Stones of smale value in comparison to those of perfect cullors, and although a very darke purpule is founde in some of the *Annatist Almaine,* a cullor of a more sub-stance for his cullor, I saye unto you as before I have sayd, Purpele is not a proper cullor, but mixt cullor, made of Murrey & blewe, or redd and blewe, soe over blewed and darkened that the french men rightly terme it *Annatist le plus* [fol. 11v] *triste,* a sade malancholy cullor, delighting but some humere, and fitting to porpose but one some fewe occasions./. Noate also that the *Annatist oryent* being a perfect cullor, and a hard stone, hath therfore his watter more bright and lucide then any soft Stone cane have/ which brightnes is the cheefe thinge wherby the *Lapidarie* knoweth at the first sight the val-lewe, goodnes, and hardnes of the stone, as shalbe more plainely shewed in the diamond hereafter./. Noate therfore when any Stone wanteth that lively brightnes, it is either a Safte Stone, a thine Stone, or a clowdye faulty Stone/ althoughe it be hard./.

Now the next perfect cullor which is redd, the *Rubye* is the most perfect redd, and if he be without blemish, and so great and thicke as he maye beare the proportion of *Diamond* Cut, he flickereth and afecteth the eye like burning fyer, especially by the candel light./ This Stone therfore of some is called, and rightly maye be called the car-bunckle/ soe called [from] the worde *Carbo* which is fyer, or a cole of fyer, neither is ther any other *Carbunckel* which cane resemble fyer so well, except a redd *Diamond* which yet I never Sawe, but have harde of only, yet have I seene a *Diamond* of the cullor of a *Jasent,* some what orrenge tawny, and a *Diamond* greene as a *Griso-lytt,* and a *Diamond* blewe as a pale blew Sapihire/ many yellowe, and many browne./ The *Rubye* ballas is more pale lyke a pale wine, and no perfect full cullor, and it is therfore a softer S[t]one, and of lesse valewe, soe are all *Rubye* ballas, now *Spynells* and *Garnets* of divers Sorts are reddish also, and resemble rubyes and *Annatists ori-ent* meetelye well/ but they are to be knowne by the softnes on the myll in cutting, and partly by theire want of that brightnes, which the hard Stone hath, and want of perfect cullor, but a redd mixed

(+)

humere: humor, tem-perament; *one:* on

vallewe: value

Safte: soft

clowdye: cloudy

RUBYE

he: it

fyer: fire

Jasent: jacinth, a bril-liant tawny red-yellow stone
Grisolytt: chrysolite; olivine or peridot
Rubye ballas: balas ruby, a Persian, pale rose-red spinel ruby; one such stone, known as the Black Prince's ruby, topped the crowns used in the Coronations of Ed-ward II and Elizabeth I
Spynells: spinels

39

with yeallowe more fyer then perfect redd, a Stone of much delight, and good valewe, but of lesse then the *Rubie,* for it is softer, as all mixed cullors are softer then the perfect cullors, and of the *Spinalls* also ther are a paler kinde lyke a delicate ould paled wyne which resemble *Rubie ballas* in like maner./.

GARNETTS.
Suryma: Surinam;
Dutch Guiana

Also *Garnets* there are sundry sorts, some called garnets *Suryma,* resembling much the *Annatist orient,* but a littel blacker & redder then the true Murrey;/ The more common sorte of garnetts are very redish, yea blacker then true redd, and somewhat yeallowish *Jasent labella* is a kinde of redd, very yeallowish [fol. 12] like the saffreon blade. but transparent and beautifull as any *Spinoller Garnett,* and as hard and bright, the common Jasent is Orrenge tawnye, a mixt cullor also./.

VERMYLE
vermyle: vermeil, an
orange-red garnet
pease: pea

Pomegranat: pome-
granate; popularized in
England after 1501 as
a badge of Catherine
of Aragon

Then ther is an other kind of redd stone called vermyle, which are very small and never found greatter then a pease, but commonly no biger then rapeseed, a red more resembling blood then *Rubye,* and is not that perfect crimson redd, most like the kirnelles of very ripe *Pomegranat,* which nature hath commended unto us in the *Rubye* to be the principall red cullor, yet this littel poore Stone hath that speciall vertue to endure the fyre, which none of the for named Stones cann doe soe well./.

SAPHIRE BLEWE

Nowe *Saphire* wherof there be two kinds or two cullors, white and blewe, which blewe is the most excelent perfect blewe that nature in any thing yealdeth, or Arte can compose./. This Stone excelleth in hardnes all Stones (*Diamond* excepted) and soe consequently in brightnes of watter as before argued, which is proved when nature yealdeth him whitte, if he be well cutt he is matchable with any diamonds, especially of the greatter ones, for a great *diamond* is not so faire for his bignes commonly as a littel one/ and a littel *Saphier* not so faire as a great one for his bignes/ The reason is that the *Diamond* Cutter for sparing the Stone if it be great will not cutt any away of his Circumference to give his diamond full shape as he maye, and will doe a littel Stone, neither doeth nature give to great ones (but rarely) any such good proportion or thicknes to their breadth, as have the littel ones commonly/ and this is generall both in Stone and

pearle, the greater the worse proportioned, Therfore proportion
g[i]ven to a Stone by Arte, by the cuning Artificer helpeth nature,
and addeth beautye as well as nature doeth, to the great commenda-
tions of that Misterye or Sience./. knowe this therfore that as the
bade workman spoiles many a good Juell both in cutting, pulishing, *Juell:* jewel
and also in the setting, Soe an excelent workman cann grace them
above that which nature give them both in cutting, setting, and mak-
ing them in valewe double of that they weare before, therfore he is
better worthy of fowerfolde better payment then any other, though
paradventure [fol. 12v] he doe it much soner, but commonly they are *soner:* sooner
indeed longer about theire worke, which maketh that they are poorer
then the bunglers, For while the good workman taketh pleasure to
shewe his art and Cuning above othe[r] men in one peece (in what
art soever) the botcher dispatches six or seaven, and gives it a good
word or a boaste, keeping his promise within his time, which greatly
pleaseth most men/ for indeed the tyme is all in most matters as
sayet[h] one/ A thing well done out of due time is ill done, and soe
hee getteth credit & custome which keepeth time, wherby he is able
to set many other at work, which though they be all bungler and
Spoilers, yet please in respect of good cheapnes, and keeping of
promise, and so growe rich./ the good workman also which is soe
excelent, dependeth one his owne hand, and can hardly find any *one:* on
workmen to worke with him, to heelpe him to keepe promise, and
worke as well as himselfe, which is a great mischeefe to him./. Nei-
ther is he alwayes in humore to inploye his spirits on some worke,
but rather one some other, also such men are commonly noe Mysers,
but liberall above theire littel degree/ knowing howe bountifull god
hath indued them with skill above others, also they are much given
to practises, to find out newe skills, and are ever trying conclusions,
which spendeth both theire time and mony, and oft times when they
have performed a rare pece of worke, (which they indeede cannot af- *pece:* piece
forde) they will give it aweay to some worthy personage for very af-
fection, and to be spoken of/ They are generally given to travel, and
to Confere with wise men, to fare meetly well, and to serve theire
fantasies, having commonly many childeren if they be maryed./. A[ll]

41

wh[i]ch are causes of impoverishment, if they be not stockt to re-
ceave thereupon some profit by other trade, or that they be as in
other countries by pencion or reward, of princes, otherwise uphelde
and competently mayntayned, although they be never soe quicke nor
soe cuninge in theire professions, depending but one theire owne
hand helpe./. Thus much I thought need to insert, in respect of the
common opinion, or common slander [fol. 13] rather, which is, that
Cuning men are ever unthrifts, and theerfor generally poore indede,
when by the causes afore sayde they are fallen poore, they have a
more unthrifty sheewe then others, for they will spend Still if they
cann come buy it, soe that I thinke they have the liberall Siences, and
it is a vertue in them, and becometh them like men of understand-
ing./. If a man bring them a rare peece of worke, they will give more
for it, then most men of tenne times their abilitye, and in other coun-
tries they are Men of great wealth, for the most parte./. Then you to
whome it apertaineth to knowe, maye perceive the reason in parte,
why they are not so heere, the more is the pittye./.
Well nowe for Greene, for certainly the *Emrod* is the most perfect
greene on earth growing naturally, or that is in any thinge, or that is
possible by Arte to make, (if it be an *Emorodd* of the owld myne.)
but rarely of the newe myne are they soe faire greene, for they are
commonly paler as it weare mixed with seae greene, and *Eemerodd*
of *Perooe* is of a thicke and troubled watter, there are in truth of
theese three kinds of *Emrods,* of each kinde divers cullors./. Noate
also that of all the fine precious Stones, there are some times white
ones, having no cullor at all, but Cleere as *Christall,* which are better
in regard of the rarety, then those which have cullor (except theire
cullor be in perfection) and somtime there are found party cullored,
as emrods the one halfe greene, and the other halfe pure cleare
white, and soe likwise of all the otheres of the fyve Stones, such for
the rarety are of the most price, and ought to be set soe, as one maye
see the Stone one both Sides, to be the naturall Stone only, else it
seemeth counterfeit by arte./. Ther are also sundry other greenish
Stones, which are no kind of emrods, nor soe good of vallue, namly
Griselite, which is popingey greene, *Egmeryne* which is a Sea greene,

pencion: pension

EMERODDE

Perooe: Peru

one: on

popingey: popinjay
Egmeryne: aquamarine

42

and *Burill* which is yet a more blueish greene, and are found very great, but if small, they be of small price or estimation./. I might well resemble these Stones unto us mankind, wherof Some be excelent and precious, and the common sort at first wiewe are like also unto them / but if you marke them weell, you [fol. 13v] shall find them mixed cullors, dissembler softe Stones, not able to endure nor comprehend Scyence nor valorous deeds, and as a good Stone maye bee yll set, and ill used soe that hee is Sould for naught; soe a good Servant nor used in his kinde, falleth frome the Ignorant to a better master, and that as I said, If the base Stones be greeat, they are esteemed, whoe doubts of that, it is the like of me./.

Nowe of Yeallowes, the best is the *Topas orient,* or most perfect goold yeallowe, if this Stone want of his yeallownes, his vallue is the lesse (except hee be pure whit, and have noe yellowe at all) for then resembleth he the *diamond,* as dothe also the whit *Saphire,* which is somwhat harder then the *Topas,* but very little./. *Topas* is better then white *Saphire* if it be naturaly whit, because it resembleth more the best watter of a *Diamond,* which is to Incline a littell to yellowe, and will abyde to be sett and cutt on Tynne no[t] the diamond myll, as the *Diamond* doth with *diamond* powder very well done./. And the yellow *Topas* which is but by Arte, as by fyer burnt white, will oftentimes returne to his perfect yellowe againe, a thinge admirable./. And a pale blewe *Saphire* which hath a greenes in his blewe will never burne white, but rather recover more blewnes, which is greatly to be marveled att likwise, Thus have I sufficiently proved the fyve principall cullors by the fyve precious Stones of most price (the *Diamond* excepted) which properly is of no cullor, but a cleare watter cullor or Ayre cullor, so lucyde and bright, as having his due forme, his splendor or light is Somtimes called his fyer, and Somtimes his watter, by which his brightnes and his hardnes is knowne./. As for excample, *Allome* or Sugar candy or gume are somewhat bright and hard, but not soe hard and bright as cristall/ *Saphire* nothing so hard nor bright as *Diamond,* which is indeede the brightest and therfore the hardest of all the precious Stones./ I have discoursed at large, of all the perfect cullors which are in the fyve Stones only and a[l]so of

Burill: beryl

wiewe: view

Sould: sold

YEALLOWES

Tynne: tin

greenes: greenness

43

weare: were; *Ridle:* riddle

the other mixed cullors, which are in all the other under Stones of softer and basser kinds, but now (as it weare in a Ridle) I demand what Stone is that which hath [fol. 14] in it two distinct and perfect cullors very apparent, and hath in it noe cullor at all, yet if one looke longe into it, it hath many cullors radient and strange, but the *Diamond*./ And although white and blacke be both thicke cullors in painting, and not transparent, yet in the diamond they are cullors transparent and cleere, and which may be counted amongst the transparent cullors both of whit and blacke, if whit and black weare counted cullors, as they are not./ wherfore I set them downe for no cullor, although indeede nothing hath his light more white, nor his shadowe more black, and being cleere, more cleerer then Ayre, yet

teyntor: tenter

being set on his black teyntor, or on any black pitch molten fast underneath unto him, he changeth not his bright cleere whitnes, as any other Stone would doe, as *Topas, Spahiere,* white *Rubye,* or what soever, which is a most admirable thinge to consider among the secretts in nature, and is the best waye to knowe a diamond frome an other Stone without hurting it./. This secret is not to be devulged, because stolne things are brought to sell, and therfore often times taken by his owne ignorantnes of the thinge hee offereth to sell, but the best hope is, they reade but fewe good bookes which use such facshions/..

OPALL

Now their is an other Stone which hath all cullors in it selfe apparently, some blacke that are transparentt cullors namly the *Opall* which in it hath a perfect fyer cullor, and all the cullors in the *Raine bowe,* though not placed in that order, but in a broken changable and retracted order, which changeth his reflections with every turne through a sertaine cloudie cleere Milkeish whitnes lyke a but the lesse it hath whitnes the better it is/ This Stone is of a great value if he be great and fayre, and is equall for his bignes to anye Stone (*Diamond* and *Rubye* exce[p]ted) but is not much harder then pearle, and easely weareth rough/ Ther is also another transparant Stone

Geratsolis: geracites; a stone the color of a hawk's neck
Turcas: turquoise
wached: washed

which we call *Geratsolis* which hath no cullors but a kynde of shyning, and if the Sune or sume bright daye light weare under it or within it, *Turcas* which is a thicke wached cullor, is also a good

stone of price and estimation, and the Softest of thicke culored
p[r]ecious Stones/ The number wherof of Such Stones [fol. 14v] are
soe manye as weare longe to receite, which I leave therfore to speake
of, as not soe needfull to the Treatise of perfect cullors, for they are
all but mixed coullors./. Vale/.

Vale: farewell (Latin)

Howe to make the picture seeme to looke one in the face which waie
soe ever he goe or stand./.

Eevery man cannot possibly (though he have the knowlege) doe
every worke he knowes, by reason of his naturall infermity of Com-
plection, or humor, as for drawing under Christall./.

Master Blanchgreene for flowers of horne./.

Questions to be talked on./.

Wherof the Carnations are to be made, and howe the precious
Stones and Pearle &c./.

In drawing after the life, site not nearer then toe yards from the par-
tye, and sit as even of height as possible you maye, but if hee be a
very highe person, lett him sitte a littel above, because generally men
be under him, and will soe Juge of the *picture,* because they under
viewe him, if it be a very lowe person or childe use the like discre-
tion in placing him somewhat lower then your selfe, If you drawe
frome head to foote, lett the party stand at least sixe yards frome
you, when you take the discription of his whole stature, and so lik-
wise for the stelling of your picture/ whate lenght soever, after you
have proportioned the face, let the party arise, and stand, for in sit-
ting, fewe cane sit very upright as they stand, wherby the *Drawer* is
greatly deceived commonly, and the party drawne disgraced/ tell not
a body when you drawe the hands, but when you spie a good grace
in theire hand take it quickly, or praye them to stand but still/ for
commonly when they are towld, they give the hand the worse and
more unnaturall or affected grace, I would wish any body to be well
resolved with themselves before hand, with what grace they would
stand, and seeme, as though they never had resolved, nor weare to
seeke, but take it without counsell./.

site: sit; *toe:* two

stelling: positioning

cane: can

the 18 of March 1624
Londres

45

WHITS

to course: too coarse

gressie: greasy

euse: use

reliqued: stored

THE GRINDING OF
YOUR COULLERS
thine: thin

[fol. 15] A more Compendious discourse conserning the art of Liming the natture and properties of the Coullers. To proceed & begine with the Coullers Whitt for it's Virgin puritie is the most Exellent, Viz:ᵗ Ceruse & whitt Lead, both subject to Inconveniēcies and are thus prevented. The Cerusse (affter you have wrought itt) will tarnish, and many tims looke of a Redish Or Yeallowish Couller. The whitt-lead, iff to much ground will glister or shine & iff you grind itt to course will bee unfitt to worke & so unservicable/ Ther is but on way to remidy itt, which is to Lay them in the sunn to or three days before you grind them which will Exhalle and draw away those sallt and gressie mixtures, that starve and poyson the Coullers besids you must scrape Away the superfices of the whitt Lead and only euse the purest of itt put to this as to all your Coullers a Littell gume arabeck of the best and whittest which you must have by you in a littell box, made into very fine powder or elce disolved into watter, as you please; and with a few drops of fair runing watter temper itt with your finger till the gume be Incorporated or disolved The gume must bee us'd att discretion; your owne practice will Informe you the best, for no Generall rulle can be given, only leave not your Coullers to moist & reliqued but some whatt thike & clamy & then cover itt cleane frome the dust till itt bee dry in the shell, and then if itt bee not to much, nor, to littell bound, you will find itt; iff to much itt will glissin, iff to Littell, drawing your finger over itt some of the Couller will come of/ India Lake to be ground with gume watter, and spread thine About the shell, Umber and some other Coullers much subject to crakle & fall frome the shell in pieces, when you find itt so take a llittell whitt sugar Candy reduced in to fine powder and with a few drops of fair watter, you must temper the Couller Againe as itt is in the shell till both the Coullers & the suggar Candy be throughly disollved, which being once dry will lye fast in the shell *English Oker* will lye fast in the shell, & workes well iff well ground, *Pink* is allso A very good Couller and workes sharpe and neatt and must be ground as the Rest; *Umber* being A fowle and gressie Couller, iff when you have bought itt, you burne itt in A crusible or Goldsmiths pott, itt is Clensed & being ground as the Rest,

46

workes well/ *Tera de Collonia* is easie to worke when itt is new
grownd and is very good to Close up the Last & deepest touches in
the shadowed places of picturs, by the Liffe. Cheristone and Ivory
are both to bee burned & so ground, the first is a very good blak
especially for drapperies and blake Aparell, but if you mak sattin itt

TO MAKE SATTIN

must be tempered witth A Littell India Lake & Indico but only to
make itt apeere with A' more beautifull Glose, which Heightned with
a' Littell lighter mixtur of more whittish in strong touches & Hard
reflections, and deep'ned with Ivory will shew marvellous well, Ivory
blake must be well tempered with suggar Candy to prevent Craking,/
But befor I begine I will shew you the reson why thes Coullers must
be washed, which is because thay are of A' sandy Loose & gravely
quallitie & so heavy & ponderous & sollid bodies that thay will
hardly be Reduced to that finenesse, requierable in this art, for iff
you thinke to make them fine by grinding thay will Instantly loose
ther beawtie/ To Refine them therfore by washing, you are to take of

HOW TO WASH
COULLERS.

Red Lead which is the first in number About an ounce or tow iff you
please and puting itt in a littell basson or such Like of Clear watter,
stire itt for a whille to Geather either with your hand or some

to Geather: together

spoone, till you see the watter all Coullered & stained with the
Couller, then Lett itt stand a' whille, and you will perceave on the
uper face of the watter A Gressy Skome A'rise, which togeather with
all the watter powr out and cast away, then fill you[r] basson with
fresh watter and stirr itt as before which done before the watter be
halfe settled powre itt into an other clean porrenger or such Lik, re-
serving behind in the first bason the dreggs & settling of the Coul-
lers, which may be the greattest parte [fol. 15v] yet Itt is to be cast
away for much is not that you are to seeke but good for a' Littell in
any Couller goes far in Limning, And if a Handfull of Red Lead
yealds a' shell or tow of good Couller, itt is Enough so itt be fine.

tow: two

The coullered & trubled watter as I sayed before, being in a' second
dish, Ade more watter ther to, and wash them well togeather as be-

Ade: add

fore, which done Lett itt settle till the watter be Allmost cleare, iff
you perceave the skume a'rise still upon the watter, powre itt of still

of: off

till the watter be cleare, for your skume is chalke or other filth in the

powr: pour

thike: thick

one: on (the one side)

flower: flour

FOR YOUR PENCILLS

Couller which you are to cast of by stirring itt, (I mean) all the Couler togeather then sufering itt to settle, and as Longe as the skume a'riseth still powr itt A'way. Itt will not be a'misse iff when you have was[h]t your Couller a'whille & stirring the watter till a'gaine itt become thike, you powre out halfe of that thickned watter into A' third dish, and washin[g] both the second & the third you will find you[r] couler of a' courser and finer quallitie, Insomuch as the third & iff you please the 4ᵗʰ and 5ᵗʰ sort will be very fine, and faire, when you have well washed Them often & by Continuall Changing and shifting the watters & Coullers You find itt perfectly Clensed, you must by littell and littell Gently draw away the Remaine of the watter, not sufering any or very littell of the Couller to goe away with itt, so that setting your dishes in the sunn & shelving them one the one side, you will find your Couller dryed and Lying A'bout the sid[e]s of the dishes, like drifts of sand, in some places you will find itt faire & cleare and fine, and in other more course and fowle, when itt is all through dryed take away with your finger or feather the finest parte of the Couller, which will Like fine flower fall away with the Least touch, Reserve itt for your use the Courser sort you may keepe for ordinary worke, But when you use this Couller you must take as much as will lye in a shell I meane only to spread About the side of a shell som whatt thinne, that you may Handsomly take itt of with your pencill, which you can not conveniently doe if you fill your shell full, or lett itt lie thike on Heaps, and with Gume watter or gume in Powlder (as I sayed before,) with a few drops of watter, temper itt finely with your finger and Lett itt spread a'bout the sid[e]s of the shells, as you did in your other Ground Collers for your Pencills, must be well chosen cleane and sharpe, pointed not deviding in to parts full & thike towards the quill, & so decending to A' Round and sharp point I preferre thesse before them that are Longe & slender as Retaining the Couller Longer & delivering Itt out more free and flowing then the other, iff any haire is Longer then the Rest take itt off with a sharp pen-kniff, or passe itt through the Flame of a' Candle, the Pencills you use in Gold or sillver you are to Reserve for thatt purpose and not to mix or temper with other Coul-

48

lors. for your Table or Carde, Itt may be ovall, or square, as you will, or the partie drawne desirs itt, Take an ordinery playing Card pollish itt and make itt so smoth as possible you can, the whitt side of itt, make itt ev[e]ry wheare even, and clean frome spots, then chuse the best abortive *Parchment* & Cutting out A'peece Equall to your Card, with fine and Cleane starch past itt on the Card which done Lett itt dry then making your Grindstone as Cleane as may bee, lay the Card on the stone, the parchment sid downeward, and then Pollish itt well on the backe sid Itt will make much the smother, you must past your parchment so that the out side of the skinn may be outward Itt being the smothest and best side to worke on. [fol. 16] You are to Lay your ground, or Primer, of a' flesh Coller so neer as you can, of the same Complexcon the partie is, rather somwhatt fairer, for by shadowing you can make itt browner att pleasure, for in Limning you must never heighten but worke itt downe to the Just Coller having prepared your Coller you Remember to fill your Pencill full of Coller rather thinn & watterish then thicke & grose, and with to or three sweeps or dashes with a bigger then ordinarie Pencill: lay itt on in an Instant for the sooner you doe itt, the better and evener will your Coller Lye and forgett not to Cover so much or more of your Card then you meane to make the face because that if you should happen to Lay the ground to Littell you will very hardly add any more onto itt, but very uneven And not suttable to the rest, Therfore all must be done att once and speedily, for iff you be Longe in Laying this Complexion the Card or rather parchment will roughell or risse and Come frome the Card

This done you are to take a pretty large shell off Mother of Pearlle or such like and before you begin to worke you must temper certaine littlle heaps of severall shadows for the face which as the oyle Painters lay on ther woden Pallats in like maner you must Lay them ready prepared in order by themselves about the border or Circomfarence of the shells /

The first Coullers you are to begine the face with are Red, that is to say of the Cheeks and Lipps somwhat strongly in the bottome of the Chinne if the partie be beardlesse as allso over, under and about the

past: paste

sid: side

roughell: ruffle

eyes you will perceave a dellicate and faint rednes About the eies somwhat Inclining to A purple, which in faire and beawtifull faces is ordinary and must be observed dilligently, all this you must worke affter the maner of washing or hatching, drawing your Pencill along and with faint & Gentle stroaks or rather washing or wipping then with pricks to Prick and Punch itt as some doe affect, In your dead Coulloring you need not be exactt and curious but rather bold and Juditious, for though your worke Appeers rough att first yett in the finishing your worke will be in your owne Power and Pleasure to sweeten & Close itt as neat & Curiously as you will. Your next worke is the faint & blew shadows About The eys the Corners and balls of them, and Grayish & blewish shadows About the temples which you are to worke frome the uper parte of the face, exceeding sweett & faint by degrees, The fainter and lighter shadows being done & some whatt smothed and wrought into the red, you mous goe over your Haire, you must first draw them with Coller as neere as you can suttable to the Life, and afterward wash them roughly as the rest.

FOR YOUR HAIRE.
mous: must

TO MAKE ARMOR;
Wessells: weasel's
Littmas: litmus

Your Armour Layd Liquid sillver flatt & even which dryed and burnisht with a small Wessells tooth handsomly Fitted into a' Pensill stick then temper the shadow for your Armour with sillver Littmas and A' littell Umber, and worke your shadows upon & over the sillver acording to the observ[a]tions in the Liffe the burnisht silver to be Left for the heightnings/ the deepnings, must be the deepest of your shadows, the thinner parte whearof with some store of sillver, must bee sweetly & neatly wrought into the sillver layd all flatt before.

FOR GOLD

As for Gold you may Lay your ground flatt with English oaker tempered with Liqued gold yett there is, a' stone growing in the oxes gall which thay call a' gall-stone which if Ground & tempered with gold is of exelent Luster, & beawtie, in the shadowing of which in the deeppest & darkest places, must be mixed A littell Blake, the hightning must be the finest and purest gold (I meane Liqued)/ Iff in your gold worke ther be any Carving or Imbosiing and that in the Lighter parts itt must be sparkling & pleasant:

50

Slashes (/) are a common indicator for a full stop, or period. Customary abbreviations, such as *-ton* for *-tion, y^e* for *the, y^o* for *you, y^r* for *your, y^em* for *them, w^th* for *with, w^ch* for *which, p^te* for *part, p̱-* for *per-* or *pro-, S^r* for *Sir,* and *Ma^tie* for *Majestie,* have all been silently expanded. In the text, square brackets enclose emendations by the present editor, noted below; angle brackets (⟨ ⟩) note later additions to a damaged manuscript by Vertue, the eighteenth-century owner of the manuscript. *U* and *v, i* and *j* have been normalized. In the marginal notes, words indexing the text (set in small capitals) are by the original copyist; index words in angle brackets are later references by Vertue; annotations and glosses are by the present editors. These last are given for words that are obsolete, that have strange spellings in Tudor English, or that, because of the context, might be misleading or ambiguous. Occasionally, the copyist made an error that he crossed out before proceeding; these instances, too, are recorded below.

p. 15, ll. 1–7: Copy is from a title page supplied by Vertue and in his hand.
 ll. 8ff.: Vertue's additions are in brackets; his source is unknown.
 l. 8: *arte of* written in above the line
 l. 11: *intending* written in above the line
 l. 16: *Romans*]ŗǿṁạṇṣ *Romans*
 l. 17: should]should should
 l. 18: Did it]Did it ǿṅḷỵ
 l. 20: any]any ẹx

p. 16, l. 2: any unworthy]any ỵṇunworthy unworthy
 l. 21: precious]ṗṛẹṣịǿṇṣ precious
 l. 22: *and innobleth* written in above the line
 l. 34: in theire]ḅẹṣ in theire
 l. 35: *good* written in above the line

51

p.17, l. 4: guift and grace]guift ~~and grace~~ and grace
l. 5: *stones* written in above the line
l. 6: *sayeth* written in above the line
l. 7: brickes]~~brikes~~ brickes
l. 27: then hee]then ~~then did~~ hee
l. 34: word blotted out after *breedeth*

p.18, l. 4: competent]co^m petent
l. 5: word blotted out after *workmen* (probably *as*)
l. 11: *ffabius* in MS to indicate capital *F;* such double consonants are made capitals in subsequent emendations
l. 16: live]~~liffe lyf~~ live
l. 19: poure men]poure ~~meg~~men
l. 27: *and godly* written in above the line
l. 33: *Royall* bounty]Royall ~~Jugment~~ bounty

p. 19, l. 12: hope]hope I hope
l. 17: and perfect]and perfect and perfect^a
l. 20: hetherunto]hethe^r unto
 not
l. 26: that not]that ?~~very~~

p. 20, l. 13: of parts]^or of parts
l. 14: breadth]brea^d th
l. 16: in the]in the ~~ss~~
l. 33: *v* in *vieue* blotted
l. 34: *most* written in above the line
l. 35: his perspective]his ~~pesp~~ perspective

p. 21, l. 7: duch whatsoever]duchwhatsoever
l. 13: *of* written in above the line
l. 16: as plainly]ar plainly
l. 20: word blotted out before *recreation*
l. 21: then]them
l. 29: *briclest* written in over *clearest,* which is blotted out
 cleane] cleare
l. 33: Dust]dust Dust

p. 22, l. 1: weather, take]weather,take
l. 3: will]~~of~~ will
l. 24: but]but ~~things~~
l. 30: countenance]countena^n ce

52

p. 23, l. 5: treasure]tr^eassure
　　　l. 22: turne]tur^ne
　　　　　　eyes]ey^es
　　　l. 23: beauty]bea^uty
　　　l. 24: lovely]lov^ely
　　　l. 29: younge]~~yone~~ younge
　　　l. 34: ends]~~sides~~ ends

p. 24, l. 10: althoug[h]]alt^houg
　　　l. 14: wher]~~V~~wher
　　　l. 21: be sure]~~he~~ be sure
　　　l. 23: *w* in *whit* is written over
　　　l. 32: *and* added in margin before *the,* which begins the line
　　　l. 33: part, even]part, ~~of~~ even

p. 25, l. 17: Ruell]Ru^ell
　　　　　　r in *or* blotted
　　　ll. 19-20: the party]the ~~patterne~~ party
　　　　　　　　　　　　　remove
　　　l. 22: remove]~~remember~~
　　　l. 23: *v* in *moving* blotted
　　　ll. 23-24: a great]agreat
　　　l. 34: bignes,]~~bussines~~ bignes,

p. 26, l. 6: drewe]drwee
　　　l. 13: kneue]~~know~~ knewe
　　　　　　graunted]gra^unted
　　　l. 16: favours]favo^urs
　　　　　　　　　　　　　　　in
　　　l. 21: so god in nature]so ~~of~~ god ~~of~~ nature
　　　l. 33: to change]~~the~~ to change

p. 27, l. 8: fifty]fivty
　　　ll.14-15: possible]possibl~~y~~
　　　l. 17: was][was
　　　l. 20: *b* in *observations* written over an *s*
　　　l. 25: second *comonly* written in above the line
　　　l. 27: last word on fol. 5v blotted out
　　　l. 28: *and countenace* written in above the line
　　　l. 35: *not* written in above the line

p. 28, ll. 2-3: perspective]p̷e̷r̷s̷p̷ perspective
l. 10: height,]hᵉight,
l. 20: punctuation (/ for .) after *lyne* is erased
l. 33: *Italians* who had]*Italians*ʷʰᵒhad
l. 35: ones]onᵉs

p. 29, l. 1: graunted, & afirmed]graunted, ⁽&⁾afirmed
l. 6: *shewe* partly blotted out
l. 7: veewed]weewed
l. 18: viued]wiued
l. 20: the nearer]then nearer
l. 28: 2 words crossed out after *scarsly*
pleaseth, moving]pleaseth, b̷u̷t̷ moving
l. 33: ill cause]ill i̷l̷ cause

p. 30, l. 14: light,]l̷i̷g̷l̷ light, or
l. 22: purposse or matter,]purposse a̷n̷d̷ matter,
l. 23: consisteth,]consisteth, consisteth
l. 28: (more]more
l. 30: *Coullors,*]*Couˡlors,*
ar fit]as fit
(marginal note) *Coullers*]*Couˡlors*
l. 34: *Blewe*]*Blᵉwe*

p. 31, l. 3: every severall]every s̷t̷o̷n̷ severall
l. 12: many]maⁿy
them]them t̷h̷e̷
l. 16: grinding with]grinding w̷h̷i̷c̷h̷ with
l. 20: finnes]finⁿes
l. 21: (marginal note) [3]]2
ll. 24-25: paller, lesse]paller, l̷e̷s̷s̷e̷ lesse
l. 32: word *(whit?)* crossed out and *oyle* written in over it
whitneth upp pearles]whitneth ᵘᵖᵖ pearles

p. 32, l. 3: *Gume*]s̷o̷m̷e̷ *Gume*
washe it,]washe it, a̷n̷d̷ w̷h̷e̷n̷ i̷t̷ i̷s̷ a̷s̷
l. 7: amonge]a̷ amonge
l. 16: as of]os of
l. 18: burneth]burneth burneth
l. 20: after it is drye]afterⁱᵗis drye
l. 24: ready grinded,]ready t̷o̷ grinded,
l. 25: them]then
l. 31: not participatinge]ⁿᵒᵗ participatinge
l. 33: as with]as w̷h̷e̷n̷ with

p. 33, ll. 19-20: is but badd]is is but badd
l. 22: seaven or]seaven o̶f̶ or
l. 34: De luce]De l̶u̶c̶e̶ luce

p. 34, l. 27: virgine]v̶f̶i̶ virgine
l. 29: *A* in *Abertive* written over some other capital letter
l. 31: sattine,]s̶a̶ sattine,

p. 35, l. 6: *for* or *befor,* at beginning of line, added in margin
l. 22: taken away]taken ᵃʷᵃʸ
ll. 22-23:carnation will]carnation v̶i̶l̶l̶ will

p. 36, l. 1: they may]they t̶h̶ may
l. 13: hand]hand hand
l. 17: liqued goolde]liqued g̶o̶o̶d̶l̶ goolde
l. 19: as littel]as i̶l̶ littel
l. 20: Ferret]ffe^rret
l. 21: word blotted out before *here*
l. 23: uppon with black]uppon ʷⁱᵗʰ t̶h̶e̶ black
l. 31: give it a]give it a̶ l̶i̶t̶t̶e̶l̶ a
l. 33: undermost]und^remost
l. 34: absurd)]absurd/

p. 37, l. 16: *principall* slightly blotted
l. 28: fyve./.]fyve;/.
l. 29: and unmixed]and m̶i̶x̶e̶d̶ unmixed

p. 38, l. 16: hard bodies]hard s̶t̶o̶n̶e̶s̶ bodies
l. 23: mistaken,]mistaken.

p. 39, l. 1: the hart exceedingly]the hart exceedingly the hart
exceedingly
l. 2: mixt cullors]mixt s̶t̶o̶n̶e̶s̶ cullors
l. 4: founde]fou^nde
l. 11: *h* of *therfore* written over another letter(?*g*)
l. 15: Noate]N̶o̶a̶t̶e̶ Noate
l. 16: a thine]ᵃo̶f̶ thine
l. 17: clowdye faulty]clowdye s̶t̶o̶n̶e̶ faulty
l. 30: *o* of *cullor* written over an *e*
l. 33: are to]are n̶o̶t̶ to
l. 34: of that brightnes,]of ᵗʰᵃᵗbrightnes,

19.3 l. 17: perfect crimson]perfect ~~redd~~ crimson
p. 40, l. 34: breadth,]brea^dth,

p. 41, l. 23: *e* in *workmen* written over *a*
 ll. 31–32: cannot afforde)]cannot ~~be~~ afforde]

p. 42, l. 7: *slander* is catchword on fol. 12v, but not on fol. 13
 l. 28: cullor]callor

p. 43, l. 1: blueish]blweish
 l. 8: ~~in his kinde~~ crossed out after *used*
 l. 14: and have noe]and ~~and~~ have noe
 l. 19: Tynne no[t]]Tynne ~~t~~ no
 l. 31: *e* of *gume* written over *s*
 l. 34: all the precious]all ^the^ precious
 l. 35: Stones only]Stones ~~of~~ only

p. 44, l. 1: other under Stones]other ^under^Stones
 l. 13: black teyntor,]black ~~tayt~~ teyntor
 l. 14: cleere whitnes,]cleere ~~cullor~~ whitnes,
 l. 18: *devulged* blotted
 l. 19: therfore]the^r^fore
 l. 21: reade but]reade ~~not~~ but
 l. 27: and retracted]and ~~retractable~~ retracted
 l. 29: Stone is of]Stone ^is^of
 l. 34: daye light]daye light daye light

 highe
p. 45, ll. 16–17: be a very highe person,]be^a^ very ~~little~~ person,
 l. 18: and will soe]and ~~and~~ will soe
 l. 19: viewe]wiewe
 l. 20: placing him]placing ~~hime~~ him

p. 46, l. 1: A more Compendious]A ^more^Compendious
 l. 16: a few]afew
 l. 18: *us'd* written over another word
 the best,]the ~~better~~ best,
 l. 21: cleane]cle^a^ne
 l. 27: a llittell]allittell
 l. 34: *iff* written over another word

p. 47, l. 4: are]ard
l. 12: & gravely]& & gravely
l. 17: an ounce]anounce
l. 22: A'rise, which]A'rise, ~~to~~ which
l. 24: watter and]watter ~~astitt~~ and
l. 25: porrenger]porrenger
l. 26: *e* in *behind* written over another letter
 dreggs]dreggs
l. 27: *yet* added in margin

p. 48, l. 12: very]aery
l. 22: a shell]ashell
l. 24: thike on]thike ~~on~~ on
l. 31: & slender]& ~~slenar~~ slender
l. 33: a sharp]asharp

p. 49, l. 1: *for your Table or Carde* written in margin
l. 12: Coller so]Coll.r ~~of yt~~ so
l. 18: or dashes]or ~~das~~ dashes
ll. 29–30: Painters]Painters
l. 31: the border]the ~~sides of the shells~~ border
l. 35: *Chinne* first written *Chinene*

p. 50, l. 1: a dellicate]adellicate
l. 5: or rather]or ~~pricks~~ rather
l. 6: affect]affech
l. 8: yett in]yett ~~by~~ in
l. 10: *o* in *Curiously* written over an *s*
ll. 10–11: Your next worke]Your nextworke
l. 15: done &]done ~~you are~~ &
l. 17: them]then
l. 28: with English]with ~~Enlish~~ English
l. 30: if Ground]is Ground

Appendix

The Limner's Materials

In *The Arte of Limning*, Hilliard provides simple directions for the selection of materials and preparation of pigments for limning. But the directions are often sketchy, assuming in the reader an antecedent knowledge of the subject. When Henry Peacham borrowed from and extended Hilliard's work in *The Art of Drawing* (1606), he often added detail that clarifies for the nonpainter the nature and manufacture of the substances. The discursive character of Peacham's thought, moreover, adds to the flavor of craftsmanship in the limner's art. Below are compiled those of Peacham's expanded descriptions that most illuminate Hilliard's procedures.

Blacks: "The best black to make your Sattens and velvets, in water colours, is the Harts horne burnt to a coale: you may buy it at every Apothecaries . . . buy the blackest, and if there be (as commonly there is) any white, or overburnt peeces [in] it, pick them out cleane, for they wil infect the rest: for a shift you may burne an old combe, fanne handle, or knife haft, or any thing els that is ivory, they wil make a very good black in water." (I2v)

Ceruse: "Your principall white is Ceruse, called in Latine *Cerussa*. . . . The Rhodians (saith Vitruvius) use to take the parings of vines or any other chips, and lay them in the bottoms of pipes or hogsheads, upon which they powr great store of vinegar, and then laie above many sheets of lead, and so still one above another by rankes till the hogsheads are full, then stoppe they up

againe the hogsheads close, that no ayr may enter: which againe after a cer-
tayne time being opened, they find betweene the lead and chips great store of
Ceruse: it hath beene much used . . . by women in painting their faces, at
whom *Martial* in his merry vaine skoffeth." (H4)

Flory: "Take Florey blew [blue], and grinde it with a little fine Roset, and
it will make a deep violet, and by putting in a quantity of Ceruse it wil make
a light violet: with 2 parte of Ceruse, and one of red lead, it maketh a perfect
Crane Colour." (I1v)

Gold: "You maie guild onely with gumme water, as I wil shew you, make
your water good and stiffe, and laye it on with your pencil where you woulde
guild, then take a cushion that hath smooth leather, and turn the bottom
upward, upon that cut your gold with a sharp knife; in what quantity you
will, & to take it up draw the edge of your knife finely upon your tongue,
that it may be onely wet: with which, doe but toutch the very edge of your
gold, it will come up and you may lay it as you list; but before you lay it on,
let you gumme bee almost drie, otherwise it will drowne your gold: and being
laid, presse it downe harde with the skut of an hare, afterward burnish it with
a dogges tooth, or bores tus[k]." (H1–1v)

Gum Arabic: "The first and principall [binder] is gumme Arabick, choose it
by the whitnes, clearenes, & the britlenes of it being broken betweene your
teeth." (G4)

Pencil: "Choose your pencils [brushes] by their fastnes in the quils, and their
sharp points, after you have drawne and wetted them in your mouth." (G4)

Vermilion: "Your fairest and most principall Red is Vermilion, called in
Latine *Minium*, it is a poison, and found where great store of quicksilver is:
you must grind it with the glayre of an egge, and in the grinding put too a
little clarified hony, to make his colour brighte and perfect." (H2v)

White Lead: "White Lead is a manner the same that Ceruse is, save that the
Ceruse is refined & made more pure, you shall grinde it with a weake water
of gum Lake, and let it stand 3 or 4 daies, Roset and Vermilion maketh it a
fair Carnation." (H4)

The Plates

CATALOGUE OF THE PLATES

PLATE I *Queen Elizabeth I* (1572)
 Inscribed Ano Dni 1572;
 Aetatis Suae 38. Mounted on back
 of the Queen of Hearts. 2″ × 1¾″
 (National Portrait Gallery)

PLATE 2 *Self-Portrait* (1577)
 Inscribed Ano Dni 1577; Aetatis
 Suae 30. Signed *NH*. 1⅛″
 (Victoria and Albert Museum)

PLATE 3 *Alice Hilliard* (1578)
 Inscribed Ano Dni 1578; As S 22.
 Monogrammed "N". 2⅜″
 (Victoria and Albert Museum, from
 the collection of the Duke of
 Buccleuch)

PLATE 4 *Unknown Lady* (c. 1580)
 Unfinished miniature. 1½″ × 1¼″
 (Victoria and Albert Museum)

PLATE 5 *Richard Hilliard* (1577)
 Inscribed Aetatis Suae 58;
 Anno Dni 1577. 1⅛″
 (Victoria and Albert Museum)

PLATE 6 *Unknown Man* (1572)
 Inscribed Aetatis Sue XXIIII;
 Ano Dni 1572. 2⅜″ × 1⅞″
 (Victoria and Albert Museum, from
 the collection of the Duke of
 Buccleuch)

PLATE 7 *Unknown Man* (early 1590s)
 Contained in original lidded ivory
 box; traditionally said to have been
 given to Lady Rich by Elizabeth I.
 2⅜″ × 1⅞″
 (Victoria and Albert Museum, from
 the collection of the Earl of Radnor)

PLATE 8 *Henry Wriothesley,*
 * Earl of Southampton* (1594)
 Inscribed Ano Dni 1594;
 Aetatis Suae 20. 1⅝″ × 1⅜″
 (Fitzwilliam Museum, Cambridge)

PLATE 9 *Unknown Lady* (late 1580s)
 Contained in original lidded ivory
 box; traditionally said to have been
 given to Lady Rich by Elizabeth I.
 1¾″ × 1½″
 (Victoria and Albert Museum, from
 the collection of the Earl of Radnor)

PLATE 10 *Sir Walter Ralegh* (late 1580s)
 1⅞″ × 1⅝″
 (National Portrait Gallery, from the
 collection of Viscount Morpeth)

PLATE 11 *Sir Francis Drake* (1581)
 Inscribed Aetatis Suae 42;
 Ano Dni 1581. 1¼″
 (National Portrait Gallery)

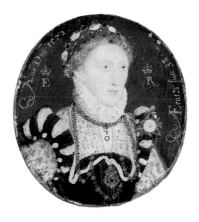

PLATE 1 Queen Elizabeth I

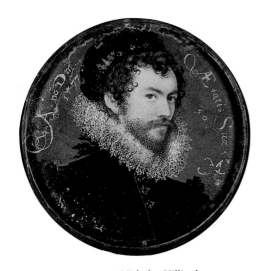

PLATE 2 Nicholas Hilliard,
Self-Portrait (enlarged)

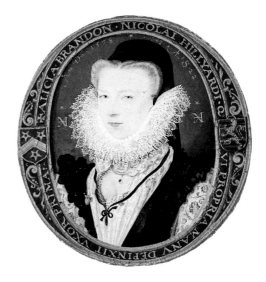

PLATE 3 Alice Hilliard
(reduced)

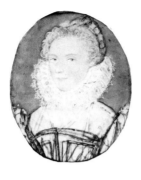

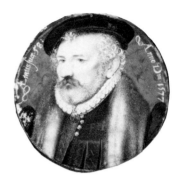

PLATE 4 Unknown Lady

PLATE 5 Richard Hilliard

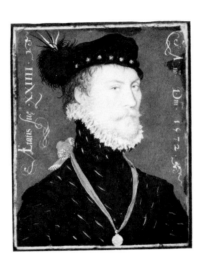

PLATE 6 Unknown Man

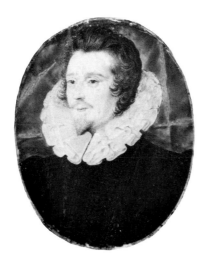

PLATE 7　Unknown Man

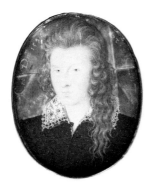

PLATE 8　Henry Wriothesley,
Earl of Southampton

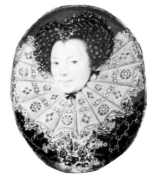

PLATE 9　Unknown Lady

PLATE 11 Sir Francis Drake

PLATE 10 Sir Walter Ralegh

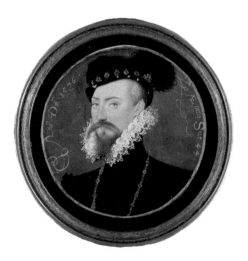

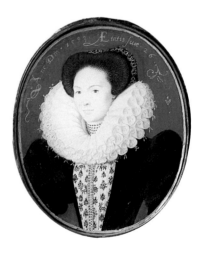

PLATE 12 Robert Dudley,
Earl of Leicester

PLATE 13 Mrs. Holland

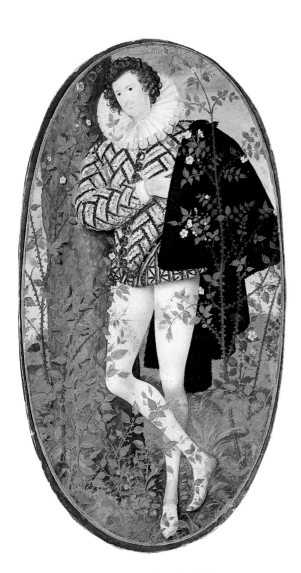

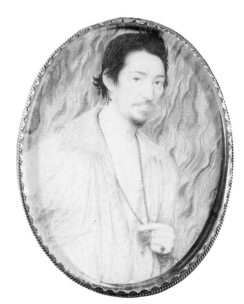

PLATE 15 Young Man Against
a Background of Flames

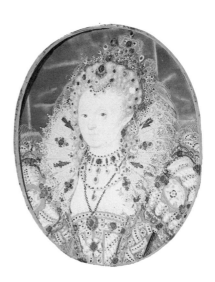

PLATE 14 An Elizabethan
Gentleman

PLATE 16 Queen Elizabeth I

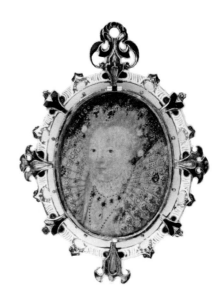

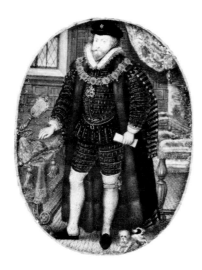

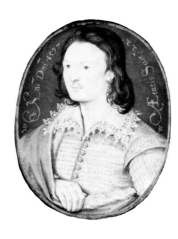

PLATE 20 King James I

PLATE 21 King James I

PLATE 22 Sir Thomas Bodley

PLATE 23 George
Clifford, Earl
of Cumberland
(reduced)

PLATE 12 *Robert Dudley,*
 Earl of Leicester (1576)
 Inscribed Ano Dni 1576;
 Aetatis Suae 44. 1¾"
 (National Portrait Gallery)

PLATE 13 *Mrs. Holland*
 (Lady Elizabeth Russell) (1593)
 Inscribed Ano Dni 1593;
 Aetatis Suae 26. 2⅜" × 2"
 (Victoria and Albert Museum)

PLATE 14 *An Elizabethan Gentleman*
 (late 1580s)
 Inscribed Dat poenas laudata fides
 ("my faith, though praised, brings
 suffering"). 5⅜" × 2¾"
 (Victoria and Albert Museum)

PLATE 15 *Young Man Against a Background*
 of Flames (late 1590s)
 Mounted on back of the Ace of
 Hearts. 2⅝" × 2⅛"
 (Victoria and Albert Museum)

PLATE 16 *Queen Elizabeth I* (late 1590s?)
 2⅝" × 2⅛"
 (Victoria and Albert Museum)

PLATE 17 *Queen Elizabeth I* (c. 1588)
 Center of the Armada Jewel. Shown
 are miniature and back—which acts
 as hinged lid—showing an ark on
 stormy seas inscribed SAEVAS
 TRANQVILLA PER UNDA ("calm
 through the savage waves"). Given
 to Sir Thomas Heneage by
 Elizabeth. 2¾" × 2" overall
 (Victoria and Albert Museum)

PLATE 18 *Sir Christopher Hatton* (c. 1590)
 2½" × 1¾"
 (Victoria and Albert Museum)

PLATE 19 *Unknown Man* (1597)
 Inscribed Ano Dni 1597;
 Aetatis Suae 22. 2" × 1⅝"
 (Victoria and Albert Museum)

PLATE 20 *King James I*
 Center of the Lyte Jewel. Shows
 James wearing the Garter ribbon.
 Red curtain and embroidered white
 doublet glimpsed through
 perforated lid with jeweled royal *R*.
 1¾" × 1⅜"
 (British Museum)

PLATE 21 *King James I*
 Shows James wearing ribbon of
 Order of the Garter with Lesser
 George. Contained in multiple
 frame from mid-seventeenth
 century, with miniatures of five
 other Stuarts.
 2⅛" × 1¾"
 (Victoria and Albert Museum)

PLATE 22 *Sir Thomas Bodley* (1598)
 Inscribed Ano Dni 1598;
 Aetatis Suae 54.
 Contained in contemporary ivory
 box. 2" × 1⅝"
 (Bodleian Library, Oxford—
 founded by sitter in year of
 miniature)

PLATE 23 *George Clifford,*
 Earl of Cumberland (early 1590s)
 10⅛" × 7"
 (National Maritime Museum,
 Greenwich)

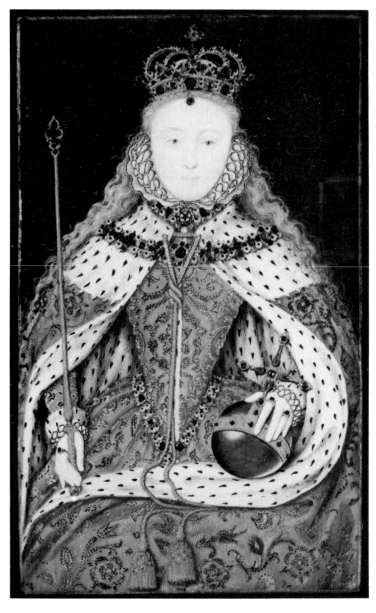

Queen Elizabeth I (c. 1569). Mounted on playing card. 3½″ ×
2⅛″. (Welbeck Abbey, collection of the Duke of Portland)

64

The Art of Nicholas Hilliard

Linda Bradley Salamon

The miniature portraits of Nicholas Hilliard (1547–1619) are a hallmark of the Elizabethan court and its style. The first major painter to be born in England, Hilliard has left us vivid images of Queen Elizabeth I and her Lords Chancellor, renowned courtiers and anonymous ladies. Only Hans Holbein surpasses Hilliard's achievement as a visual mirror of the appearance and character of Tudor men and women. Many of the extant miniatures survived in the private collections of the sitters' descendants; most are now national treasures of Britain. Hilliard's treatise, *The Arte of Limning*, however, is far less familiar. Although brief, it is the first treatise on art theory written in English, and it reveals much about the mind behind Hilliard's art. The importance of miniatures and text alike as guides to Elizabethan culture and its origins is beyond question.

Although he was aware of landscape and the narrative painting he calls "story work," to our knowledge Hilliard nonetheless painted only portraits, which he never names "miniatures." He made drawings for them in live sittings, and accurate likeness was his aim. *The Arte of Limning* confidently asserts, "of all things the perfection is to imitate the face of man kind . . . soe neare and so weel after the life, as that . . . the party, in all liknes for favor and complection is or may be very well resembled."[1] Such a statement of commitment to the unique individual never occurs to the mannerist theorist Giovanni Paolo Lomazzo, from whose treatise *The Arte of Limning* departs, nor indeed to the father of modern art theory, Leon Battista Alberti.[2] Hilliard's art relies on an observing eye and a sympathetic intuition.

The Arte of Limning also recalls, however, that the merits of a Hilliard painting in its age were not realized in "the face of man kind" alone.

> [Limning] excelleth all other *Painting* what so ever, in sondry points, in giving the true lustur to pearle and precious stone, and worketh the metals *Gold* or *Silver* with themselfes which so enricheth and innobleth the worke that it seemeth to be the thinge it se[l]fe . . . beining fittest for the deck[ing] of princes bookes or to put in Jewells of gould and for the [imitation] of the purest flowers and most beautifull creaturs in the finest a[nd] purest coullers which are chargable. (p. 16)

Here are displayed a manuscript illuminator's standards, a goldsmith's train-ing, and a craftsman's pride. In its carved ivory case or bejeweled and en-ameled gold locket, a Hilliard miniature is a complex *objet d'art*. The un-bending brocade and ribboning, the elaborate coiffure, the stiff lace ruff, and the patterned jewels form a complex decorative surface that may seem to overwhelm the pale, impassive face. Henry Constable's sonnet on a Hilliard portrait of Sir Philip Sidney's Stella (see the Epigraph) expresses admiration for the esteemed effect of the day: technical mastery of a virtuoso "arte" that bears comparison with Raphael.

Despite their size and conscious artifice, Hilliard's miniatures are an as-pect of the rise of portraiture across Europe in the fifteenth and sixteenth centuries, when Renaissance nobles and churchmen commissioned the premier artists of the period to produce likenesses of themselves and those important to them. The images are not solemn stone effigies on tombs or portrayed donors of sacred objects, but depictions of men and women with unique qualities and often with a precise station in society, designated by their dress or attributes. In furs and jewels, scepters and birettas, the portraits of Jan van Eyck, Leonardo da Vinci, and Titian record status, individuality, and evanes-cent charm. Hilliard's countesses and courtiers stand in this tradition, and his delicate limnings were used to make statements both public and private in Elizabethan court life.

In *The Arte of Limning,* brief reports of courtly behavior merge with descriptions of medieval materials and hints of Renaissance and mannerist thought. The combination, and the discursive anecdotes that express it, reward the reader of the treatise with insight into the working life of an Elizabethan painter. Hilliard briefly describes his studio practice in varying degrees of detail and affirms the conscious appeal of his difficult craft to a sophisticated taste.

He does not undertake the systematic presentation of line, plane, and form common to Renaissance treatises; he ignores analytic optics and gives short shrift to the anatomical measurements that dictate proportion. The absence of such formal organization reminds us that in the visual arts England lagged a half-century behind Continental advances.[3] The simplicity and candor of the text, however, give *The Arte of Limning* its appeal. Hilliard scatters views on an array of aesthetic questions, often by association, throughout his text. Surveyed systematically with illustration from the miniatures, the treatise gives a strong sense of Nicholas Hilliard, the artist and the man.

The shape of Hilliard's accomplishment as a painter—recognized since the seventeenth century—has been well described by modern scholars. In a seminal essay, John Pope-Hennessy first assessed *The Arte of Limning* against the doctrines advanced by Italian mannerist art theorists; in *A Lecture on Nicholas Hilliard,* he set the direction for modern studies of Hilliard's *oeuvre*.[4] As curators and connoisseurs, Pope-Hennessy, Carl Winter, and Graham Reynolds have gone far toward giving us a just appreciation of Hilliard's perfected art.[5] In *Nicholas Hilliard* Erna Auerbach established the first comprehensive handlist of paintings by, or closely associated with, Hilliard; Dr. Auerbach surveys the documentary evidence on the life, the training, and the working conditions of Hilliard and his contemporaries.[6] Roy Strong's scholarship distinguishes the canons of known British and foreign portraitists and elucidates the meaning, motive, and function of Tudor images, emblems, and decor. Recent scientific analyses of miniatures conducted under Strong's aegis at the Victoria and Albert Museum are now an essential tool for studies in the field.[7]

The publication of a new, textually sound edition of the Edinburgh manuscript of *The Arte of Limning* affords an opportunity to reassess Hilliard's achievement in light of his own commitments and goals. The treatise and the miniatures illuminate each other, and the resulting interpretation can be examined in the multiple contexts of court life and of the relation of limning to Elizabethan literary convention. (Many observers have commented, for instance, that miniatures are analogous to sonnets, a notion pursued here.) The impact of the goldsmith—on the paintings, on the treatise, and on the aesthetic milieu of the age—also deserves attention. What follows, then, is a survey of the sources of Hilliard's art, the demands imposed by his medium and his aristocratic sitters, and the fate of his works, as revealed by the treatise and by poets' *obiter dicta* on art. *The Arte of Limning* is pressed for all that it will yield, and the result should be the most thoroughgoing examination of Hilliard's thought and accomplishment yet made available. Speculation must

stop, however, at the words on the page. We cannot fully estimate whether the painter genuinely admired the Queen who was his paramount patron or simply exploited her commission, whether he believed in the civilizing concept of Petrarchan love or shrewdly capitalized on a windfall convention. Such conjectures, like many intriguing questions including costume, lie outside the scope of his commentary in *The Arte of Limning*.

In Hilliard's work we find an uneasy dialectic between qualities almost opposite. The limnings achieve a reconciliation between linear surface-patterning on the one hand and naturalistic treatment on the other. The formal lines of forehead and jaw are set against the detailed realism of ruff and fur; the stylized design of fabric and wig balances an often engaging human expression. In the courtly functions of the miniatures, public display balances intimate gesture, for they could be worn as adornment with the image either openly proclaimed or elegantly concealed. In the treatise, sketches of advanced Renaissance ideas balance the late-Gothic survivals so appropriate to the Elizabethan *mise-en-scène*. And in the painter, the aspiring craftsman struggles to tip the balance toward the status of gentleman-artist. The best of the individual miniatures nevertheless have an integrity that derives from the fresh observation with which Hilliard presents them. His vision of human personality is readily identifiable; we look past the porcelain skin, the slight smile, and become acquainted with the dignity or insouciance of his Elizabethans.

The threads of influence leading to a Hilliard miniature are many; *The Arte of Limning* gives little definite information about the sources of his art. The single subject he chose to paint, the style in which he painted, the form in which his work is cast—each element appears to reflect varied origins in manuscript and medal, northern realism and Italian mannerism. The paramount issue in Hilliard's own mind is his subject, the attempt to portray a newly realistic likeness. To be sure, we have some images, rather than hieratic symbols, of the appearance of medieval Englishmen: a somewhat cruel genuine portrait in the bronze tomb effigy of Phillipa of Hainault (d. 1369), queen of Edward III;[8] the features of Richard II (1377–99) in the Wilton Diptych in the National Gallery confirmed in the formal, frontal pose of the Westminster Abbey panel; the 1488 portrait of Lady Margaret Beaufort with its emerging sense of mass, now in the National Portrait Gallery; Henry VII in Torrigiani's bronze tomb effigy and in Michael Sittow's 1505 panel in the National Portrait Gallery. Such monumental portraits almost invariably represent sovereigns in royal state; few likenesses remain of the courtiers and citizens of the Plan-

tagenet reigns. Nor does the body of impersonal full-scale portraits—by Bettes, Scrots, Flicke, and Eworth—of the Henrician and Marian reigns provide a model for Hilliard's limnings.

Manuscript illumination—miniature painting on parchment—offers one major influence on Hilliard's art. Some English manuscripts include attempts at portrait-illuminations: East Anglian prayer books of the thirteenth and fourteenth centuries such as Queen Mary's Psalter (c. 1320) and fifteenth-century poetry manuscripts such as Lydgate's life of St. Edmund (BM Harleian 2278). Indeed, the illustrator of Thomas Hoccleve's *De Regimine Principum* (BM Harleian 4866) (c. 1410) tried to remind readers what Chaucer had looked like, albeit a decade after Chaucer's death.[9] In Tudor England, however, religious art was decimated by the Act of Supremacy (1534) and the dissolution of the monasteries; the ideological devastation of illuminated manuscripts only accelerated the impact of the rise of printed books. Some illuminators found secular employment by portraying their sovereigns as authentication on such documents as international treaties, court records from the King's Bench, charters for the foundation of colleges for the New Learning, and letters patent confirming grants of land.[10] The most recent studies of Hilliard and miniature painting, by Jim Murrell and Roy Strong, suggest that the chief source for Hilliard's art was the influence of Burgundian manuscript ateliers carried by émigrés of the Ghent/Bruges school to the Tudor royal library.[11] Hilliard's grounding in this long tradition is undoubted: *Limning*, his constant term for his art, derives from *illuminating*; he nods in the treatise at "small voloms in privat maner" (p. 16). His friend Richard Haydocke notes with assurance that limning "was much used in former times in Churchbookes (as is well knowne)," so is "but brought to the rare perfection we now see" by Hilliard.[12] Moreover, one of Hilliard's early miniatures (c. 1569) shows Elizabeth in the frontal, enthroned pose, with the robe of state, the regalia of crown, orb, and scepter, and the tangential relation to descriptive likeness (Plate, p. 64) that had characterized official symbols of royalty at least since Richard II. Hilliard's effort surpasses the standard types in fluency of line, though it does not match the accomplishment of his best work. The Burgundian/English tradition of illumination gave him a medium and the beginnings of a technique.

The principal influence on Hilliard's portraits he names with utter directness as "*Haunce Holbean*, the greatest Master truly in both thosse arts after the liffe that ever was, . . . and the[r]withall a good inventor" (p. 19). Holbein (1497?–1543) brought Italian and Flemish visual concepts and subtle

developments in Renaissance portraiture to England, initially under commission from Erasmus to create a lasting record of his deep affection for Sir Thomas More.[13] Erasmus received the drawing of More's circle for a painting unhappily never completed; later generations have the Rotterdam humanist to thank not only for Holbein's penetrating portrait of a martyr to conscience but also for puissant icons of Henry VIII. Holbein came late to Henry's court; settling permanently in 1536, he was retained as one among many named "King's painter," of whom the most notable was the miniaturist Lucas Horenbout (Hornebolte).[14] Moreover, Henry trusted Holbein's perception to an extraordinary degree. Like Henry VI a century before, and like the d'Este and Hapsburgs of Renaissance Italy and Spain, Henry VII wanted to view physical images of the eligible noblewomen of Europe as he pursued his erratic matrimonial course, and Holbein was his chosen recorder.[15] (The touching portraits that remain can only increase confusion over Henry's taste in wives.) Thus Holbein domesticated the portrait in England, both as memento of absent friends or beloved ladies and as awesome image of the mighty at court.

It has long been a commonplace that economical line was Hilliard's heritage from Holbein; Hilliard also shares with Holbein the ability to express personality traits without any great play of feature. Certainly Holbein was also fascinated with reproducing the texture of fabric and the luster of gems characteristic of northern painting since Jan van Eyck (1370?–?1440). Holbein did not produce a unique miniature style, however; his miniatures may well have been derived from the same mechanical drawings he used for large oil portraits.[16] By 1600, when Hilliard praised Holbein in *The Arte of Limning*, painting in monumental scale was already established as his major accomplishment. Hilliard pays homage to Holbein in the portrait of his father (Plate 5), with its pronounced modeling and deeply incised features, its sober sense of weight and ruminative gaze, and especially its tactile rendering of rich fur and grizzled beard against the black merchant's robe. But this miniature, an early one, is not a typical Hilliard product. Hilliard was to move well beyond imitation of his master into a linear style, a lightened palette, and a sensitivity all his own.

When we seek other painters who may have influenced Hilliard's style, *The Arte of Limning* provides some guidance. Hilliard acknowledges no "englishe borne" antecedents, for "*Europe . . .* breedeth or might breed more then a hundred workmen for us one" (p. 19). The artist most prominent in *The Arte* is Albrecht Dürer (1471–1528), whom Hilliard knew as copper engraver, as theorist, and—he says—as painter.[17] Dürer's appeal to Hilliard is readily ap-

70

parent: he is "the most exquisite man that ever leaft us lines to vieue for true delination, the most perfect shadower that ever graved in metall, for true shadowes" (p. 20). Hilliard obviously values the scrupulous naturalism of northern graphic art, in which objects are minutely described in black-and-white patterns on the picture plane. He can extend no higher praise than to suggest that the would-be limner imitate the hatching in Dürer's prints as a model for the deployment of shadow. Though he honors Dürer as inventor as well as engraver, he has less respect for the work: Dürer's attempts to bring scientific measurement to human proportion are overly rigid, "hard to be remembred, and tedious to be foloued" (p. 19). Except for formal reminiscence of an occasional portrait such as *Johannes Kleberger* (1526; Vienna, Kunsthistorisches Museum),[18] Hilliard's work does not spontaneously recall Dürer. Hilliard's acquaintance with northern engravers extends as well to Lucas van Leyden and to Hendrick Goltzius, who—in a critical opinion not confirmed today—"aproched *Albertus* very neer" (p. 20). His comment that Goltzius "afecteth an other maner of line, which is swifter acording to his spirit, and doubtles very excelent" (p. 20) suggests an appreciation of the elongated forms and languid poses of this mannerist artist that may have affected his mature work (Plate 14).[19]

The most unreserved homage in *The Arte of Limning* is praise for the modern Italian style of Rosso and Raphael. Hilliard believes their works excel in "beautifulnes, and sperit in the linament and Jesture, with delicacye of feature, and limes [of] hands and feet, surpassing all other portractures of the duch whatsoever, yea even nature it self" (p. 21). Delicacy of feature and a mild spirit are lessons that Hilliard might take from the south to soften his style and add grace to the strong lines of Dürer. Given the likelihood that Raphael was known in England only through graphic reproduction, however, his influence is at best only dimly reflected in Hilliard's miniatures. England was in most ways distant from Catholic Italy in the late sixteenth century. As Elizabeth's Latin master Roger Ascham reminds us, the manners and styles displayed by travelers returning as "Englishmen Italianated" were open to grave question. Ordinary Italians themselves, not on diplomatic missions, were as little welcome—Federigo Zuccaro's brief visit in 1575[20] is the exception that underlines the fact—and Hilliard would have known few. There is finally no secure evidence, in the treatise or in the miniatures, that Hilliard grasped the achievement of Renaissance Italy. Thus Hilliard's admirer Haydocke makes only a brave boast when, playing Vasari/Plutarch, he compares his friend with "the late-worldes-wonder Raffaell Urbine."[21]

71

One compositional habit of Hilliard's mature work suggests his awareness of the motifs of mannerism in Italy and the Hapsburg Empire. The occasional full-length portraits of the 1580s and 1590s—by no means his most successful efforts—almost uniformly take a stock pose: the figure turned in the direction of a bent leg and pointed toe, the opposite hand on or near the engaged hip, costume and decor that insistently display status (Plates 18, 23). The pose is reminiscent of dukes and emperors such as Charles V, as painted by Titian, Seisenegger, and François Clouet. Many intermediaries could have brought this convention to Hilliard's purview, among them William Scrotes's High Renaissance portrait of the poet Surrey (1546)[22] and the portrait of Christopher Hatton at the Inner Temple probably painted by Cornelius Ketel around 1575—more than a decade before Hilliard's miniature of Hatton. While Hilliard's august Lord Chancellor has the Great Seal at hand and wears the Order of the Garter awarded to him in May 1588, the debonair courtier of the full-scale portrait recalls the broader scope of Hilliard's art. Around his neck Hatton wears a long gold chain from which is suspended, cupped in his right hand, a carved medallion of the head of Queen Elizabeth.

For Hilliard's accomplishment is not wholly defined by portraiture; his miniatures take on additional meaning from their use as ornamental possessions. Worn as jewelry, displayed as curios, used as vehicles for symbolic statements, they reflect his training and practice as a goldsmith. As a free member of the Goldsmiths' Company like his maternal grandfather, his father, and his father-in-law before him, Hilliard began a craftsman's life as jeweler, embosser, and engraver. From youth he was experienced both in techniques of relief and line-incision on metal and in fashioning ornaments to be suspended from chains or held "in hand neare unto the eye" (p. 29). The Second Great Seal of Elizabeth I, a drawing probably for another seal, and a few enameled cases remain to show that he never abandoned his original vocation in precious metals (Plates 17, 20).[23] Hilliard's union of portraiture with these craftsman's skills echoes the Renaissance fashion of portrait medals *all'antica* by Matteo de'Pasti, Pisanello, and others that originated in the Italian Quattrocento as a learned assertion of power and individuality. These round medallions with their proud expressions and low relief, their mottoes and inscriptions, share the spirit of one facet of Hilliard's *oeuvre*.[24]

The motifs and iconography of the medals moved north and west with the Flemish, who long served as the artistic couriers of Europe and later sought an English refuge from Catholic Spain. In 1519, Quentin Matsys cast a bronze medal of Erasmus at his direction, inscribed IMAGO AD VIVA EFFIGIE EXPRESSA;

in the 1560s, during Hilliard's apprenticeship, Steven van Harwick produced in England several clearly lettered silver portrait medals, some in three-quarter profile and scrupulously rendered costume. Moreover, contemporary with Hilliard's 1576–78 visit to France and his early work there, the eminent goldsmith and sculptor Germain Pilon was casting medals of—among others—Charles IX and Henry III of France which, given Hilliard's entrée to ducal circles, he may well have seen. His acquaintance with the medal, as compositional form and as art object, seems a reasonable conjecture.

The medals' typical, emblematic inscriptions offer a logical source for the handsome calligraphy that brings early Hilliard miniatures to the surface (Plates 2, 3). Again, a painted northern intermediary is available, both through Dürer—in such powerful pictures as his *Oswald Krel* (1499; Munich, Alte Pinakothek)—and still more plausibly through such Holbein portraits as *Sir Brian Tuke* (1532?; Washington, D.C., National Gallery) and *Robert Cheseman* (1533; The Hague, Maritshuis).

Finally, miniature portraits independent of either manuscript or medal had begun to emerge in the early sixteenth century. The Medici and their mannerist court painters, among them Bronzino and François Clouet, created a vogue for miniatures in France and Italy in the 1540s and 1550s.[25] By whatever means this aristocratic fashion reached England, Elizabeth apparently recalled it when she came to the throne and required official seals and licensed symbols; she was inspired to create a personal iconography of herself as Virgin Queen. Every courtier was to court her, and the victorious gained tokens of her favor—including little pictures of the ageless Queen.

A Hilliard miniature is thus a confluence of medallic form and illuminated content produced under fortunate patronage. No combination of northern realism and linear tradition with Italian grace and *maniera* can explain his work; those of his pictures that most suggest Continental influences are least characteristic of his production. Notably, he tenders no previous painter any credit for his coloristic skill, his heritage from the illuminators. Hilliard the goldsmith and limner, at home equally in jewels and in small portraits, found the right climate in the court of the maiden queen, fond of ostentation and in need of an image. For over thirty years, Hilliard satisfied Elizabeth's fancy for glamorous presentation in a uniquely English version of the Renaissance cult of likenesses intended to display power and taste. His miniatures express his era, the *pax Elizabethiana*, as distinctive in style as Florence under Lorenzo de' Medici or the Fontainebleau of François I.

The Making of a Miniature

The Arte of Limning reveals Hilliard's technical methods for limning no more comprehensively than it does the origins of his art. Despite his stated intention to provide a working manual, when we search *The Arte of Limning* for information about how he limned a portrait from first sketch to finished miniature, we glean no more than rudimentary facts about his technique. We must turn to the pictures for fuller illustration. As Jim Murrel has said, "In the absence of any documentation of the early development of the methods of the miniaturists, a description of the techniques . . . relies almost entirely on scrupulous examination of the pictures themselves."[1]

Miniatures were painted on fine vellum—preferably "virgine Parchment" from "*Abertive*" lambs, Hilliard says—rubbed "smothe as any sattine, and pasted with starch well strained" onto a burnished white card "without speckes or Staynes" (p. 34). Since Holbein's day, playing cards had served as backings that were ideal in size and weight, a practice that allowed the incidental private wit of backing Elizabeth (Plate 1) with the Queen of Hearts and a lovelorn young man (Plate 15) with the Ace. The treatise indicates that Hilliard first sketched general outlines, but only two independent drawings certainly by him are extant, one of them in preparation for a metal seal.[2] Thus we can easily believe that—except for his later portrayals of Elizabeth I—he typically worked from live sittings without preliminary studies, sketching directly onto the whitened vellum. After all, he speaks almost reflexively of "pictures after the life" virtually as a definition of portraiture, in contrast to history painting or landscape. His view is underscored by insistence on the power of the observing eye to distinguish a youthful conformation of features from an elderly one, and a beautiful face from an ill-favored one. "The rule of the eye," the "Jugment of the eye," the "many things doe painters see . . . which wee deserne not" (p. 20)—empirical observation by an especially gifted, much practiced eye is all. Life drawing is the basis for Hilliard's limning.

Thanks to the more detailed, orderly commentary of Edward Norgate's *Miniatura* a quarter-century after *The Arte,*[3] we may deduce that the first step in limning proper—reached only on fol. 9 of Hilliard's treatise—was to lay down a wash, "not thine driven as ane oyle cullore" (p. 34), of the white pigment called "carnation" used for flesh. The wise limner tested first too pale a shade, since too red or brown a choice would be irremediable, and made the face a bit fuller, the forehead a bit higher than life. The right tone and

accurate rendering of the features were then achieved with individual strokes of the thin brush Hilliard calls a "pensill."

Lines were drawn on the ground-color with very great care, "with thine lake alone with a very smalle pensile . . . till you be sure you bee in the right waye, for afterwards ther is no alteration when the lyne is apparant. . . . the botching or mending wilbe perceived wher one hath taken away any caler one the face, for the carnation will never be of the same cullor againe" (p. 35). The lake—a compounded pigment of purplish-red that gives a semitransparent appearance—is thus the material with which the drawing of features was achieved.

Despite the exactions of this delicate medium, Hilliard reveals himself in *The Arte of Limning* as a precise, confident draftsman. Analyzing the living face, he enunciates the abstract qualities of beauty: complexion, proportion, expression. But when he approaches the practical matter of reducing the face to paper, in typical fashion he substitutes the concrete physical features of eyes, nose, and mouth (p. 25). Theory still does not match studio practice, for he recommends as the first line to be drawn not any of these features, but rather his characteristic forehead stroke. "That lyne must be a scalle to all the rest" (p. 25), he says. With the outline of the profile drawn, apparently Hilliard next sketched the most important features, which are dictated as much by the impulse to clean line as by facial structure. Central to beauty, the nose "giveth cheefe favor, for one shall never see an Ill favored face, that hath a weel propo[r]tioned nosse" (p. 25). The accurately drawn mouth is most respon- sible, in its expressive mobility, for resemblance to the sitter, "although liknes is contained in every part, even in evry feature, and in the cheekes, chinne, and forhead with the compasse of the face, but yet cheefly in the mouth" (p. 24). Scant help there for the eager novice; nor does Hilliard tell us how he drew an accurate mouth or a beautiful nose.

Consonant with his emphasis on the painter's observing eye, Hilliard expends the greatest care on describing the importance of technique for draw- ing the eyes, "the life of the picture." "Chiefly the drawer should observe the eys in his pictures, making them so like one to another, as nature doeth, giving life to his worke" (p. 24). That portion of the iris not covered by the lid must be perfectly round, the pupil carefully centered within it, and a "whit spek" accurately placed to reflect the light source otherwise illuminating the picture. And in the miniatures indeed we frequently see round, wide-open eyes, with the lids bold arcs above them. Hilliard adds a direction for perspective fore- shortening, required by his normal three-quarter profile view, which explains

another characteristic visible in the miniatures: "the furthest eye from the drawer must be a littel hig[h]er then the hethermost . . . if the drawer sit any deall hig[h]er then the party drawne, but if lower, then the further eye must be a littel lower" (p. 24). Thus the mirror from which he painted his self-portrait (Plate 2) must have been above his line of sight, while the unknown young man shown in Plate 6 stood below him. Such attempts at naturalistic drawing in the round occasionally go astray; the farther eye of *Young Man Against a Background of Flames* (Plate 15) recedes a bit abruptly. Yet even in this picture, as Hilliard claims, the eyes contribute most to the illusion that the sitter is alive and gazing coolly back at us.

To the drawing of such features as the ears, the eyebrows, the jaw, or the hair, on which he clearly lavished attention, Hilliard gives little mention. A frequently quoted passage comprises the only direct explanation of the way in which play of feature conveys emotion:

> in smilling howe the eye changeth and naroweth, houlding the sight
> just between the lides as a center, howe the mouth alittel extendeth,
> both ends of the line upwards, the Cheekes rayse themselves to the eye-
> wards, the nosterels play and are more open, the vaines in the tempel
> appeare more and the cullour by degrees increaseth, the necke com-
> monly erecteth it selfe, the eye browes make the straighter arches, and
> the forhead casteth it selfe in to a plaine. (pp. 23–24)

Here is evidence for the constant observation that must have been required for Hilliard's incisive outlines. But the only other example is the changing facial structure of old age (p. 26). Hilliard does not explain why his drawing conveys life—or at least liveliness, since we cannot test veridical representation—so successfully.

Achievement of the central likeness on the carnation wash and of the initial tinting of the hair may well have concluded the first sitting, Norgate's description reports. But if the sitter's patience lasted, *The Arte of Limning* suggests, Hilliard began upon the only remaining technical step to which he gives attention, the modeling of features that he calls "shadowing." "Shadows showe the roundnes" (p. 28).

> *Limming* is but a shadowing of the same cullor your grownd is of. . . .
> be verye well advised what lines you drawe, and drawe them very

76

lightly with some of the same carnation and a littel lake amonge very thinly mixtioned, . . . that it scarce at first maye be discerned. (p. 35)

Shadowing in *Lymning* must not be driven with the flat of the pensel as in Oyle worke, distemper or washing, but with the pointe of the *Pencell* by littel light touches with cullor very thine, and like hatches as wee call it with the pen, though the shadowe be never so great, it must be all so done by littel touches, and touch not to longe in one place, least it glisten, but let it dry ane howre or to, then dipen it againe. (p. 37)

Even the modeling intended to suggest three-dimensional plasticity behind the facial planes is achieved not by painterly means but by graphic lines, in "littel touches." Indeed, "hatching with the pene in Imitation of some fine well graven portrature of *Albertus Dure*" (p. 37) is Hilliard's advice for the best way to learn modeling technique. The goal is plasticity of such subtlety that no observer can detect it. "So to shadowe as if it weare not at all shadowed, is best shadowed" (p. 30), Hilliard observes, confident in the art that conceals art. High relief is obviously not in question. "To shadowe (sweetly as wee weell calle it) and round well, is a fare greater cuning then shadowing hard or dark" (p. 30). Scattered across four leaves of the manuscript come assertions that—as line is the key to drawing—this painstaking process of incremental intensifying is the heart of the limner's art. "This is the true order and principall Secret in *Limning,* which that it maye be the better remembred, I end with it" (p. 37). And, turning to jewels, he does.

 Once the central likeness has been captured—the relief of individual features and the exact shade of complexion recorded—the presence of the subject is no longer necessary to the picture's completion, nor would many courtiers tolerate a wait of "ane howre or to" between strokes. We may reasonably conjecture that Hilliard limned costume, details of background, and some of the many splendors of dress at a time and place other than a first or even second live sitting. The treatise makes offhand reference to "the *Painters* memory" (p. 22) and the costs to "they that without patterne drawe out of thier owne head" (p. 25). As more convincing evidence, an unfinished miniature in the Victoria and Albert Museum (Plate 4) presents a blue background and tinted face but hair and ruff just emerging into detail, shoulders and dress a rudimentary sketch. The clear outline around the skull and the pinks along each cheek and jaw that begin to "shadow" the carnation affirm the practice adumbrated in *The Arte*. A half-finished miniature of William Cecil, Lord

Burghley, is completed to virtually the same degree.⁴ Such a procedure would account for the occasional lapse in relationship of head to body in Hilliard's miniatures—the heads floating on ruffs that conceal no anatomically imaginable neck, the bodies pinched by unbending fabric patterns, the legs and feet that put their possessors *en pointe*. The pretty arms and bosom of Alice Hilliard herself (Plate 3) are too small in scale to carry her head. Cardboard torsos may be a price that sitters willingly paid for the rich, decorative effects that Hilliard gave their finery. Although Hilliard finds representation of clothing unworthy of any comment in *The Arte of Limning*, he is very good at it. As Graham Reynolds has remarked,

> However elaborate the neckwear may be in that age of ceaseless experiments with ruffs and collars, Hilliard is always master of its form . . . ; and when he is called upon to draw the intricate geometrical patterns of the reticella lace adorning collars and cuffs, the way in which he combines freedom of line with exactness of detail is always a source of the keenest aesthetic pleasure.⁵

The final aspect of miniature painting, and the content of a major portion of the treatise, is color. Hilliard is virtually silent on the choice or application of color for an emerging miniature, but *colors* in the sense of pigments are the craftsman's first concern. When he turns, on fol. 3, from theoretical comments to "directions to the art of limning," the "fierst and cheefest precepts"—prior even to bright light—involve care for the purity and durability of ingredients for paints. He gives particular attention to the water for solution of pigments "distilled most pure, as the watter distilled frome the watter of some clear spring" (p. 21). For opacity and luster he prescribes gum arabic "of the whitest and briclest broken into whit pouder" and sugar candy equally white and pure (p. 21). (But too much gum "wilbe some what bright lyke oyle caller, which is vylde in lymning" (p. 32)—the translucent glow of oils is *not* desirable.) All ingredients should be ground with pestles of crystal or other hard, semiprecious stones, kept in ivory boxes, cleaned only by brushing with feathers, and protected from every bodily contact: exhalation, dandruff, spittle, or natural oils. Nothing could be more homely, an earthiness that touches the remainder of the treatise in "some sweatye hand or fattye finger" and "a very little eare waxe" (p. 36); yet nothing could better underline the fragility of the medium. When, in one of *The Arte*'s amplest rhetorical gestures, Hilliard begins "of *Coullors,* for which ar fit for limning, and which ar not" (p. 30),

he provides a checklist of undesirable, "unsweet" pigments ("all ill smelling coullers all ill tasting") and of those to be chosen if available. All of them need to be ground, washed to separate coarse from fine particles, and then ground again into fine powder. In more leisurely fashion, he notes what "some authors sayeth" concerning the number of colors, makes requisite obeisance to the capacity of white and black—light and shadow—to depict all nature, and turns to a lengthy catalogue for the preparation and appropriate use of various forms of white, black, murrey (a purplish crimson or carmine), red, blue, green, and yellow.

The treatise makes clear Hilliard's relish for a bright palette. His early pity for John Bosham, forced by poverty to work only in white and black (p. 18), and his late explanation that those two colors are "thicke" (opaque) and not transparent (p. 44) only confirm his reluctant concession "whether th[e]y be the only coullours, or no coullers at all (as many others say) for my part I thinke them worthiest to be first placed being the most used" (p. 31). He dutifully follows Lomazzo in recommending a magical seven-color palette: "Many recollections of Lomazzo's scheme," says Pope-Hennessy, "leave no doubt that Hilliard's views on the harmony and gradation of colour were substantially those of the Italian writers of his time."[6] But Hilliard's personal allegiance is clear: "I saye for certayne truth, that ther are . . . but fyve perfect cullors in the world which I prove by the fyve principall precious stones (bearing cullor)" (p. 37). No Italian text but an illuminator's workshop provides the recipes for calcinating and tempering the homely ingredients in which Hilliard revels: lamb bones, egg and oyster shells, ivory, white lead and red lead, fruit pits, copper blue bice, indigo, lee of soap ashes, cedar green, ocher and other earths, saffron water, ox gallstones, white roses, iris green. Precious Venetian ultramarine draws mention for its cost alone.

The workman at his pestle preparing colors almost forgets the limner applying those colors from their small shells to a vellum surface. But a few practical tips for the painter emerge. The reduction of white lead—twice ground, the finer portion sorted out by washing into three grades—produces a fine "sattin whit," which glistens (p. 31) and a white for linen, paints that might make Hilliard's miraculous ruffs and laces. The coarsest grade of white, ground again, "is best to be ussed for the flesh couller properly called cornations, which in no sort ought to have any glistning" (p. 31) but needs an admixture of red lead and, depending on the sitter's complexion, the yellow pigments massicot or ocher de ruse. These are the discoveries of experience, like the use of litmus and indigo as "shadowinge blewes" around the temples and cullen

(Cologne) earth, umber, ocher de ruse, and soot for various sorts of "heire cullor" (pp. 33, 34). Given the painstaking labor and the expense of producing his colors, Hilliard is unsurprisingly concerned with their preservation.

> Noate also that velvet blacke after it is drye in the Shell, it worketh never more soe weell, as at the first grinding or tempering, wherfore for principall workes, and even for the Centor of the eye, being but a littel tytle, I use always to temper a lyttle one my grinding stone, having it always in powder ready grinded, washt, and dryed for store, Soe use I to have most of my other cullors, that I may easely temper them with my finger in a shell, adding *Gume* at d[i]scretion/ soe have I them all-wayes cleane and fayer and easyer to worke./ Thus a limner should doe, but for sparing time and cost, some usse to worke out of theire ould Shells of cullors, thoughe they be naught and dusty. (p. 32)

There we see the exacting craftsman;[7] the artist still eludes us.

Although *The Arte of Limning* leaves Hilliard's gift for drawing unexplained, it suggests another aspect of the miniatures' appeal: human psychology. He attempted to portray, after all, not just physical person but personality. To capture the private face of his sitters—the "grace of countenance" he sought—required sufficient rapport for composed self-presentation. Hilliard's career depended on relationships with people of rank and means; some of his most memorable portraits demonstrate considerable success in establishing trust. The treatise confirms the conscious effort needed to kindle such communion between subject and limner.

The first problem is posing the subject, for "ill setting of the party drawne"—so that he or she moves too easily—is "the greatest cause of leesinge the liknes in pictures" (p. 25). As an afterthought to the treatise, Hilliard suggests that sitters "be well resolved with themselves before hand, with what grace they would stand, and seeme, as though they never had resolved, nor weare to seeke, but take it without counsell" (p. 45). To achieve such studied élan, he strove for an atmosphere congenial to his cultivated sitters. "*Discret* talke or reading, quiet merth or musike ofendeth not, but shortneth the time, and quickneth the sperit both in the drawer, and he which is drawne" (p. 22).[8] Staving off boredom serves not the courtier's whim but the painter's fundamental requirements. Thus when the head was done Hilliard allowed his subject a well-reasoned change. "After you have proportioned the face, let the

party arise, and stand, for in sitting, fewe cane sit very upright as they stand, wherby the *Drawer* is greatly deceived" (p. 45). Albeit tactfully, Hilliard chivvied those who sat for him into the composition of his choice. *The Arte of Limning*'s closing image of a Hilliard sitting suggests that, despite his music and laughter and his suave conversation, he kept a good measure of control:

> tell not a body when you drawe the hands, but when you spie a good grace in theire hand take it quickly, or praye them to stand but still/ for commonly when they are towld, they give the hand the worse and more unnaturall or affected grace. (p. 45)

Representation of hands in Hilliard miniatures often suggests, however, that he was unable to benefit from his own insight.

The charm or swagger of many Hilliard miniatures is due in some degree, of course, to the wishes of his sitters. Their rank and his commissioned status in most cases demanded a certain deference. Sometimes an elevated pose was called for: "if hee be a very highe person, lett him sitte a littel above, because generally men be under him" (p. 45). The demands of the collaboration could be exasperating; one cause for a defect, Hilliard says, may be "some speciall device or affection of the stander to be drawne in so standing" (p. 30). Inevitably, the question of flattery arises. Accepting Hilliard's commitment to paint "his best graces ... which giveth us such pleasinge" (pp. 22–23) and the idealistic tradition in which it stands,[9] we may still wonder whether self-interest caused him to prettify. Compared to the several extant large-scale paintings of Hilliard's fellow west-countryman Sir Walter Ralegh, for instance, the miniature (Plate 10) is outrageously handsome, unconcerned with a character of quicksilver and flint. In fact, it bears so notable a resemblance to Hilliard's self-portrait (Plate 2) that an unusual current of sympathy may have passed between them. And Elizabeth's decision to remain forever youthful in her public presentation means that, while the ornate encrustations of her dress grow increasingly lavish at Hilliard's hand, the face becomes a bland mask with no truth in it. Hilliard did not so much bow to convention—and command—as turn his Queen into a jewel, a hard and polished, many-faceted image of wealth and might.

The Arte of Limning shows Hilliard as a bit of a snob. He reveals obvious pride in his acquaintance with Ronsard (p. 19) and with Sir Philip Sidney, "that great scoller, and excelent *Poet*, great lover of all vertu and cuninge" (p. 27).[10] Yet his admiration for Sidney seems genuine; it was, after all, much

shared. He may be merely circumspect in his modesty before the Queen—"which to speake or writ of, weare fitter for some better clarke"—when he claims she "greatly bettered my Jugment" (p. 29). But he also cites the taste of the gentleman who "seeth an exelent precious stone, or diserneth an exelent peece of musike with skill indeede and is . . . moved above . . . the vulger" (p. 23), and he repeatedly accepts criticism from "the better and wiser sort" but not "the Ignoranter and basser sort" (p. 35). With Sidney, Hatton, Robert Devereux, the Earl of Essex, and their imitators displaying Italianate *sprezzatura* around the court, Hilliard could hardly fail to become an interpreter of that aristocratic aplomb.[11] Belief in his truthfulness is certainly encouraged by the sullen, almost libertine expressions he recorded on some of his men (Plates 8, 19). Ultimately, his vision of human beauty was a bright one. He almost assumes that complexion will be "faire and beautiful," he uses *grace* virtually as a synonym for *expression,* and he often finds a countenance "sweet." He is a painter of "the most beautifull creaturs"—that is a part of his appeal.

Hilliard's greatest success at capturing fleeting expressions lies in his portraits of women. The affection with which he gazed on English ladies is cheerfully apparent throughout *The Arte of Limning*. Though Italians are lovely,

> rare beautys are even as the diamons are found amongst the savage indians, more commonly found in this yle of england then else where, such surely as art ever must give place unto. (p. 21)

Through Hilliard's pencil, art did its best. Here lies not only his best opportunity to portray the fair, but—he says—his greatest danger as well. The limner must "behould, and very well noate, and Conceit to lyke, soe that he can hardly take [the glances] truly, and express them well, without an affectionate good Jugment, and without blasting his younge and simpel hart, although (in pleasing admiration) he be very serious" (p. 23). Given such natural responsiveness, a limner should be "in hart wisse, as it will hardly faill that he shalbe amorous" (p. 23). The question again arises: should we take Hilliard's statement at face value? Hilliard was past fifty when he declared the painter's romantic susceptibility. Moreover, the conceit is antique: Pliny narrates how the great Apelles fell in love with a slave of Alexander's while painting her, a story that could have reached Hilliard's orbit through Castiglione's defense of painting as a necessary accomplishment for gentlemen.[12] Hilliard's remarks thus stand in a long tradition; indeed, they may reflect a literary commonplace, for Shakespeare's Bassanio exclaims over "fair Portia's counterfeit,"

> But her eyes—
> How could he see to do them? Having made one,
> Methinks it should have power to steal both his,
> And leave itself unfurnish'd.
>
> —*Merchant of Venice*, III.iii.123–26.

Is the sentiment therefore necessarily false? As Pope-Hennessy has remarked, "the limner, for the most part a purveyor of love tokens, must be capable of sensing the longing which his portrait was designed to satisfy."[13] The evidence that Hilliard had a full measure of that capacity lies in his limnings.

The miniatures of young women, often anonymous, amply demonstrate Hilliard's affinity for the feminine personality. Their intimacy is not limited to their small size. The faces are defined but rarely tense, the lines distinct but never hard, and the subjects' eyes meet the spectator's examination far more often than in the portraits of great Elizabethan names.[14] The feminine portraits required special effort, for the relative delicacy of features made the greatest demand on Hilliard's modeling technique. On a miniature scale, moreover, fine definition of feature could easily lead to insipidity or a certain sameness among the fashionably dressed ladies. It is a triumph of Hilliard's psychology, of his ability to coax from a woman her most attractive aspect, that each is a recognizable individual. Mrs. Holland, for instance, displays a piercing intelligence and composure in her cool pallor, finely shaded temples, and serene lips (Plate 13). She is the total aristocrat, secure in her slim elegance, the sort of lady-in-waiting who could make Elizabeth feel old and gauche.

Hilliard recognized that every woman is not beautiful, that some may be "to palle, too red, or frekled &ce" (p. 29). Thus another lady (Plate, p. 2) is sallow in complexion and rather blunt of feature, notably in her nose. Hilliard has done his best to place her in a design of special beauty, but he admits that she is not pretty. Admirable character, however, is suggested by the intense head tipped slightly forward, the not unfriendly mouth, and the earnest gaze that reserves judgment. In contrast a third lady—though fully framed by her perfect curls, perfect ruff, and black-and-white fabrics and bows—looks out at us with amiably shy eyes, a demure mouth that is not quite complacent, and hints of a snub nose and a plump double chin (Plate 9). Her extreme youth and self-satisfaction escape the confines of her formal attire, and we are free to conjecture her an eager bride. Whether the portrayed personality accurately represented the living woman we cannot know. But each of these

women revealed something to Hilliard; their variety affirms the quality of his insight.

Despite Hilliard's close observation of the facial changes that make up a smile, every observer will notice that, by modern standards, most of Hilliard's subjects do not smile but offer the steady gaze of repose. Only a slight upward turn of the mouth occasionally appears, and it is more prim than merry. We must recall, however, that sitting for a Renaissance portrait was a solemn matter, as serious as photography in its earliest days: the subject wished to be depicted for posterity in a typical expression. The open grin—the matter of a moment—would not appear in portraiture until Frans Hals. Renaissance viewers knew how to deduce personality from small variations in detail; thus the poet in *Timons of Athens* compliments the painter with a connoisseur's eye:

> How this grace
> Speaks his own standing! What a mental power
> This eye shoots forth! How big imagination
> Moves in this lip! To th'dumbness of the gesture
> One might interpret.
>
> —*Timon of Athens,* I.i.31–35

Under such constraints, Hilliard's gift for presenting character with a perception that can rise to the lyrical is the more admirable. Though he idealized his subjects to some extent, we should be grateful for that revelation of gracious aristocrats. Otherwise, dependent on the monumental state portraits of Elizabeth's functionaries marching down gallery walls, we would have no notion of what moved an Astrophil or why Daniel loved his Delia.

The effect of a Hilliard miniature is not based wholly on the scale, delicacy, and psychological insight of the portrait, although all contribute. Part of its stylized impression lies in the representation of gold, silver, and jewels decorating the sitter, and the whole is often set within a gold and jeweled setting. As a goldsmith, Hilliard happily claims this aspect of his art. Indeed, the initial point of distinction for limning as "a thing apart from all other *Painting* or *drawing*" is that it excels "in giving the true lustur to pearle and precious stone, and worketh the metals *Gold* or *Silver* with themselfes" (p. 16). The thesis must have preoccupied him, for he interrupts his discussion of black pigments to reassert, "Take this for a generall rule, that *Lymning* must excell all *Painting* in that . . . it must give evry thing his proper lustre as weel

as his true cullor light and shadowe" (p. 32). Reflection, radiance, appropriate glow—all to be achieved with water-based paints—are the accomplishment of a Hilliard miniature.

The use of gold is a *retardataire* touch, recalling manuscript illumination as one principal source for the limner's art; by contrast, it is no part of the humanist vision of the individual and his world that inspired vivid portraiture in Italy.[15] Hilliard, however, sought to delight the eye. Casually the treatise announces, "liqued goolde and Sillver must not be tempered with the finger, but only with the penssel . . . and with a pretty littel toothe of some Ferret or Stote, or other willde littele beast" (p. 36). The gold most visible in the miniatures is the calligraphy with which, well into his mature period, Hilliard dated and initialed his work and indicated his subject's age. Etched in a fine Italian hand[16] against a flat blue bice surface, these lovely tracings create a cameo effect (Plates 19, 22). Throughout his works, particularly in portraits of courtiers, Hilliard applies touches of gold that add literal brilliance to the buttons and threads and chains of costume with such discretion that the gilding is not easily revealed when the miniatures are displayed in a museum case or in reproduction. But when the painting shown in Plate 15 was held in the hand and turned in the light, how the gold-flecked flames must have climbed! Hilliard consciously used gold for highlighting alone, as we may deduce from his 1606 request to trim the late Queen's tomb: "as a Goldsmith, I understand howe to set foorthe and garnishe a pece of stone work, not with muche gylding to hyde the beawty of the stone, but where it may grace the same and no more."[17] Sparingly, the limnings include gold.

The effect desired by the Elizabethan age is achieved, in *The Arte of Limning* as in the miniatures, not only by jeweled settings but by jewels limned into pictures and pictures limned in jewel colors. Why? "For whoe seeth an exelent precious stone . . . and is not moved . . . with an amorous Joye and contentment?" (p. 23); the ruby "afecteth the eye like burning fyer" (p. 39); "if one looke longe into it, [the diamond] hath many cullors radient and strange"; "so lucyde and bright, as having his due forme, his splendor or light" (pp. 44, 43). Hilliard's fascination with deep color, sparkle, and symmetry is inescapable. Gems are the tools of his daily trade, and he values them most for their purity of saturated color. He defines his palette in jewel tones: the ideal colors are amethyst, sapphire, emerald, topaz, and ruby—best because brightest, rarest, and truest in hue. Like the rainbow, gems "sheweth the naturall mixture of cullors, and a sweete and agreeable varietie in their mixtures . . . in such a kindly beautifull order, as all the art of the worlde

cannot amend it" (p. 38). Precious stones are as real and natural as flowers, with the added virtue of transparency. Nature makes sapphire the perfect blue in "brightness of watter"; nature commends to us the ruby "like the kirnelles of very ripe *Pomegranat*"; "*Emrod* is the most perfect greene on earth growing naturally" (pp. 40, 42). To Hilliard, these stones are elemental. Gems are not mere ornaments to enhance his sitters, but an important part of the reality he paints.

In the treatise, the drawing of features receives little more attention than the painting of gems that catch and hold the viewer's eye.

> Sattine seruce grinded with oyle of whit popy, whitneth upp pearles in oyle coullors most excelently, and . . . is long in dryinge, this is an experience of mine owne finding out. (p. 31)

> Give the light of your Pearle with silver some what more to the light side then the shadowe side, and as Round and full as you cane, then take good whit delayed with a littel *Masticot,* and underneath at the shadowe side give it a Compassing stroke which showes the reflection that a Pearle hath. (p. 36)

Alum and sugar candy can simulate the hard brilliance of crystal, and so on. Hilliard is uneasy about his mastery of these techniques for painting gems "that being never so littel they seme precious Stones naturall, cleere and perspicuous" (p. 34). The talent is not part of the rigorous art that is limning, but a minor decorative skill, like that of a carpenter who paints friezes on his products. Nonetheless he exercises it fully, building up a thick impasto of bright pigment on burnished silver.[18] So important is a dramatically jeweled effect that in the Welbeck Abbey frontal miniature of the Queen in coronation robes he has even imbedded a tiny diamond into the cross on her royal orb (Plate, p. 64).

Gems are only one aspect of a particularistic aesthetic that permeates Hilliard's miniatures. The disposition of each detail becomes equally significant: the eyes as sparkling as the diamonds, the proportions of features as orderly as the symmetrical pendants, the complexion as fair as the lace, the hair as distinct as embroidery threads. Jewels detract from personality no more than mannered clothing blurs social state; rather, both add to the richness of image. The face so framed is rarely subordinated in interest. As his jeweler tells Timon of Athens, "Believe't dear lord, / You mend the jewel by the

86

wearing it" (*Timon* I.i.172–73). The effect of the jeweler's hand on the painter's composition is especially visible in the bravura portraits of Elizabeth (Plate 16). In carefully symmetrical rows, chains circle the Queen's neck, pendants descend her bodice and climb her balancing headdress, earrings join curls in circling her face, and every gem on the framing ruff radiates from the regal features. The jewels set her skin and her hair aglow, and they draw our eyes to hers. One long line sweeps upward from the gem-studded rosette on her bosom along the arch of her nose to the gem-studded center of her coronet. In its opulent encrustation with *trompe l'oeil* jewels, the whole makes a perfect pattern. The Queen's *grande tenue* has become her beauty and her strength.[19]

For Hilliard, finally, jewels have a psychological value. The absence of purple from his palette gives an indication: "french men rightly terme it *Annatist le plus triste,* a sade malancholy cullor, delighting but some humere, and fitting to porpose but one some fewe occasions" (p. 39). Such was rarely Hilliard's humor.[20] But the analogy of faultless gems to men of constant character and flawed gems to triflers brings out a rueful note:

> I might well resemble these Stones unto us mankind, wherof Some be excelent and precious, and the common sort at first wiewe are like also unto them/but if you marke them weell, you shall find them mixed cullors, dissembler softe Stones, not able to endure nor comprehend Scyence nor valorous deeds, and as a good Stone maye bee yll set, and ill used soe that hee is Sould for naught; soe a good Servant nor used in his kinde, falleth frome the Ignorant to a better master, and that as I said, If the base Stones be greeat, they are esteemed, whoe doubts of that, it is the like of me. (p. 43)

We may wish for Hilliard's sake that Elizabeth had better valued her best jewels.

The northern strain in Hilliard's personal taste and artistic training, his commitment to the natural in its most glamorous aspects, and his goldsmith's hand—these give the miniatures an integrity beyond their artifice. Hilliard's contemporaries were pleased with the handsome designs that glorified their mortal faces; the facility needed to capture distinction in a few lines and colors took him to court, and his jeweled limnings in their glittering cases have survived because they found a role in the polished civility of court culture. We cannot grasp the miniatures' full meaning without examining their place as *objets d'art* in a stylized society commanded by the Queen.

The Setting for the Miniatures

 When Elizabeth succeeded to the throne in 1558—Nicholas Hilliard's twelfth year—England was remote from sophisticated centers of Continental culture. Religious conflict had divided the country for twenty years and exacerbated the hostile ambitions of France and Spain; the Anglican settlement was still to come. The reign of the young Queen without husband or heir, many of whose subjects questioned her legitimacy, seemed vulnerable to swift extinction. An era of stability and growth in which all the arts might flourish was utterly unlikely.[1]

During the years when Elizabeth I ruled and Hilliard flourished, the population of England grew by more than twenty-five percent, from between three and four million to more than five million, while London's population doubled from 100,000 to nearly a quarter-million as people, driven alike by agrarian crisis and by ambition, rushed to town. Among the swarming thousands, those that history records—the Drakes and the Raleghs, the gentry and nobility who competed for offices and so had some say in the country's affairs—numbered perhaps five thousand. About a thousand people lived at Elizabeth's court by the 1570s, perhaps two hundred her attendant lords, ladies, and household officers, the remainder royal huntsmen, grooms, and servants such as Nicholas Hilliard. William Cecil—Elizabeth's Principal Secretary, later Lord Treasurer, and co-architect of her reign—privately estimated that of eight hundred wealthy landowners fewer than a hundred peers and ambitious gentlemen had genuine political power. Offices and, to a large extent, events were governed by a system of royal and noble patronage that provided the favored with licenses, monopolies, charters, and other grants by letters patent that permitted the holders to collect fees, rents, and tariffs. Such grants, the functions *and* income of which conferred status, were won by successful suitors at court (including "new men" of talent and promise as often as scions of the aristocracy) whose interests were thus bound by the Queen's whim. Elizabeth, intermittently guided by Cecil and others in the privy chamber, deployed the resources of patronage brilliantly—indeed, she raised royal favor to an art.

Finances both public and personal were an incessant issue in court life. Henry VIII's devaluation of the currency; the influx of capital from the sale of Tudor-confiscated Catholic holdings; the release of precious metals from the New World aided by intrepid English privateers; the ruinous costs of eighteen years of continuous war in the Low Countries, France, and Ireland

required by Elizabeth's carefully shifting international allegiances; above all the relentless pressure of an exploding population on food and other necessities in a preindustrial economy with a faltering wool trade—all these factors combined to produce critically severe inflation, part of a general European price revolution, throughout the latter half of the sixteenth century. Many of the oldest families became virtually land-poor, unless they chose to rack their tenants; a young aristocrat could watch his fortune dwindle and disappear while he waited to inherit, and the unscrupulous grew rich all around him.[2] Fortunes were to be made by the enterprising, not least merchants who could purchase estates and aspire to gentle status. A craftsman like Hilliard, reliant on his labor and ingenuity rather than on capital and constantly in need of costly materials, was easily forced into debt, bankruptcy, and suits to such powerful patrons as Burghley's son and heir, Robert Cecil.[3]

Despite the price paid by ordinary Englishmen, burgeoning wealth from land speculation and nascent manufacturing and mining permitted the expenditures on luxury and comfort, on learning and the arts, that created the flowering of Elizabethan culture. The support of the Queen and her principal favorites—Robert Dudley, Earl of Leicester, Essex, and others raised to exalted place—underwrote poets, playwrights and actors' companies, musicians, and architects on an unparalleled scale. Men of talent but no resources were supported in producing new beauties; men of position like Philip Sidney and Walter Ralegh were encouraged in seeking artistic expression. Because of such patronage, in good part, we remember Elizabeth's court: the gracious sovereign with her caparisoned cavalcades, the spacious days in which men celebrated the *pax Elizabethiana* by building great mansions and comfortable houses, planting broad acres, laying the foundation for a modern state. To be sure, the writings of the 1590s make clear that the cosmetic shimmer of royal progresses and military campaigns only masked the turbulence that marked people's lives. But the arts, not least Hilliard's limnings, preserve the elegant façade of this undemocratic demi-nation.

Elizabeth had sound precedent for the creation of an elaborate court style, graced by the arts, in the example of her father. Henry VIII had succeeded to a throne backed by the largest personal fortune any English sovereign had known, and from the outset he lavished his resources on generous patronage of composers and musicians, of the architects and decorators of Hampton Court and Nonsuch, and of chivalric pageantry. Already in 1513 the Twelfth Night revel—a holiday later much favored by Elizabeth—included, Hall's chronicles tell us, disguises "after the manner of Italy called a mask, a thing

not seen afore in England."⁴ Indeed, Henry founded the Office of the Revels, a state department commissioned to organize Tudor pageants and masques. He enjoyed neomedieval playing at war in tilts and tournaments according to the code of knightly combat, in emulation of the old Burgundian court. The zenith of such chivalrous spectacles may have been his contest with François I on the Field of the Cloth of Gold at Guisnes in 1520, a festival of processions, banquets, masques, tournaments, and fireworks. Holbein himself was not above designing ornately patterned armor to decorate these nostalgic jousts, an ornamental gatehouse for Whitehall, and jewelry. Dazzling personal adornment—in silver damask, white satin, and gold tissue, decked with liquid pearls, twinkling rubies, and massive gold—may have been Henry's most powerful symbolic legacy to Elizabeth.

On January 14, 1559, Elizabeth entered the City of London in her first procession as Queen, and the next day, Sunday, marked her Coronation; on both occasions she wore the costume depicted in Hilliard's early miniature (Plate, p. 64), painted at least a decade later. The Mantle of State and kirtle (dress), preserved from Queen Mary's coronation in 1553, are described in the 1600 Inventory of the Wardrobe of Robes:

> The Coronation Robes: one Mantle of Clothe of golde tissued with golde and silver furred with powdered Armyons [ermine] with a Mantle-lace of silke and golde with buttons and Tassels to the same . . . [and] . . . one kirtle of the same tissue, the traine and skirts furred with powdered Armyons the rest lined with Sarceonet, with a paire of bodies and sleeves to the same.⁵

The fabric, as we can barely discern, is yellow-and-cream silk woven with silver metal loops and silver gilt threads in a design of rose sprays and fleurs-de-lis, and the jewels prominently include at the center of the collar a Tudor rose of red and white enameled petals set in gold. The crown (presumably Elizabeth's personal crown among the three used in Tudor coronations) covers a crimson velvet lining with diamonds and pearls on each arch, a border alternating gold crosses set with sapphires and fleurs-de-lis set with rubies, a circlet of rubies, sapphires, and pearls, and a major ruby to crown it all. Accounts at the Exchequer record the seemly state in dress prescribed for the forty ladies and thirty gentlemen who escorted Elizabeth: crimson velvet with cloth-of-gold sleeve linings for the highest ranked, crimson satin for the middling state, crimson damask with velvet linings for commoner servants. In this

blaze of glory, nothing is forgotten, whether "Apparrell of Tinsel" for "The quenes Fooles" or "Cotton Wolle To drye upp the oyle after the quene is annoynted."[6]

This regal vision was by no means limited to gentlefolk. On the day before the Coronation, Elizabeth was carried in an open litter through the city from the Tower of London to Whitehall—through Fanchurch, "Gracious Streate," Cornhill, Soper Lane, Cheapside, "the little conduit," past Paul's Churchyard, toward Fleetbridge, past St. Dunstan's to Temple Bar, and on to Westminster—receiving the greetings and homage of her people. The pamphlet *The Quenes Maiesties Passage through the Citie of London to Westminster*, published ten days later, demonstrates the political masterstroke in this festive event. Every carefully orchestrated pause included a pageant or "dumb show" on the set pious and patriotic themes of the Tudor dynasty: the union of York and Lancaster into one single rose (an Elizabeth like her grandmother, Henry VII's queen), the four virtues of governance (pure religion, love of subjects, wisdom, justice) treading upon the contrary vices, the beatitudes (meekness, mourning, peacemaking, and the rest) visible in Elizabeth's past, Christian truth revealed as the daughter of time, an analogy to "Debora the judge and restorer of the house of Israel." Always there was music and "orations" by children to interpret the spectacles, always the Queen turned aside to attend them, always she proffered humble thanks for gifts of English and Latin verses, an English Bible, a thousand marks in gold in "a purse of crimosin sattin richly wrought with gold." The pamphleteer proudly underlines both the achievement of the grandly arrayed merchant companies of the City "whiche without anye forreyne persone, of it selfe beautifyed it selfe" at "the cities charge, that there was no coast spared," and the gracious acceptance of the monarch, "no lesse thankfullye to receive her peoples good wille, than they lovingly offred it unto her," with special kindness to "the baser personages [who] offred her grace any flowres or such like."

With its emphasis on concord, justice, and mercy, the progress was a Protestant love feast, and a consciously dramatized one: "If a man should say well, he could not better tearme the citie of London that time, than a stage wherin was shewed the wonderfull spectacle of a noble hearted princesse toward her most loving people."[7] From this first moment, Elizabeth used the combination of majestic impact and personal appeal as a tool to bind her people to her, a tool both effective and original. To all, the Queen's grand dress was an outward and visible sign of her inward, invisible grace.

Elizabeth began with the political artistry she meant to sustain throughout

her reign. Within a decade the anniversary of her accession, November 17, was celebrated as a major national festival, with bellringing, bonfires, thanksgiving prayers, schoolmasters' pageants, free cakes and wine, and collegiate orations across England. In 1576, the Church added the day to its rota of Holy Days, to observe and celebrate salvation from papistry;[8] in a more classical vein, scholars and poets lauded Elizabeth in masques as Astraea, Diana, Cynthia, Laura, Gloriana, . . . the maiden Queen. She continued to exhibit herself to her people, in fabulous splendor, during daily processions from Presence Chamber to Privy Chamber, from Greenwich to Whitehall by barge, from Whitehall to Windsor by coach of red leather studded with silver gilt nails.[9]

Most far-reaching of her gestures were the famous summer progresses— every year between 1559 and 1579 (except 1564) and again in the 1590s— through the countryside of southern England, making a virtue of the necessity to leave unsanitary, fever-ridden London by accepting courtly entertainment at the elegant new manor houses built by her newly elevated and enriched courtiers. "It pleaseth her in the summer season to recreate herself abroad, and view the estate of the country, and hear the complaints of her commons injured by her unjust officers,"[10] reported William Harrison, canon of Windsor, though the judicial note is hardly striking in his account of four hundred baggage carts and twenty-four hundred horses. Nor does it characterize the stylized dumb shows of the victory of Chastity, Modesty, and Temperance over Cupid, composed by Thomas Churchyard for the royal visit to Norwich in 1578, or the Arthurian emblems and romance decor designed for seventeen days of "Princely Pleasures at Kenelworth Castle," Leicester's residence, in 1575.

The chief note was unparalleled physical splendor. Sir William Spring, Sheriff of Suffolk, went out to greet the Queen with "two hundred young gentlemen, clad all in white velvet, and three hundred of the graver sort apparelled in black velvet and fair chains . . . with fifteen hundred serving men more on horseback, well and bravely mounted . . . which surely was a comely troop."[11] Not only munificent display but also generosity on a major scale was expected of a noble host. "The Queene visited my house at Mitcham, and supped and lodged there, and dined there the next day," one knight laconically notes. "I presented her with a gown of cloth of silver richly embroidered; a black network mantle with pure gold, a taffeta hat, white with several flowers, and a jewel of gold set therein with rubies and diamonds. Her

Majesty removed from my house after dinner the 13th of September with exceeding good contentment."[12]

The Queen's delight in such rich gifts, especially jewelry, is amply documented in the extant lists of New Year's gifts she exacted from her courtiers. Many of the presents in the early years, especially the offerings of the ranking noblemen and bishops of the realm, are money presented in embroidered silk and satin purses; the total sum for 1562 was £1,262.11.8.[13] (In return, she presented covered bowls, cups, and smaller trinkets of gilt, weighed by the ounce.) For the years 1572 through 1594 when the fashion had changed, however, there exist lists of sumptuous jeweled presents that must have beggared their donors, the leading favorites of the hour.

Juells . . . given her Majestie on Newe-yeres daye, anno 14° regni sui, &c.:

First, one armlet or skakell of golde, all over fairely garnishedd with rubyes and dyamondes, haveing in the closing thearof a clocke, and in the fore parte of the same a fayre lozengie dyamonde without a foyle, hanging therat a rounde juell fully garnished with dyamondes, and perle pendant; weying 11 oz. qua dim. and farthing golde weight. In a case of purple vellate all over embranderid with Venice golde, and lyned with greene vellat. Geven by therle of Leycetor.

Item, a juell of golde, being a branche of bayleaves, and thearupon a rose of golde enamuled white, with a fayre ballas in the middes, and six red roses, about the same, every of them haveing a lozengie dyamond. In the toppe of the rose is a spyder, having a lozengie dyamonde on her backe; and under the same rose, a bee with two dyamondes on her; weying 3 oz. dim. q^a. Geven by therle of Warwycke. . . .

Item, a payre of braceletts of gold, enamuled, and garnished with five agathe hedds and five mother of perles, the peece; 2 oz. dim. q^a. Geven by Lord *Stafforde*. . . .

Item, a flower of golde enamuled, having a pauncy with an amatast lozengye and two daysyes, in the one of them a rubye, and in the other a dyamond, with a butterflye betweene them; 3 q^a. dim. of an ounce. Geven by the Lady *Cheake*. Geven by her Majestie to Mrs. *Lucye*.

Item, a fayre juell called pyzands of gold, fully garnished with ru-

93

byes and dyamonds, and flowers sett with rubyes, with one perle pen-
daunte, and another in the toppe; thre ounces dim. Geven by Mr. *Hat-
ton,* Esquier.[14]

Staggering as these records are in their minute detail, it is notable that
they take no account of limnings. Occasionally a hint arises, among the em-
broidered sleeves, smocks, and petticoats given by ladies and lesser gentlemen:

> By Mrs. *Levina Terling,* the Queen's
> personne and other personages,
> in a box fynely painted.
> With her said Majestie.
>
> By Mr. *John Yonge,* a table paynted
> in a frame of wallnuttree, and
> certeyne verses about it of
> money: and a round piece of silver.
>
> The table delivered in
> charge to *George Bredeman,*
> Keeper of the Pallace of
> Westminster; the peice of
> silver with the Queen.[15]

Elizabeth clearly kept the items of value. This moment in the political dance
of court life, then, may be the setting for the Elizabethan miniature.

Independent information about the intended purpose of the miniatures is
little to find and hard to sift. *The Arte of Limning* is scant help, for Hilliard
makes no more reference to the destiny of his work than casually proclaiming
it "fittest for the deck[ing] of princes bookes or to put in Jewells of gould"
(p. 16) and defining its lighting by the need "to be veewed of nesesity in hand
neare unto the eye" (p. 29). To their sittings the Queen too brought prior
assumptions. In one of the households where she spent her difficult, threatened
youth, the Calendar of State Papers records, her last stepmother Queen Cath-
erine Parr ordered small portraits and gave them as remembrances to those
close to her, such as Edward VI and her future husband Thomas Seymour,
who wished "to thinke on the ffryndly chere that I shall reseive, when my
suight shalbe at an end." Edward and Elizabeth also engaged in such an

exchange, the sister assuring the young king in an accompanying letter that time would not fade her affections as it might the color.[16] Only the letter with its rather conventional expression remains to demonstrate her acquaintance at an impressionable age with such declarations of a politic sentiment. To aid our understanding of her mature aims, the only sources are incidental anecdotes in contemporary accounts and depictions by sixteenth-century painters themselves.

The diplomatic use of portraits was by no means an Elizabethan invention; for decades, ambassadors traveling between Continental courts had carried paintings of their sovereigns virtually as calling cards. Records show that Elizabeth continued this practice with a variety of embassies, over the years dispatching full-scale portraits to Archduke Charles of Austria, Frederick II of Denmark, Catherine of Navarre (this one gallantly intercepted by her brother, Henri IV of France), and even—carved on a gemstone—to the Czar of Muscovy.[17] Thus in *The Arte of Limning* Hilliard can confidently assert as a matter of course that it is "for the service of noble persons very meet ... to have the Portraits and pictures of themselves their peers, or any other forraine [dignitaries]" (p. 16). Their special value in the negotiation of state marriages, common throughout the Tudor reigns and notably employed in Elizabeth's lengthy "courtships" with Eric of Sweden and the Valois sons of Catherine de' Medici, easily extended the potential romantic associations on which she could play.[18]

The earliest documentary reference to miniatures proper nicely conflates diplomacy and courtship. In 1564 Sir James Melville, ambassador to London from Mary, Queen of Scots, reported that Elizabeth "took me to her bedchamber, and opened a little cabinet, wherein were divers little pictures wrapped within paper, and their names written with her own hand upon the papers. Upon the first that she took up was written, *My Lord's picture*. . . . She seemed loath to let me see it; yet my importunity prevailed for a sight thereof, and found it to be the *Earl of Leicester*'s picture. I desired that I might have it to carry home to my Queen; which she refused, alleging that she had but that one picture of his. I said, your Majesty hath here the original."[19] So, like any woman in love, Elizabeth cherished the image of her then and longtime favorite, the Earl of Leicester (Plate 12); so, too, she had begun a collection. In 1566, the observant Spanish ambassador recalled seeing Elizabeth wear, on a long, gold chain suspended from her waist, a miniature painting of Mary of Scotland, then within months of her son James's birth and her forced abdication.

Across subsequent decades of diplomatic history there appear similar examples of the formal display of miniatures of Elizabeth. In 1577 the English agent Dr. Wilson told her that Don Juan of Austria was "moche pleased" at Fulke Greville's miniature of the Queen; in 1585 Lord Willoughby sent home news that the King of Denmark continually wore her picture "within a tablet of gold"; Robert Cecil, visiting Henri IV in 1598, "passed the time in familiarity, both in discourse of the Queen and her Court, showing to divers the picture I weare"; Sir Henry Unton, after a similar visit to Henri's court, declared that his miniature of the Queen had had greater effect than all his eloquence. "[I] offred it unto his Viewe verie seacretly, houlding it still in my Hande: he beheald it with Passion and Admiration . . . protesting, that he never had seene the like; so, with great Reverence, he kissed it twice or thrice."[20] Romance transcends statesmanship. What began as novelty had thus, by the closing years of Elizabeth's reign, become the occasion for a new form of conventional flattery. The documents remain to us not from any connoisseur's motive, but from self-interest in the prudent courtiers who recorded them.

Visual evidence for the display of limnings, particularly those intended to be worn, offers a more convincing account of the studied role they played in court culture. Indeed, modern understanding of Elizabethan iconography and ceremonial splendor draws much of its power from such images as Marcus Gheeraerts's emblematic "Ditchley" portrait of Elizabeth (1592), commissioned for a lavish regal entertainment offered by Sir Henry Lee, her Master of the Armoury, and Robert Peake's *Queen Elizabeth Going in Procession* (c. 1601), celebrated by her last Master of the Horse Edward Somerset, Earl of Worcester.[21] The use of art objects to decorate clothing evolved gradually in portraiture across the Tudor reigns. Holbein's full-scale paintings of Anne of Cleves and Jane Seymour provide a model for lavish, symmetrical jewelry, and portraits of Mary I by Eworth and Antonio Mor reveal a massive, reliquary-like jewel with pendant pearl, suspended from a pearl choker and jeweled cross. Depictions of Elizabeth show her wearing the Lesser George of the Order of the Garter, the Phoenix, Pelican, and Three Brothers jewels after which monumental portraits are named, and all manner of cameos and huge gems *en cabochon*. The wearing of identifiable portraits emerged in the 1560s at the hand of Steven van der Meulen, who shows "picture boxes" suspended from chains around ladies' waists and—sometimes covered by a Tudor rose— from ribbons or chains around the necks of gentlemen, including Sir William Petre and Leicester.[22] Extant examples of an Elizabethan locket case opened to reveal a limning within are rare—George Gower's oil portrait called *Lady*

Walsingham in the collection of the Viscount De L'Isle, dated 1572, is one such.[23]

Hilliard's miniatures themselves, preserved as accoutrements that sometimes rewarded valor and service, tell us something of the role they played. In 1579, the Queen gave Sir Francis Drake an enameled and cameoed gold jewel surrounded with rubies, diamonds, and pendant pearls, containing her portrait by Hilliard and her Phoenix emblem of virginity and strength renewed; Drake can be seen wearing it—with the miniature hidden under the cover—in an oil portrait in the National Maritime Museum, Greenwich. When Sir Thomas Heneage raised an army to counter the Spanish invasion in 1588, Elizabeth acknowledged his defiance with the Armada jewel—now a treasure of the Victoria and Albert Museum—containing her portrait and an emblem of the ark, safe in a sea of danger.[24] The memorial picture (c. 1596) in the National Portrait Gallery of Sir Henry Unton, soldier and tireless ambassador, shows him wearing a portrait of Elizabeth as a badge of office, surrounded by the narrative of an eventful life to which royal service gave meaning.[25] The portraits in these magnificent gifts are as symbolic as the *imprese,* declarations of a grateful nation embodied in its Queen.

Only a minority of Hilliard's limnings, however, were summoned to fulfill such symbolic functions, just as a minority of his sitters were distinguished Elizabethans. We know from extant cases that some of the private miniatures were also worn on the person, but we have curiously little visual record of such adornments—only a few of Hilliard's ladies have lockets clearly pinned to sleeve or shoulder. An explanation is not far to seek: the passionate feelings that the pictures represent were personal, sometimes even illicit. Thanks to the frequently hinged covers, the contents could remain the secret of the wearer. With a *soupçon* of flirtation, the whole could then be further hidden. The Queen, we hear at second hand, once insisted on acquiring a portrait of Robert Cecil that "Lady Derby wore about her neck and in her bosom," and handsome Lord Herbert of Cherbury preened himself that a knight's wife gazed, when solitary, with "earnestness and passion" upon his portrait which "she caused to be set in gold and enamelled, and so wore it about her neck so low that she hid it under her breasts."[26] Public documents are silent about these private relations. To explore the intimate setting for Hilliard's most elusive works, we must turn to literature as a reflection of Elizabethan culture.

The place of Hilliard's miniatures in Elizabethan life must finally be deduced from the pictures themselves and from the poetry of the age. The start-

ing point, when the court is the setting, must be the Queen. Elizabeth I is the most prominent single figure in Hilliard's *oeuvre;* his images of her—and of her successor, James I—form a substantial proportion of his production. Symbols of a gracious majesty and a secure throne, his mature icons of Elizabeth are no more intended to reveal a specific woman than are modern signed photographs or the portraits of monarch and president on stamps and bank notes. "Behold the Queen!" these portraits trumpet. "Gloriana decked in glory!" Meant to achieve effortless awe, they endow their recipients with the dignity, not the personality, of the giver. This Queen is not Anne Boleyn's daughter but immortal Astraea, the legendary maiden whose coming signals a golden age of benignity and peace.[27] Head of a new church as well as a new state, she is almost to be worshiped; thus her picture in a jeweled case replaces ornate reliquaries from the old papistical days.

The image of regality was Elizabeth's deliberate choice. In 1563 she had drafted a proclamation that no picture of her be circulated until "some speciall person that shall be by hir allowed shall have first fynished a portraicture therof, after which fynished, hir Majesty will be content that all other payntors ... maye at ther plesures follow the sayd patron or first portraictur."[28] No mere mortal artist could do Elizabeth justice. Thirty years later, the situation had changed little; Sir John Davies's acrostic compliment observed, with truth as well as a grasp of line and light, that few dared attempt it.

TO HER PICTURE

Extreame was his audacitie,
Little his skill, that finisht thee;
I am asham'd and sorry,
So dull her counterfeit should bee,
And she so full of glory.

But here are colours red and white,
Each line and each proportion right;
These lines, this red and whitenesse,
Have wanting yet a life and light,
A majestie, and brightnesse.

Rude counterfeit, I then did erre,
Even now when I would needs inferre

Great boldnesse in thy maker;
I did mistake, he was not bold,
Nor durst his eyes her eyes behold;
And this made him mistake her.

—"Hymnes to Astraea" XII (1592)

In Hilliard Elizabeth found the "conning payntor" that she sought. Once she was satisfied with his version—traditionally said to have been sketched from life in the sitting described in *The Arte of Limning* (pp. 28–29)[29]—the pattern was forever set. Age was not allowed to wither her; she stares past her critics, brazenly remaining glamorous as truth passes with time. Hilliard must have learned to produce a passable copy almost mechanically, for in *The Arte of Limning* he refers to his own work in a reference to an anonymous painter's turning out from memory "the picture of her majestie in fower lynes very like" (p. 28).[30] With a touch like alchemy, Hilliard earned near-monopoly for his sunlit vision.

Hilliard provides a visual analogue for the metaphors of light and shadow that pervade Elizabethan poetry. The Queen herself, versifying "On Monsieur's Departure" (c. 1582), declared, "My Care is like my shaddowe in the Sune"—perhaps recalling the conversation with her limner, when she chose to turn away from all shade (p. 29). For the external wearing of inner worth, Hilliard's miniatures are matched only by Redcrosse, Britomart, Prince Arthur, and all the company of Spenser's land of Faerie. Depicting Elizabeth's image and ancestry in the mirror of *The Faerie Queene*, Spenser begged,

O pardon me thus to enfold [it]
In covert vele, and wrap in shadowes light,
That feeble eyes your glory may behold,
Which ells could not endure those beames bright,
But would be dazzled with exceeding light.

—*Faerie Queene*, II.P.5 (1590)

Enfolded in a jewel, a Hilliard depiction of Elizabeth is intended to dazzle. Even the details chime together. Spenser's Britomart reflects both the power of her own inner purity and a veiled facet of the maiden Queen when she enchants an opponent with escaping hair that

99

Like to a golden border did appear,
Framed in gold smithes forge with cunning hand:
Yet goldsmithes cunning could not understand
To frame such subtile wire, so shinie cleare,
For it did glister like the golden sand.

—*Faerie Queene* III.vi.20[31]

Like Spenser's voice, Hilliard's hand trained subtle wires into a symbolic statement of Elizabeth's magnificence.

His court portraiture did not stop with the Queen. One index of his success is the number of important men he recorded: William and Robert Cecil and Christopher Hatton from the government; Shakespeare's patron the Earl of Southampton, Fulke Greville, Francis Bacon, and perhaps Sidney from literary circles; Drake, Ralegh, and Sir Charles Blount among military adventurers. Some portraits are as formal as the Queen's late icons—Hatton takes the conventional pose in robes thick with a chancellor's rank—but some surprise us by their insight. Leicester's almost coarse features and ruddy coloring are dominated by hooded eyes and a lifted right eyebrow that express a calm hauteur (Plate 12), while the tousle-haired portrait of Drake—as prodigious in size as his globe-girdling achievement—reveals a bluff, hardy man, out of his element in stiff court dress (Plate 11). His plain-living appearance has a tonic effect among the languorous gallants. The hints of individual character that bring alive for us such long-known names as Southampton (Plate 8) demonstrate how Hilliard moved on the edge of powerful circles, observing and sketching the Queen's gentlemen.

In *The Faerie Queene*'s dedicatory letter to Ralegh, however, Spenser declares that Elizabeth "beareth two persons, the one of a most royall Queene or Empresse, the other of a most vertuous and beautifull Lady." It is no accident that Hilliard's portraits include Elizabeth's semiofficial suitors: Leicester, Hatton, Ralegh, Essex. The political masterstroke of her relationships with these men helps us understand the miniatures' role in the court's elaborate dance. Already in 1559, an anonymous poet wrote on behalf of the maiden Queen,

Here is my hand,
My dear lover England,
I am thine both with hand and heart, . . .
Until death us two do part.[32]

The bride of the nation could be pursued as well by individual men. As her reign stabilized and religious conflict waned, as the likelihood of a foreign marriage faded with her youth, the woman alone on the throne required an occupation for volatile and ambitious nobles that would bind them to her personal service. She had the wit to play upon her maidenhood and ostensible eligibility by combining the latest fad from the Continent, neoplatonic Petrarchan lovelonging, with the jousting and chivalry that Tudors used to emphasize their Arthurian origins.

Knights had, after all, competed for the admiration of ladies whose favors they wore in tournaments, a tradition happily continued. The Whitehall of Wolsey and Henry VIII included a tiltyard (in subsequent centuries the Horse Guards) for such mock-martial sports, and Holinshed's *Chronicles* note that "the first, the second, and the third of Maie, 1571, was holden at Westminster, before the Queene's Majestie, a solemne Just at the tilt, tournie, and barriers. The Chalengers were Edward Earle of Oxford, Charles Howard, Sir Henrie Lee, and Christopher Hatton, Esquier, who all did verie valiantlie; but the chiefe honour was given to the Earle of Oxford."[33] Leicester had tilted for the Queen, in armor now in the Tower of London, in the 1560s; in subsequent years, it was Sir Henry Lee who swept all before him, acting as Elizabeth's official champion against all comers in the elaborate tilts he orchestrated annually on her Accession Day. Spectacular costumes, engraved armor, and poetic emblems thinly disguised the knights—a wild or savage man in green, a fiery phoenix knight, Essex all in black, Lee in armor decked with suns, Sidney as shepherd knight—whose caparisons and homage to their ladies far outshone their military prowess.[34] Among the best visual records of these events is Hilliard's painting of George Clifford, third Earl of Cumberland (Plate 23), who succeeded Lee as official Queen's Champion in 1590. Her glove is pinned to his bonnet with a handsome jewel, his gauntlet is thrown down before him in defiance, and the near-sneer in the left corner of his mouth echoes the arrogance in his gaze. Plumed and bejeweled, his sword improbably pushed out of sight, this is the Knight of Pendragon Castle (visible in the middle distance) whose symbols include caducei, laurels, stars, and celestial globes.[35] The magic must have been successful, for Spenser salutes Cumberland in the dedications to *The Faerie Queene* as "The flowre of chevalry, now bloosming faire . . . As goodlie well ye shew'd in late assaies."

Elizabeth, of course, remained the unattainable lady. Through the 1590s she continued to play the cruel fair, granting and withholding favors. A poem

written about 1590, frequently attributed to her and certainly expressing her personal myth, begins:

> When I was fair and young and favour graced me,
> Of many was I sought their mistress for to be,
> But I did scorn them all and answered them therefore,
> Go, go, go, seek some other where,
>> Importune me no more.
>
> How many weeping eyes I made to pine with woe,
> How many sighing hearts I have no skill to show,
> Yet I the prouder grew, and answered them therefore,
> Go, go, go, seek some other where,
>> Importune me no more.[36]

The "beautifull Lady" dispensed her portrait—but little more—to the beseeching men who aspired to be her consort. This Elizabeth Hilliard painted too, as in the masterly portrait of 1572. Despite the assertion of the Tudor rose pinned prominently on her shoulder just under the calligraphic crown and *R* (Plate 1), this picture carries conviction in its frankness. She is unlike many Hilliard ladies, for little attempt at prettiness disguises the long, arched nose, the deep-set eyes, the firm lips and narrow chin. Here is a dignified woman dressed in her favorite black and white, in sleeves powdered with pastel flowers, a woman whose clear, thoughtful gaze addresses the cares of state seriously. Not yet imperious or wholly imposing, the lady earns our sympathy. She carries no scepter, wears no great crown or carcanet; rather, a picture lies central among the gems on her breast. From such small signs we must deduce the origins of the private exchange of miniatures among well-born Elizabethans.

Many sitters to Hilliard's pencil were not the famous folk of the age but now-unknown ladies and gentlemen, usually young. To these citizens who followed the Queen's lead, a Hilliard miniature provided the ideal display of a lady's beauty or a lover's pining. The Petrarchan passion expressed in English syllables by Sidney, Davies, and Daniel required material mementos as well. Before 1570, the Queen's tutor Roger Ascham was already complaining that sojourners returned from Italy were "daily dalliers with such pleasant words, with such smiling and secret countenances, with such signs, tokens, and wagers, . . . with bargains of wearing colours, flowers, and herbs, to breed oc-

casion of ofter meeting of him and her."[37] A delicate limning makes a good love token, and Hilliard's gift for capturing charm in a fleeting glance suits intimate feeling as well as symbolic grandeur. The portraits of himself and his wife (Plates 2, 3) might almost be samples of his powers, with shining Alice painted in a calligraphic oval set within the circular frame. Less intimate tokens could be set as "cabinet" miniatures, for a more public display of esteem. Elizabeth is said to have given a set of ivory-cased miniatures (including her own and that in Plate 7) to Penelope Rich, the Earl of Essex's sister and Philip Sidney's dear Stella; we know from Constable's sonnet (Epigraph) that Lady Rich later sat for Hilliard. At any rate, exchanging these souvenirs was certainly in vogue by the 1590s. Marlowe's King Edward, dispatching Piers Gaveston to Ireland, exclaims,

> Here take my picture, and let me wear thine;
> O might I keep thee here as I do this,
> Happy were I: but now most miserable.
>
> —*Edward II,* I.iv.127–29

One indication of how these pictures were worn and treasured is Hilliard's unusual miniature of a *Young Man Against a Background of Flames* (Plate 15). Here is a man like Hamlet when mad with love, "his doublet all unbrac'd, / No hat upon his head, . . . Pale as his shirt"; at any moment he might raise "a sigh so piteous and profound / As it [would] seem to shatter all his bulk" (*Hamlet* II.i.78–81, 94–95). The Petrarchan flames prove that he burns with love, the portrait that he impulsively reveals admits for whom, the placement of that picture on his breast shows that, were he fully dressed and smiling, his despair would be his secret. Psychology and surface pattern combine to picture for us a rarely externalized emotion: sleepless eyes and unshaven cheeks, ruffled hair and crumpled shirt, the exhausted pose of hand on hip, the lack of embroidered clothing to distract. The long, pointed chain, echoed in the shirt opening, draws attention from the pain in his eyes to its cause on his breast, with earring and finger ring as parentheses. This flamboyant miniature—the flames are picked out in gold to match the jewelry—might have as its theme the romantic miniature itself. Here is Hilliard's match for what Sidney's Astrophil (1591) sought: "fit words to paint the blackest face of woe" (I) or to "breathe out the flames which burn within my heart" (XXVII).

As weapons in the wars of love at Elizabeth's court, miniatures have been compared to the sonnet sequences, a parallel fashion of the 1590s. Both artifacts take sharply defined and highly ornamented forms. Both compactly express deep devotion, yet both were offered in formal courtship that glosses over sexuality just as it repudiates the passage of time. Miniature and sonnet alike, tendered to one whom the giver loved, could glow with private allusions to which the lovers alone were initiated. (In a sequence he had no plans to publish, Sidney did not expect the significance of "rich" to be so obvious, and miniature-inscriptions such as Hilliard's "Attici amoris ergo," on P.21-1942 in the Victoria and Albert Museum, remain in good measure obscure.) Picture and poem both are a form of pleading. In *The Two Noble Kinsmen*, for instance, two miniatures that instantly evoke Hilliard help their subjects compete for the love of Emilia:

> Good heaven,
> What a sweet face has Arcite?
> . . . What an eye,
> Of what a fyrsparkle, and quick sweetness,
> Has this young Prince?[38]

Miniatures and sonnets share decor as well as subject. Just as Hilliard asserts that "the eye is the life of the picture" (p. 24), so countless sonnets expound on the lady's eyes as the wellsprings of all joy. In Hilliardesque terminology, Sidney specifies their hue:

> When Nature made her chief work Stella's eyes,
> In colour black why wrapt she beams so bright?
> Would she in beauty black, like painter wise,
> Frame daintiest lustre mixt of shades and light?

> —*Astrophil and Stella*, VII (1591)

Again, Hilliard's treatise observes with care the "lovely graces" of a smile that smoothes the forehead to a plane "for peace and love to walke upon" (p. 24); in the *Amoretti* Spenser similarly asks us to "Mark when she smiles with amiable cheare, . . . / When on each eyelid sweetly doe appeare / An hundred Graces as in shade to sit. / (Lyke) unto the fayre sunshine in somers day . . . / Thrugh the broad world doth spred his goodly ray" (XL). Poet and painter

have seen the same feminine essence. The limner, however, can defeat the sonneteer in illustrating the hyperbolic blazon of a lady's splendors traditional since before Petrarch but, without Hilliard as intermediary, absurd to modern eyes.

> For loe! my love doth in her selfe containe
> All this worlds riches that may farre be found:
> If saphyres, loe! her eyes be saphyres plaine;
> If rubies, loe! her lips be rubies sound;
> If pearles, hir teeth be pearles both pure and round;
> If yvorie, her forhead yvory weene;
> If gold, her locks are finest gold on ground;
> If silver, her faire hands are silver sheene;
> But that which fairest is but few behold,
> Her mind, adornd with vertues manifold.
>
> —*Amoretti*, XV (1595)

In miniatures, hair like gold wires and an alabaster breast are not only comprehensible but expressive, and few indeed can behold the elusive smile of a face secreted in a case. Perhaps most poignantly, pictures as well as verse can serve the common Renaissance conceit of shoring fragments against the ruins of time. Daniel knew that a portrait could keep the memory of his Delia as young as in the springtime of their love:

> When Winter snowes upon thy golden heares,
> And frost of age hath nipt thy flowes neere:
> When darke shall seeme the day that never cleares,
> And all lyes withred that was held so deere.
> Then take this picture which I heere present thee,
> Limned with a Pensill not all unworthy:
> Heere see the giftes that God and nature lent thee;
> Heere read thy selfe, and what I suffred for thee.
> This may remaine thy lasting monument,
> Which happily posteritie may cherish:
> These collours with thy fading are not spent;
> These may remaine, when thou and I shall perish.
>
> —*Delia*, XXXIV (1592)

He spoke prophetically. Today, Hilliard's miniatures give us a more vivacious image of long-dead lovers than any sonnet can.

Perhaps the best evocation we have of romance among Elizabethans, as expressive as any Benedick or Romeo, is Hilliard's beau among the roses (Plate 14). This yearning youth is sometimes identified with Essex, but the Victoria and Albert Museum does well to label him simply *An Elizabethan Gentleman*, for he is the glass of fashion and the mold of form, the ideal type of a suitor affecting lovelonging in the eternal May of Arcadia.[39] The assurance of impossibly elegant legs, the artful drapery of the cloak that sets off the roses and thorns of love—these are the gestures of a symbol; eye and nose lack the distinctive spark of life that so convinces in the *Young Man Against a Background of Flames*. The inscription and white roses form an inner oval that frames the head and hand-on-heart in a composition as perfect as the folded ruff and the rigid, herringboned doublet. Leaves and their shadows against the legs add to the pattern, contrasting with the roses on black just above. Capable of showing the massive solidity of a Hatton, Hilliard at the zenith of his powers here chose to limn a midsummer day's dream of a lover. The deliberate mystery of the motto *Dat poenas laudate fides*[40] might echo Astrophil:

> The curious wits, seeing dull pensiveness
> Bewray itself in my long-settled eyes
> Whence those same fumes of melancholy rise,
> With idle pains and missing aim do guess.
>
> —XXIII

Hilliard's best work thus illuminates for us not only Elizabeth and her courtiers in the rich plumage of their courtship ritual but also the literature that records their dance.

But the old Queen could not live forever, the sonnet craze faded, and the notion of adoring an image of the beloved was rejected with other extravagant conceits. In the new century and the new reign, led by Queen Anne of Denmark, fashion turned to the limnings of Isaac Oliver, with their pronounced modeling and affecting melancholy. Hilliard's works were used once again as official public images of the new sovereign, broadcast wih a lavish hand. James I employed Hilliard extensively and in 1617—two years before Hilliard's death—confirmed his monopoly on small pictures for twelve more years. Records tell

of the King dispensing his portraits on chains, sixteen at a time, to good servants returned from an embassy to Denmark.[41] Appropriately, Hilliard's pictures of James (Plates 20, 21) are cramped and monotonous. Their composition and iconography—crowded architectural setting, unexplained lily, diagonal drape, distracting landscape seen through a window yet lighting inexplicably falling from the opposite side—are reminiscent of certain mannerist portrait types, such as Lorenzo Lotto's presumed *Self Portrait* in the Borghese Gallery in Rome. Hilliard's style has lost its freedom, and the effect is mechanical and derivative; James's eyes express neither sprightliness nor majesty. James, whose contemporaries thought him an ugly man, was most reluctant to sit for any portrait;[42] without a sympathetic patron, Hilliard's gifts may have atrophied. In any case, the static products turned out by his studio suggest the cynical distribution of Hamlet's comment on Claudius: "My uncle is King of Denmark, and those that would make mouths at him while my father lived give twenty, forty, fifty, a hundred ducats apiece for his picture in little" (*Hamlet*, II.ii,346–49).[43] Hilliard ended as he began, a bread-and-butter Royal Goldsmith and Engraver, with scope and energy gone.

In Elizabeth's final address to Parliament in 1601, she stated succinctly her era's equation of mortal and moral glory. "Assure yourselves that the shining glory of princely authority hath not so dazzled the eyes of our understanding but that we will know and remember that we are also to yield an account of our actions before the great Judge." But the aesthetic of light did not long survive the Queen. When Francis Bacon came to write "On Beauty" in the Attic essays that exemplify the alternative to copious ornamentation of style, he began, "Virtue is like a rich stone, best plain set; and surely virtue is best in a body . . . that hath rather dignity of presence, than beauty of aspect." He is firm about the painter's inability to capture human feeling: "That is the first part of beauty, which a picture cannot express; no nor the first sign of life."[44] Bacon seems to rebuke Hilliard's attempt to convey the dignity of nobles and the loveliness of ladies.

The goldsmith's luminescent aesthetic may still have a legacy. Before Hilliard appeared on the scene, literary references to painting as imitation betray a dusty humanist heritage; they give no space to fresh observation and original composition. Hilliard's career, however, ran parallel to the richest half-century of development in English literature. Thanks in part to the new poetry—but thanks too to Hilliard—*mimesis* acquired a new meaning: all art should present an image of what is, not what previous artists have wrought. Reinvigorating an old rhetorical term, critics demanded that literature convey the vivid de-

scription that is *enargia*. In 1595, the poet George Chapman explained this goal with a new metaphor that amply counters Bacon and suggests a connoisseur's appreciation of Hilliard's goals.

> That *Enargia,* or cleerenes of representation, requird in absolute Poems is not the perspicuous delivery of a lowe invention; but high, and harty invention exprest in most significant, and unaffected phrase; it serves not a skilfull Painters turne, to draw the figure of a face onely to make knowne who it represents; but hee must lymn, give luster, shaddow, and heightening; which though ignorants will esteeme spic'd, and too curious, yet such as have the judiciall perspective, will see it hath, motion, spirit, and life.
>
> —*Ovids Banquet of Sence,* "Epistle to Royden"[45]

THE ARTIST IN *THE ARTE*

As Hilliard intended, *The Arte of Limning* provides a clear if incomplete conception of how he set about painting a miniature. In its informal structure and style, it also reveals much about the character and circumstances of Nicholas Hilliard. The text is a declaration of his most pressing concerns as a craftsman/artist, in order of their priority to him; left incomplete and rhetorically unpolished, it is all the more expressive. It sketches an outline of Hilliard's working conditions, of his ambition, and of his respect for his mystery. Just as his best miniatures show a fruitful tension between the draftsman and the goldsmith, so *The Arte of Limning* shows a similar tension in his life: an ambivalence between the class and task into which he was born and the dignity that he considered the just reward of his achievement. Two principal themes of the treatise—limning at court and manufacturing paints and handling jewels in the shop—suggest the ambiguity Hilliard must have experienced daily. In *The Arte's* casual, occasionally poignant phrases, we can see the first signs of a changing status for the visual artist already won in Italy by Leonardo and, the example that Constable's sonnet intimates, Michelangelo.

As a goldsmith, Nicholas Hilliard was a merchant-craftsman or, in his word, an "artificer"—a status equated by contemporaries as Thomas Smith

and William Harrison to that of the husbandman or small farmer.[1] The Gold-smiths' Company of which he became a freeman in 1569 after the customary seven-year apprenticeship was, like the Merchant Taylors, Drapers, Grocers, Ironmongers, and the rest, one of the wealthy and powerful survivals of the medieval guild system, with distinctive liveries and banners, halls in the City, and stalls in the arcades of Thomas Gresham's Royal Exchange. Such commercial organization made master craftsman and shopkeeper one and the same, with workroom, shop, and household—for family, employees, and apprentices—all the same rented premises, in Hilliard's case for much of his life The Maidenhead in Gutter Lane.[2] The social order was, however, in flux; the Statute of Artificers of 1563, a monument of Elizabethan Parliamentary legislation, demonstrates the perceived need to stem the tides of change (and pehaps to fix labor markets for the convenience of landowners and proprietors) by settling terms of apprenticeship and employment contracts, stabilizing working conditions, and reducing the numbers of unemployed unskilled laborers.[3] Admired yet never financially successful, in such an era Hilliard reflects the restless aspiration of one to whom doors seem almost open.

Throughout the latter half of *The Arte of Limning*, the experienced craftsman dominates. Hilliard not only describes in detail—for "gouldsmithes" as well as gentlemen—the hues and proper cutting of gems, but he mentions the relative "price or estimation" of almost every precious stone he discusses: with a commercial sense of priority "the *Lapidarie* knoweth at the first sight the vallewe, goodnes, and hardnes of the stone" (p. 39). And the limner knows to the penny what he has paid for ultramarine: 3s.8d. for a carat of only four grains (p. 33). His suggestion for calculating the artisan's skill expended on jewelry is ingenious:

> an excelent workman cann grace [Juells] above that which nature give them both in cutting, setting, and making them in valewe double of that they weare before, therfore he is better worthy of fowerfolde better payment then any other. (p. 41)

The chief reason for prizing such efforts is of course not commerce but art: "the cuning Artificer helpeth nature, and addeth beautye as well as nature doeth" (p. 41). Thus pride in his craft and exacting standards for its performance far outweigh petty-bourgeois concerns in the treatise. From the outset Hilliard states that the painter will achieve stature only if he is a perfectionist, true to himself alone. Painters should "doe theier utermost best not respecting

the profitt or the lenght of time nor permit any unworthy worke to be pub-
blished under their name to comon view, but deface it againe rather and never
leave till some excelent pece of Arte were by him or them performed worthy
of some comendations"⁴ (pp. 15–16).

Hilliard sees little of such precise work, however, but rather disproportion
and poor perspective disguised by neatness and pretty colors (p. 28), hasty
shadowing so that "mending wilbe perceived" (p. 35), and greedy speed in
diamond cutting. "For while the good workman taketh pleasure to shewe his
art and Cuning above othe[r] men in one peece (in what art soever) the botcher
dispatches six or seaven, . . . wherby he is able to set many other at work,
which though they be all bungler and Spoilers, yet please in respect of good
cheapnes, and keeping of promise, and so growe rich" (p. 41). Hilliard pours
scorn on the "botcher" and "bungler" who through ill training spare time
and cost by cutting corners (p. 41); unlike past eras when "one good workman
then mad an other, so one bocher nowe adaies maketh many, and they in-
creasse so fast that good workmen give over to usse their best skill, for all
men cary one price" (p. 16). The days of painstaking apprenticeship are over;
the genuine art involved in either limning or gem-cutting goes unrecognized.
We cannot escape the conclusion that Hilliard's slow pace and lack of profits
drew few apprentices to his shop and left him reliant wholly on his own
labor.⁵ "The good workman also which is soe excelent, dependeth one his
owne hand, and can hardly find any workmen to worke with him . . . which
is a great mischeefe to him" (p. 41). As an individual talent, he was econom-
ically well before his time.

Lacking the income of the merchant-goldsmith's productive workshop,
Hilliard had the wit to imagine another source, one long since effective on the
Continent and soon to flower in Stuart England—noble patronage for painting
as a fine art. On the second leaf of *The Arte of Limning* he blandly asserts,
"And *Princes* comonly give them competent meanes, by which not the work-
men soe much as themselves ar eternized, and famously remembred as the
nuresses of vertue and Arts" (p. 18). He pointedly praises "*King Henry the
eight* a *Prince* of . . . *Royall* bounty, soe that of cuning Stranger even the best
resorted unto him" (p. 18), notably Holbein.⁶ That he bitterly imagines such
support as a lost opportunity for himself seems clear: good workmen should
"be as in other countries by pencion or reward, of princes, otherwise uphelde
and competently mayntayned, although they be never soe quicke nor soe cun-
inge in theire professions, depending but one theire owne hand helpe" (p. 42).
Hilliard's cry of pain is undoubtedly real; even as he dashed off the treatise,

his career was beginning to wane. The Queen had never been overprompt or overgenerous in rewarding his services, and—throughout the late 1590s and into the new century—he repeatedly needed the intercession of Robert Cecil, both at court and with the Goldsmiths' Company, to remedy his financial situation with leases and pensions.[7] The eclipse in 1601 of another patron, the Earl of Essex, further constricted his revenues. In an age of inflation his distress was genuine; only from James I did he receive continuing compensation in respect of his long-standing stature.

Hilliard had every reason, then, for attempting to distinguish himself and the limning of his maturity from the artificer's status of his youth. His art is defined in good measure by that disdainful distinction. Limning "tendeth not to comon mens usse, either for furnishing of Howsses, or any patternes for tapistries, or *Building,* or any other worke what soever" (p. 16)—it is not merely decorative. Although he can cleverly imitate gems in his paintings, Hilliard firmly ranks that skill secondary among his talents: "that . . . is no parte of limming; . . . it appertaineth merly to ane other arte. . . . it is but as a mayson or Joyner . . . cane also paynt or guilde his freeses" (p. 34). Despite its allegiance with jewelry, limning to Hilliard belongs not among the crafts but among "all the rare siences especially the arts of *Carving, Painting, Gouldsmiths, Imbroderers*" (p. 19). His motives for making such a claim are more than financial. Throughout the sixteenth century, while English poetry written and defended by knights and earls was brilliantly acclaimed, the fine and applied arts were produced largely by guildmen doing piecework to order in near-anonymity. A Hilliard or a Smythson was an exception. (The gently born George Gower, who became Serjeant Painter, apologizes for his scapegrace career of "pensils trade" in verses painted on his self-portrait.)[8] Aware of his rare talent, Hilliard scraped to survive as a jeweler; not born to wealth or status, he lived surrounded by courtiers and painted many whose rank was quite new. To a sensitive man, the situation must have been painful. No wonder he hoped to bring about change.

The claims Hilliard makes for painting as a "rare sience" are, nevertheless, by no means original. The painter-theorists of the Italian Renaissance had felt the sting of artisan's rank, so much so that, in Pope-Hennessy's words, "discussion of the status of painters and painting is one of the standard concomitants of later 16th century art theory."[9] As early as 1400 Cennino Cennini asserted gingerly that the more theoretical occupations were worthier, that painting "which calls for imagination . . . in order to discover things not seen" is one such occupation and that men are attracted to it from "a lofty spirit,"

natural enthusiasm, and intellect. The humanist Leon Battista Alberti roundly declared in 1435 that "the art of painting has always been most worthy of liberal minds and noble souls, . . . of free men"; he recommended that painters be "as learned as possible in all the liberal arts" and advocated friendship "with poets and orators . . . who have a broad knowledge of many things." Leonardo da Vinci (c. 1510) gloried in "the mind of the painter" and "the dignity which is the science of painting."[10] As the guild system waned and died, artists sought to differentiate their skill from the mechanical by stressing its intellectual range, hence its place among the liberal arts—the learning of independent men. Giovanni Paolo Lomazzo, on whom Hilliard could draw directly thanks to Haydocke, opens his preface by recurring to Cennini's distinction among the arts of man and placing painting, with its impact on "understanding," high among them; he closes it by naming "this most necessary science of painting . . . a compendium of the greater part of the liberal artes," at least the *quadrivium*.[11] Hilliard thus has ample precedent for concluding a defense of "cuning men" with the words, "I thinke they have the liberall Siences, and it is a vertue in them, and becometh them like men of understanding" (p. 42). A learned profession is the highest status to which he can aspire.

For the acknowledged artist, particularly in Italy, talent rather than birth created status. Andrea Mantegna and Titian were ennobled, and Dürer wrote from sunny Venice in 1506, "Here I am a gentleman, at home I am a parasite." Henry VIII is said to have perceived, "I can make any number of men of title but I cannot make a Holbein."[12] The skill to achieve great works, theorists and artists since Cennini have known, is an inborn gift of but a few men— those Hilliard names "Ingeniously borne" (p. 15). Hilliard follows mannerist thought in asserting that the source of such God-given talent requires respect: "as for an naturall aptnes of or to painting after the liffe thosse surly which have such a guift of god ought to rejoyce with humble thankfulnes" (p. 17). But, Hilliard intimates, some families irreverently scorn and suppress this unusual craft in a child.

> Let us therfore honore and prefferre the election of god in all vocations and degrees, and suerly he is a very wisse man that can find out the naturall Inclination of his childeren, in due time, and soe applie him that waye which nature most inclineth him, if it be good or may be made good, as it may be ussed though in childhood abussed. (p. 17)[13]

The gifted artist is also well born.

The stated motive for *The Arte of Limning* is revealing. Its purpose is "to teache the arte of limning . . . as also to shewe who are fittest to be practisers thereof, for whom only let it suffice that I intend my whole discourse" (p. 15). To be sure, he teaches his art, but first things come first. Following Lomazzo, he begins by asserting that gentlemen are fit limners because private means allow them to work at leisure, because limning employs suitably noble (and expensive) materials for suitably noble purposes, and because it is performed under clean conditions and can be casually laid aside if the dilettante-painter grows distracted. "It is a kind of gentill painting, . . . sweet and cleanly to usse"; "a good painter hath tender sences, quiet and apt, and the culers them-sellves may not endure some ayers . . . sweet odors comforteth the braine and openeth the understanding, augmenting the delight in limning"—no sugges-tion of dirt, smells, or workingman's hands may intervene in this fastidious-ness. Hilliard's reasons why gentlemen make the best painters are already raised in Lomazzo's preface; modest success for this argument may be reflected in Baldassare Castiglione's great essay on the manners of the Italian gentleman *Il Cortegiano* (1519). But Hilliard could find happy confirmation closer to home and in language startlingly close to his own, in *The Boke Named the Governour* of Sir Thomas Elyot, who believed "that it is commendable in a gentilman to paint and kerve exactly."[14] The evidence Hilliard selects to sup-port his point echoes such gently born and liberally educated models. He begins with deferential citation of precedent in noble Romans who painted, including Marcus Aurelius's court painter (pp. 15, 18), and he decorates his text with Latin tags, *Honos alit artes* (Honor sustains the arts) and a quotation from "famous and eloquent cissero" (pp. 18, 20).[15] The resources of humanist scholarship are thus brought to bear on the notion that only gentlemen should limn.

But the defense may protest too much; limning is "secreat a man may usse it and scarsly be perseaved of his owne folke" (p. 16). And Hilliard must concede that "doubtles though gentlemen be the metest for this gentill caling or practize, . . . not every gentelman is so gentel sperited as som others are" (p. 17). The inescapable conclusion is the converse of the original premise: limners should in fact be considered gentlemen, whatever their birth. God himself undergirds such a claim. "Heer is a kind of true gentility when god caleth" (p. 17). The best precedent is not a Roman but Bezalel and Oholiab, workers in painting and precious stones, whom God gave skill—and "Gaen-tility"—to decorate the Temple (Exodus 31:1–11).[16] Hilliard thoroughly ap-proves the position he imagines granted to Albrecht Dürer as "a worth[y]

counselor . . . unto the city of *Norenbourgh*" (p. 19). Thus he defines for his era the limner as artist who deserves a new respect from English society. But he does not, like Philip Sidney on behalf of poets, adopt the advanced thought among Italian Renaissance theorists who speak of painters as inspired, godlike creators of a second nature.[17] As a craftsman embedded in the quotidian, Hilliard retains his allegiance to observation and representation "after the life."

The final revelation of *The Arte of Limning* is the image of this one artist as a man of mildly Bohemian temperament, naive but genuine intellect, and considerable personal charm. His writing hints at aristocratic taste and sensibility that extinguish his bourgeois caution. His endlessly straitened financial circumstances, for instance, are not solely the result of changing socioeconomic conditions such as inflation, competition, and underpricing.

> Such men are commonly noe Mysers, but liberall above theire littel degree/ knowing howe bountifull god hath indued them with skill above others, . . . oft times when they have performed a rare pece of worke, (which they indeede cannot afforde) they will give it awaye to some worthy personage for very affection, and to be spoken of. . . . If a man bring them a rare peece of worke, they will give more for it, then most men of tenne times their abilitye. (pp. 41–42)[18]

The born artist paints because he loves it, cavalierly gives away his work at a whim, and buys what he admires without counting the cost. "Cuning men are ever unthrifts" (p. 42), Hilliard casually remarks, but he finds it a sign of a generous and intellectual view of the world. "Neither is he always in humore to inploye his spirits on some worke, but rather one some other" (p. 41)—inspiration keeps no hours and cannot be summoned at will. Yet Hilliard knows the precariousness of his gift and advises great care "least it be sone taken from them againe by some sudaine mischance, or by their evell coustomes, their sight, or stedines of hand decay"; "be he never so cunning by teaching or naturall Inclination, yet it will growe out of him as haire out of the head, or fall from him whether he will or no" (p. 17). Artistic skill is a hostage to fortune.

Advice to the painter on how to counter his fate is a poignant part of *The Arte of Limning*. "This exortation give I more that he be diligent, yea

ever diligent, and put his whole uttermost and best endeavors to exceell all other" (p. 17). Even when not commissioned, his capacities should be rigorously engaged, "much given to practises, to find out newe skills, and . . . ever trying conclusions" (p. 41). Such admonitions are neither surprising nor original—Alberti prescribes "study and diligence" for the painter across five pages, buttressed by historical precedent from Pliny—but Hilliard speaks them feelingly. Similarly, thoughtful writers from Cennini at least to Michelangelo had called for a well-regulated sobriety of life, but Hilliard's dictum on conduct convinces us that he draws on experience. "[The talented ought] to be very wary and temperat in diet and other government"; "I meane sleepe not much, wacth not much, eat not much, sit not long, usse not violent excersize in sports, nor earnest for your recreation/ but dancing or bowling, or littel of either" (pp. 17, 21).[19] When he writes, "They are generally given to travel, and to Confere with wise men, to fare meetly well, and to serve theire fantasies, having commonly many childeren if they be maryed," we recall his large family and his discussion with Sidney, and we know he describes his own vagaries. The comment that "gent or *vulgar* wee are all generally commanded to turne awaye ouer eyes frome beauty of humayne shape, least it inflame the mind" (p. 23) is surely more than received piety. Finally, the note most appealing to the modern reader is Hilliard's expression of the private joys that arise from commitment to his art:

> yea if Men of worth did knowe what delight it breedeth, how it removeth mallancoly, avodeth evell occasions, putteth passions of sorrowe or greefe awaye, cureth rage, and shortneth the time, they would never leave till they had attained in some good meassur, A more then comfort. (pp. 17–18)[20]

This energetic figure has integrity from within, and he finds rewards well beyond the monetary, "even an heaven of Joy in his hart to behould his own well doings remaining to his credit for ever" (p. 17).

The aesthetic response is more than the emotional reaction of a mercurial temperament. Beneath the surface of Hilliard's text is an intellectual value just beginning to emerge in Tudor England, finding its first voice in Elizabethan critics: judgment, the detached, instructed taste that allows connoisseurship.[21] A cardinal principle of humanist learning drawn from classical thought, judgment in Hilliard's words is not yet a formed faculty for evaluation on principles of decorum.[22] He uses the term in two ways: one a habit of the eye,

the other of the mind; one a function of simple reason, the other of a nascent taste. The first aspect of judgment appears to function at a level just beyond observation, while the second—in references of some asperity—is the province of the *cognoscenti*.

The basic sense enters *The Arte of Limning* with Lomazzo, Dürer, and art-theoretical topics. "To define [perspective] brefly, [it] is an art taken from, or by, the efect or Jugment of the eye" (p. 20), which in this case interprets foreshortening. Evaluation of good proportion in the human face requires no special knowledge, for "ouer devine part . . . by an admirable instin[c]t or nature, Jugeth generally . . . and knoweth by nature without rule or reasson for it, whoe is well proportioned" (p. 23); good judgment may in fact substitute for knowledge of the "true Ruell" (p. 25) in establishing proportion. A trained eye is all that is required. But when aesthetic issues of genuine moment to Hilliard arise, a subtler faculty is summoned. The most important aspect of beauty—"grace in countenance," or expression—"can neither be weel ussed nor well Juged of but of the wisser sort, and this princepall part of the beauty a good painter hath skill of and should diligently noet"; the painter cannot capture the passing glances of a handsome face "without an affectionate good Jugment" (p. 23). This appreciative faculty for responding to beauty is by no means available to all. Only the most skillful, after all, understand that the effects achieved by *chiaroscuro* are gross and inelegant. In perhaps the key passage in *The Arte of Limning,* Hilliard roundly declares that "the lyne with out shadowe showeth all to a good Jugment, but the shadowe without lyne showeth nothing" (p. 28). Human expression and the use of line and light define Hilliard's characteristic art; the judgment to recognize and admire this style is a refined palate indeed.

More interesting than the faculty of judgment in the painter is the capacity for aesthetic appreciation that Hilliard adumbrates in patrons, for his are among the earliest hints in English of the rise of cultivated taste as a mark of aristocracy. Some of his references point to the first level of little more than polite observation; they are merely a new form of compliment. Thus Hilliard praises "*King Henry the eight* a *prince* of exquisit Jugement and *Royall* bounty"; with a nice sense of hierarchy, he depicts himself modestly instructing Sidney in knowledgeable discrimination of proportion, while on the other hand "her Majestie curiouse d[e]maund hath greatly bettered my Jugment" (p. 29). Relations between painter and patron will proceed best when each possesses and employs the educated restraint predicated by taste.

Be not hastye to lesson [the forheade] at every mans worde, but pro-
ceede with Jugement./ I have ever noted that the better and wiser sort
will have a great patience . . . If they find a fault, they doe but saye, I
thinke it is to much thus or thus, referring it to better Jugement. (p. 35)

—presumably the painter's own. Hilliard's appeal to "the learned & better
sorte" is never more flattering. Finally, and less artfully, he makes rudimentary
use of a sophisticated conception of relations between picture-space and viewer-
space, hence of a communication between painter and observer that transcends
the single captured moment. Hilliard understands the special style required to
create effects when the picture "is to be veewed of nesesity in hand neare unto
the eye" (p. 29), and he has thought about placing a noble sitter to express
hierarchy when "generally men be under him, and will soe Juge of the *picture*
because they under viewe him" (p. 45).²³ Illusion is conveyed to the viewer
by less mechanical means when sitters are asked to consider how they wish
to "seem"—but "as though they never had resolved" (p. 45), when perspective
is described as the art of deceiving "bothe the understanding and the eye" (p.
20), indeed when Hilliard turns over in his mind the old idea of falling in love
with a pictured sitter (p. 23). But even to observe such comments risks over-
stating them. Hilliard is no aesthetic theorist, simply a gifted court painter
who understands intuitively the power of his art.

To some extent, Hilliard succeeded in his attempt to be emancipated from
his role as fashioner of decorative jewelry into a position of public respect as
creator. He began his career as court-servant in the painter's medieval position
of *valet de chambre* to the Duc d'Alençon, and when he participated in Eliz-
abeth's funeral he was part of her Great Wardrobe. But in 1606 Henry Pea-
cham paid Hilliard the sincerest form of compliment by writing a treatise on
limning, then later including it among the requirements of his *Compleat
Gentleman*—a theoretical victory, at least. Hilliard's case for the status of his
art was finally won when his last license to be principal miniaturist to James
I, issued two years before his death, saluted him as "Nicholas Hilliard, Gentle-
man."²⁴ Standing between unknown manuscript illuminators and Stuart pa-
tronage of Rubens and Vandyke, he became the first English artist to emerge
from anonymity into the great Renaissance desideratum which he often ten-
dered his sitters: "credit for ever," lasting fame. That is just what, rather
wistfully, he wished. "The Ilands indeed seldome bring forth any cunning
Man, but when they doe, it is in high perfection so then I hope there maie

come out of this ower land such a one" (p. 19). In his special art, Nicholas Hilliard approached perfection.

THE ARTE OF LIMNING AS ART THEORY

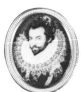

The Arte of Limning founds a genre, a long line of treatises that includes the works of such English painter-aestheticians as William Hogarth and Joshua Reynolds. Unlike Hilliard's pictures, however, *The Arte of Limning*—although much imitated in the early decades after its publication—passed into extreme obscurity until Philip Norman's antiquarian interest and John Pope-Hennessy's scholarship in art theory brought it back to light in this century.[1] The treatise provides an invaluable introduction to Hilliard's range of interests. It is not, to be sure, a formal treatise moving in organized fashion from point to line to plane to mass on the pattern of fifteenth-century Italian treatises. In his writing, as in his painting, we can see a combination of the Italian theory and mannerist elegance that Pope-Hennessy found, together with northern realism and pure English empiricism. As a painter, Hilliard commands our admiration for directly communicated truth and for linear decoration in a setting close to pure design. The treatise presents us with both commitments, unresolved: verisimilitude and stylization, content and technique are held in balance. Drawing on more learned sources as well as on experience, the text is a compressed statement of a practicing painter's main preoccupations.

Structurally, *The Arte of Limning* falls into two distinct portions, the "Precepts & directions" or "the arte . . . and the True method" announced in the opening sentences. The first portion (pp. 15–30)—precepts or "arte"—contains almost all the theoretical and aesthetic discussion Hilliard includes. It has two parts: an introductory defense of limning as a genteel occupation backed by the authority of Renaissance learning (pp. 15–21), and a set of precepts for conduct, idealization, proper proportion, and use of light (pp. 21–30). The second portion (pp. 30–45)—directions or method—is principally a practical manual on colors, their application, and their analogues in the hues of gems (pp. 37–45). Rhetorical gestures indicate the transition between segments, the clearest of them reading, " . . . I end with it./. And nowe I thinke it fitt also to speake somwhat . . ." (p. 37). Despite such tacit organization, in discursive fashion Hilliard anticipates subsequent topics and introduces after-

thoughts in *aperçus* that link the two portions. Lomazzo and Dürer, who are central to the theoretical section, for example, make a brief reappearance in the instructions on modeling (pp. 36 and 37).

The earliest leaves of the treatise, then, establish Hilliard's relationship to the Renaissance art theory that had flourished in Florence, Rome, and Milan over the preceding two centuries. The latent organization of Hilliard's material follows the pattern that, as Erwin Panofsky has shown, distinguishes Renaissance treatises from medieval texts on painting.[2] To be sure, with England out of the mainstream in the visual arts, *The Arte of Limning* retains late-medieval characteristics: Hilliard's palette does not vary greatly from that of the illuminators in "small voloms in privat maner" who preceded him, and his anecdotal recipes for preparing colors differ little from the directions of Cennino Cennini. The function of the guild organization to restrict "trade secrets" is reflected in references to the "Misterye" of diamond-cutting and to the means for recognizing diamonds without damaging them, a secret "not to be devulged, because stolne things are brought to sell" (p. 44) but here presumably safe from the criminal and illiterate.[3] Yet Hilliard means to be very up-to-date, to provide for the miniaturist a companion to the Italian treatise on painting translated by his friend Richard Haydocke, Giovanni Paolo Lomazzo's *Trattato dell'arte della pittura* (1584). An otherwise cryptic passage of rhetoric reveals his intent to attack his subject in learned fashion: "wisdome comprehendeth all things it entereth into all arts, it goeth through them, and considereth of them, it turneth back againe and devideth them, it placeth them in order and observeth their severall graces" (p. 24).[4]

We have no certain way to know the extent of Hilliard's acquaintance with other writings on art theory. He names only Lomazzo "& others" and Dürer, with whose engravings Haydocke silently illustrates his translation.[5] Hilliard disarmingly remarks that he need not describe large-scale painting since Lomazzo has done so better than Dürer, and he refers the reader to Lomazzo on illusionistic foreshortening, expressive gesture, proportions relative to height, and the error of *chiaroscuro*. Moreover, like Lomazzo, Hilliard has reservations about the academic quality and the tendency to plasticity in Dürer's theoretical work.[6] Lomazzo clearly emerges as the principal literary source that requires acknowledgment. However, exhaustive biographical study provides no hint of Hilliard's knowing more Italian than casual court conversation might require. Thus he probably knew the *Trattato* and all its antecedents only from Haydocke's English version of the first five of Lomazzo's seven books, discreetly but heavily edited to remove extensive Catholic icon-

ography.[7] The sixth book—on the actual practice of painting, including remarks on colors, flesh, modeling, portraiture, and the relation of colors to stones—would surely have been of interest if it had been accessible. But Hilliard makes no reference to it. In any case, he cannot have read the *Trattato* in English before Haydocke translated it in the 1590s, when his style had coalesced and much of his best work was behind him.

Hilliard uses Lomazzo, in the end, not as a model but as an encyclopedic reference work. He points to the *Trattato* in a form of footnote, citing chapter and verse for authentication or for comment on matters in which he has no further interest. One long section concludes, for instance, "*Paulo Lamatzo* maintaineth mine oppinion," another "let [the drawer] *Read Lamatzo*, his second bouck of actions and Jeastures wher he shall find good observations" (pp. 30, 24; cf. 18, 28). The modern reader of Lomazzo's exhaustive but unsystematic work finds such a response wholly sympathetic, particularly in the arid stretches of astrology, magic, and numerology that are clearly foreign to Hilliard's pragmatic mind. The value of the *Trattato* to Hilliard is its synoptic review of the principal motifs and issues in art theory since Alberti prepared his *della pittura* for Brunelleschi in 1436.[8] Whether from reading Lomazzo or listening to Haydocke, who knew his Armenini, Hilliard recognizes the obligatory topics of line, light and shadow, and proportion; he dispatches them compactly. He knows that the *paragone* between painting and sculpture is another expected heading but, in a headlong rush to assert his own views on line and proportion, he postpones discussion to "the last leafe" (p. 20)—and forgets to return to it.

The first reference to the Quattrocento rebirth of a classical concept in the arts appears in the title and intention of Hilliard's text: it is an "art" with distant roots in Aristotle and Horace, an orderly codification of knowledge about its subject aimed at instructing the novice in its practice.[9] After the opening defense of limning Hilliard cites abundantly the "rulles" of Dürer and Lomazzo, and subsequent sections are full of "precepts for Observations, ore directions to the art of limning" (p. 21): rules for cleanliness, for choosing a north light, and for capturing colors. The note is not academic prescription but helpfulness, for at such points Hilliard addresses his readers with concern as well as imperatives. He admires mastery of technical knowledge; "cunning," equated with acquired skills, is a quality he recognizes in Holbein, Dürer, and Italian painters generally, in clever jewelers and able strangers at court. The rationalism of this approach is Albertian, but one of its motives—a feeling for the poor state of his art—echoes the mannerists.[10] Not a decline

from Raphael and Michelangelo, however, but the success of ignorant hacks is Hilliard's complaint. Whether misplacing a reflected light, misrepresenting the proportions of a child's body, or misusing shadows to cover errors, "there is . . . much faire worke wherin such grosse error is" (p. 28). The rules a good limner should follow are pragmatic directions derived from experience and only secondarily buttressed by Italian learning. (Hilliard, after all, had been painting for a quarter-century when Lomazzo wrote the *Trattato* and for another decade before Haydocke translated it.) Less a rule than a helpful hint is Hilliard's use of the humanist doctrine of learning by imitation, one we can easily believe he followed.[11] "*Holbeans* maner of *Limning* I have ever Imitated" (p. 19), he tells us early on, and "Imitation of some fine well graven portrature of *Albertus Dure*" (p. 37) is his final admonition to the student of modeling.

The compositional rules that Hilliard chooses to discuss apply to line, light, perspective, and proportion; shadow is merely an aspect of light except in modeling, and coloring is a separate process based not on theory but on craft. "Line" to Hilliard is not the mannerists' metaphysical *disegno* but simply an outline of the brush upon the surface, such as "your first line which you drawe . . . that must be most truly drawne" (p. 25). Line is such a basic element that he offers no special commentary but uses it as a point of reference for every other aspect of composition: "the principal parte of painting or drawing after the life, consiste[t]h in the truth of the lyne . . . for the lyne with out shadowe showeth all to a good Jugment, but the shadowe without lyne showeth nothing" (p. 28). Dürer is, he says, the key source for all the arts for "which drawing is the enterance the very high waye and foundation" (p. 19), and Dürer was a perfect master of line. The accolade speaks for itself.

On the second basic element of his art—light—Hilliard offers extensive commentary. His first rule for the would-be limner, cleanliness, applies to preparation; the first rule for practice concerns the source of light of the working site. "Let your light be no[r]thward, somwhat toward the east which comonly is without sune, *Shininge in*. on[e] only light great and faire let it be, and without impeachment, or reflections, . . . a free sky light the dieper the window and farer, the better" (p. 22). Such open, natural lighting pervades his instructions. In facial drawing, the detail to which he gives greatest attention is exact placement of reflected light at the center of the eye (p. 24). Among gems, he prizes most highly the "transpareant and pure, not of a thicke or troubled matter, but clere and yet not pale" (p. 38). All is lucidity, the light of day realistically depicted. Hilliard's medium required that painterly shading

be subservient to drawing, but his disdain for *chiaroscuro* effects goes beyond complacency in his own mode. He presents his views with the noblest of all sanctions, the Queen's agreement. At her first sitting with him, she proved willing to reveal herself as straightforwardly as possible, choosing for her sitting—with Hilliard's warm approval—"the open ally of a goodly garden, where no tree was neere, nor anye shadowe at all, save that as the heaven is lighter then the earthe" (p. 29). Hilliard reports his explanation to Elizabeth that sharp contrasts in lighting are useful only to the lazy painter whose drawing is eased by a silhouette or to the homely sitter who has flaws to conceal. Hilliard refuses to evade the truths of broad daylight, when brightness falls from the air onto his sitter and his palette. He allows exceptions for narrative painting when the subject requires darkness, but the example he chooses underscores the intensity of his stance: "the troupe of *Judas* going to seeke *christ* in the garden by night with torches and lanthornes," "the trayterous act Done by night" (p. 30).

If Italianate ideas are ever to appear in Hilliard's discourse, light should be the theme. Leon Battista Alberti defines the very outlines and surfaces that make a composition by their shifting reception of light and asserts, "colours take their variation from light," for "nothing can be seen which is not illuminated and coloured."[12] Light is the irreducible matrix in which a Fra Angelico, a Botticelli, a Piero della Francesco exists. And indeed, Hilliard's sustained discussion on the topic (pp. 28–30) concludes the entire theoretical half of his treatise with the words "*Paulo Lamatzo* maintaineth mine oppinion (more then any other that ever I hard) in his bouck, saing what is shadowe, but the defect of light" (p. 30). Hilliard is technically correct, but in this instance he outdoes his source. At the conclusion of a forty-page discourse on light, Lomazzo adds a half-page disclaimer on shadow in which the passage Hilliard apparently indicates reads, in Haydocke's translation, "I thought good to say this little in the conclusion of this treatise: because shaddowes are as it were the tayle of light, insomuch as there can be nothing more base and object than they, being of so Melancholye and heavie a Nature."[13] Hilliard's rule that only a single strong source of light should fall upon the subject also appears in Lomazzo, credited to Michelangelo. Lomazzo, however, appends a complimentary notice of the effects Leonardo, Raphael, and others achieve with deeply shadowed modeling, as against the "flat and dead" work of those who reject *chiaroscuro*.[14] Leonardo, of course, is the supreme exponent of high relief through contrasting light and shadow; for him, not light but shadow is the second principle of painting, after the outline. To grasp the full impact of

Hilliard's views we need only compare the anecdote concerning Queen Elizabeth in *The Arte of Limning* to these notes from the *Codex Urbinas Latinus 1270* of Leonardo:

> A very high degree of grace in the light and shadows is added to the faces of those who sit in the doorways of rooms that are dark. . . . The shadowed part of the face is obscured by the shadows of the room and . . . the lighted part of the face [shown] with the greater brilliance which the air gives it.[15]

Cecilia Gallerani (c. 1485; Cracow, Czartoryski) leaps to the eye, the polar opposite of Hilliard's Mrs. Holland (Plate 13). Thus Hilliard goes beyond accepted Italian practice, in theory as in visible results. In his rejection of shadow on the picture-plane, more is at stake than mannerist art theory or even northern commitment to realism. With an evangelical fervor, he makes honesty the issue. "Beauty and good favor is like cleare truth, which is not shamed with the light, nor neede to bee obscured, so a picture . . . greatly smūtted or darkned . . . is like truth ill towld" (p. 29).

Hilliard is at his easiest and most anecdotal discussing line and light, the natural elements basic to drawing and painting. But he attends with alacrity to the new Renaissance sciences of perspective and proportion as well. Since he deals wholly with portraiture, rather than extensive representations of three-dimensional space, we are not surprised that he is chary about perspective.

> Painting perspective, and forshortning of lines, [is] with due shadoing acording to the rule of the eye, by falshood to expresse truth in very cunning of line, and . . . perspective, to define it brefly, is an art . . . for a man to express anything in shortned lines, and shadowes, to deseave bothe the understanding and the eye. (p. 20)

Illusion can be deceit, albeit in the interest of expressing truth; that is virtually all Hilliard has to say. In Lomazzo's opening chapter he could have found painting described as "the *Counterfeiter* and (as it were) the very *Ape* of Nature." But Lomazzo promptly couples perspective with geometry and arithmetic as necessary tools, describes the impact of perspective on light, includes it as one of the five theoretical branches of painting, and finally writes an entire fifth book to provide rules for its use. We may surmise that Hilliard, finding these hints unhelpful, turned the page. At any rate, those full-length

pictures that illustrate his own attempts at foreshortening (Plate 14) demonstrate a very hazy grasp of the technical principles.

Of all the traditional subjects he treats, the discussion most characteristic of Hilliard is his comment on proportion, which Panofsky has called "the favourite theme of Renaissance art-theory."[16] The relative priority that Hilliard assigns to his own experience, to learned authority, and to estimable contemporaries is definitive. Hilliard first treats proportion as second among the three aspects of beauty in the human face, more significant than coloring but less so than expression, which he calls "grace in countenance" (p. 23). These three qualities constitute "favor" (today's good looks). Hilliard continues by explaining how an uninstructed draftsman, attempting to work from the life rather than from memory, may lose proportion by careless posing of the sitter. The proper corrective: use of the forehead line as a marker for pose and for proportion (p. 25), a precept that the most casual observer can see exemplified in any Hilliard miniature. Hilliard knows the widely accepted contemporary theory in the matter: "*Albert Dure* giveth this rulle/ that comonly all faces howld one measure and true proportion . . . that the forhead is of the lenght of the nose, and the nose as long as frome the nose to the chinne" (p. 26).[17] But he immediately counters with his own observation of unattractive people who meet that standard and handsome people who do not, such as the low-browed Sir Christopher Hatton and wise old people with high foreheads.

Concerning the total body, Hilliard comments extensively on relative proportions among men, an issue raised by Vitruvius, explored by Alberti and Leonardo, codified for artists' use in Dürer's *Four Books of Human Proportion* (1528), and detailed across forty-five pages of the *Trattato*'s first book by Lomazzo, who places proportion first among the five theoretical aspects of painting. Like Lomazzo, Hilliard "corrects" Dürer. He finds the Nuremberg master's rules for proportion not only tedious but overly concerned with absolute measurements, which he thinks more appropriate to sculpture than to painting. Following a brief reference to Lomazzo, Hilliard narrates his own bravura gesture in demonstrating to Sir Philip Sidney the visible difference between the head, legs, and thighs of a tall man and a short man. The lesson of this mutually flattering anecdote is clear: "ower eye is cuninge, and is learned without rulle by long usse, as littel lads speake their vulger tonge without gramour Rulls" (p. 27). In the practical directions for limning, proportion appears no more. Genuine artistry, to Hilliard's mind, is not to be learned in any Renaissance rule book; the "mastery and skill [that] consisteth

in the true proportion and line" (p. 28) are the flowering of natural aptitude in the born painter. Light and proportion, the standard themes of theory to which he gives greatest attention, are the qualities that in the miniatures he most made his own.

Concerning the subject to be painted *The Arte of Limning* is more independent from Continental art theorists. Hilliard shares certain attitudes with his Italian predecessors, but reliance upon them is in no way apparent. Of all the arts, to be sure, painting most obviously adduces the classical dictate that art imitates nature and the artist, nature's maker. The rationalist Alberti affirms, "The painter is concerned solely with representing what can be seen," yet "any master painter who sees his works adored will feel himself considered another god." Lomazzo the idealist names painting an art "because it imitateth naturall things most precisely" and the artist, one who can "imitate God in nature."[18] Hilliard still sounds genuine and fresh as he declares that "all *Painting* imitateth nature or the life in every thinge it resembleth . . . , but of all things the perfection is to imitate the face of man kind." And in particular, limning "so enricheth and innobleth the worke that it seemeth to be the thinge it se[l]fe even the worke of god and not of man" (p. 16).

The merit of combining representation with "enrichment"—the conjoint effort of nature and of art—is a tacit assumption in Hilliard's thought. The able painter has "art and Cuning," knowledge and natural talent; the goldsmith who cuts a stone "by Arte . . . helpeth nature, and addeth beautye as well as nature doeth" (p. 41). The colors of the rainbow take "such a kindly beautifull order, as all the art of the worlde cannot amend it by mixture or other order, nor well in Arte compare by imitation with the same" (p. 38). The paired terms that inform the imagining of Spenser's Garden of Adonis and Bower of Bliss and of *The Winter's Tale* come readily to Hilliard's pen as well, notably in repeated references to the medium of his own craft, jewels "that nature . . . yealdeth, or Arte can compose" (p. 40).

In that aspect of nature that Renaissance portraiture made its own—the human face—accurate imitation does not require ruthless realism. "There is no person but hath variety of looks, and countenance, as well ilbecoming as pleassing or delighting," explains Hilliard disarmingly; among them he intends to paint "even his best graces and countenance," the most benign and attractive possible. He knows the issue is a central one on which others have felt strongly: "it is not amis to say somwhat in briffe tuching this point, leaving the better handling therof to better wits, wherin the best shall find infinite arguments, right pleasa[nt] to discoure upon" (p. 22). His own argument—

perhaps following Lomazzo who insists that what "most neerely resembles the life [is] exceeding pleasant"[19]—makes nature an ally; Hilliard clearly believes that grace of expression is inherent in the face if only the painter can seize the moment. In adding prettiness to accurately rendered likeness, he does not believe he falsifies; rather, he considers that the painter has a special eye for and responsibility to true beauty. "The grace in countenance, by which the afections apeare [is the] princepall part of the beauty a good painter hath skill of and should diligently noet" (p. 23). Thus Hilliard aimed to heighten the attractive, but only where he found it; he tells the truth, if perhaps not all of it.

In choosing to paint people at their best, Hilliard has many precedents in the classical theory of imitation. Aristotle had written in the *Poetics* (15.11) that "we must copy the good portrait-painters who, while rendering the distinctive form and making a likeness, yet paint people better than they are." In Italian art theory even Alberti with his devotion to scientific observation had emphasized selection of the beautiful to imitate. For an interesting *istoria* animated by decorum, he prescribes figures, poses, and gestures that convey loveliness, grace, and lively motion. The apprentice painter will strive "not only to make all the parts true to his model, but also to add beauty there." The mild idealization required to express the grace behind the truth subsequently became canon in the writings of Michelangelo, Vasari, and of course Lomazzo. But Hilliard could easily find such neoplatonizing ideas closer to home. In his *Apology for Poetry* (1595) Sidney denigrates, perhaps with a glance at Aristotle, "the meaner sort of painters, who counterfeit only such faces as are set before them" as against "the more excellent, who . . . bestow that in colours upon you which is fittest for the eye to see."[20] Finally, the whole tenor of *The Arte of Limning* suggests that Hilliard had his own reasons, both tactful consideration of his patrons' wishes and his personal taste, for choosing to limn what delights the eye.

On expression, the Italian tradition insists that, in painting as in poetry, the task of the artist is to express emotion—the contents of the mind and the emotions of the soul—and thus to summon responsive emotion in the viewer. The means to accomplish that goal had been known since Alberti's *della pittura,* which explains in brief how

the *istoria* will move the soul of the beholder when each man painted there clearly shows the movement of his own soul. . . . These movements of the soul are made known by movements of the body. Care

and thought weigh so heavily that a sad person stands with his forces and feelings as if dulled, . . . [while] in gay and happy men the movements are free and with certain pleasing inflections.[21]

John Spencer, translator and student of Alberti, tells us that "this well worn concept [of affective humanist painting] is presented for the first time to the world of European arts and letters: emotions of the soul may be expressed by the body."[22] Leonardo regards the capacity for expressiveness as an aspect of decorum requiring much empirical study, indeed as one of the glories of painting that guarantees its superiority to poetry. "Paintings, if they show actions consistent with the mental attitudes of those depicted, will be understood as if they spoke." Even Leonardo's repeated urgency pales beside Lomazzo's incorporation of the concept into his opening definition: "Painting is an arte which . . . not onely representeth the thicknesse and roundnesse [of corporall thinges], but also their actions and gestures, expressing moreover divers affections and passions of the minde."[23] He provides an exhaustive, sometimes ludicrous catalogue of the iconographical poses and gestures appropriate to more than a hundred emotions or aspects of character. Thus Hilliard merely states a commonplace when he admits the existence of "Il favored, or unpleasant faces" (p. 26), of expressions of wrath and sorrow, wantonness and pride, gravity and cowardice. But he is convinced that "a sad and heavy countenance in picture is sine of some eivel" (p. 24). The thoughtful countenance is often to be seen in Hilliard's pictures, but the violent and depressed emotions do not appear. His skill is most exercised in trying to catch "thosse lovely graces wittye smilings, and thosse stolne glances which sudainely like light[n]ing passe and another Countenance taketh place" (p. 23). Idealization and expressiveness merge in Hilliard's work.

Hilliard's is a fully realized art. Its deft observation and fresh effects are a genuine transformation of the illuminators', medalists', and jewelers' works from which it sprang. The combination of psychological realism with decorative richness has given Hilliard's miniatures a compelling power for four centuries; *The Arte of Limning* reveals the mind behind the gifted eye and hand. In the limnings Hilliard documents the daily ceremony of Elizabethan life in its most attractive aspects. With their brocades, ruffs, and twinkling jewels arranged in a studied formality, the paintings are entrancing objects. Hilliard gains our assent not only to his sitters' physical grace and high station, but to their human qualities: candor or complacency, pride or *timor mortis*.

The Arte of Limning conveys a personality of equal charm, aside from

the mild note of injured merit common to Elizabeth's good servants. The painter's incisive statement is as apparent in the treatise's unself-conscious commentary as in the crisp lines and pure colors of his limnings. The principal concerns in the text—suffusing light, elegant proportion—and its small compass clearly stamp it as Hilliard's work. Like the limnings, the treatise takes respectful but casual note of distinguished predecessors—the major Renaissance and mannerist theorists of Italy and the Low Countries—and moves beyond their doctrine to add personal anecdote and Hilliard's singular discoveries.

Beneath the surface of Hilliard's delicate *oeuvre*, moreover, are the first stirrings of a new vision for figure painting in England. Encouraged by Haydocke to conceptualize his skill, Hilliard articulated an emergent understanding of communication between painter and sitter, painter and observer—the conversation across time that transcends craft and marks art. In arguing for a disinterested and cultivated judgment in his patrons, Hilliard imagined the Stuart audience for painting that his own limnings began to create. In *The Arte of Limning* he founded English art theory, and he inaugurated a tradition.

NOTES

1. *A Treatise Concerning the Arte of Limning writ by N Hilliard,* transcribed by Arthur F. Kinney, fol. 3v. All subsequent references to Hilliard's treatise, citing page numbers of the present edition, appear in the text. The principal previous edition, *Nicholas Hilliard's Treatise Concerning the Arte of Limning,* was prepared for the Walpole Society by Philip Norman, vol. 1 (Oxford, 1911–12), 1–54. For a recent modernization, see R. K. R. Thornton and T. G. S. Cain, eds., *A Treatise Concerning the Arte of Limning* (Ashington, England, 1981), 62–115.

2. Hilliard's immediate inspiration for *The Arte of Limning* was Richard Haydocke, trans., *A Tracte Containing the Artes of Curious Paintinge Carvinge & Buildinge,* by Jo. Paul Lomatius (Lomazzo) (London, 1598). Though known as a portraitist, Lomazzo thought little of the role, in part because the painter must submit to the wishes of the sitter; see Lomazzo, *Trattato dell'arte della pittura,* vol. 6, chap. 50— "Compositione di ritrarre al naturale"—in the large portion of his treatise not translated by Haydocke. To Alberti, who requires copiousness and variety in the *istoria,* or subject, of a painting, any single-figure composition is inappropriate: "Solitude displeases me in *istorie*" (John R. Spencer, trans., *Leon Battista Alberti On Painting* [New Haven, 1966], 76). For fuller treatment, see "*The Arte of Limning* as Art Theory" in the present edition.

3. "I suppose it is debatable how far Elizabethan England can be called civilised. . . . It was brutal, unscrupulous and disorderly. But if the first requisites of civilisation are intellectual energy, freedom of mind, a sense of beauty and a craving for immortality, then the age of Marlowe and Spenser, of Dowland and Byrd, was a kind of civilisation" (Kenneth Clark, *Civilisation: A Personal View* [London, 1969], 163). Concerning the chief claimant to glory in the visual arts of the era, Clark subsequently notes, "If I want to cheer myself up about the state of painting today I think of the feeble, mannered, self-conscious, repetitive painting that went on in Rome for about fifty years in the sixteenth century" (p. 174).

4. John Pope-Hennessy, "Nicholas Hilliard and Mannerist Art Theory," *Journal of the Warburg and Courtauld Institutes* 6 (1943): 89–100; *A Lecture on Nicholas Hilliard* (London, 1949). His *Portrait in the Renaissance* (New York, 1966) introduces thoroughly the wider context in which Hilliard painted.

5. Carl Winter, *Elizabethan Miniatures* (Harmondsworth, England, 1943); "Hilliard and Elizabethan Miniatures," *Burlington Magazine* 89 (1947):175–83. Graham Reynolds, *English Portrait Miniatures* (London, 1952); "The Elizabethan Image," *Apollo* 91 (1970):138–43; *Nicholas Hilliard and Isaac Oliver,* rev. ed. (London, 1971).

6. Erna Auerbach, *Nicholas Hilliard* (London, 1961).

7. See John Murdoch, Jim Murrell, Patrick J. Noon, and Roy Strong, *The English Miniature* (New Haven and London, 1981), as well as Roy Strong, *The Cult of Elizabeth: Elizabethan Portraiture and Pageantry* (London, 1977), *The English Icon: Eliz-*

abethan and Jacobean Portraiture (London and New York, 1969), and *Portraits of Queen Elizabeth I* (Oxford, 1963).

8. Joan Evans, *English Art, 1307–1461* (Oxford, 1949), 1–100, 139–58; O. Elfrida Saunders's descriptive *History of English Art in the Middle Ages* (1932; reprint, New York, 1969), 145–216, adds helpful background information.

9. See David Piper, *The English Face* (London, 1957), 22, 27, fig. 1.

10. On the heraldic role of illuminations in royal Plea Rolls, *inter alia,* see Erna Auerbach, *Tudor Artists* (London, 1954), 17–46, 59–69, 81–87, 96–100, 119–31.

11. Jim Murrell, "The Craft of the Miniaturist" in Murdoch et al., *English Miniature,* 1–4; and Roy Strong, "From Manuscript to Miniature" in Murdoch et al., 25–31, 45–49. Strong draws on Gordon Kipling, *Triumph of Honour: Burgundian Origins of the Elizabethan Renaissance* (Leiden, 1977). Evans, p. 16, notes the first recognition of "lymenours" as distinct from scribes in the 1403 ordinance of the manuscript illuminators' craft guild.

12. Haydocke, *Tracte,* 126.

13. Erasmus's friendship for Sir Thomas More caused him to send his own portrait by Quentin Matsys, "so that we may be always with you, even when death shall have annihilated you" (Pope-Hennessy, *Portrait in the Renaissance,* 96). Influenced by Cicero's *De Amicitia,* Erasmus evolved a cult of friendship that used images as keepsakes: "Portraits are less precious than jewels . . . but at least they bring my Willibald to me" (Johan Huizinga, *Erasmus of Rotterdam,* trans. F. Hopman [London, 1952], 239.

14. Auerbach, *Tudor Artists,* 6–8, 49–52, 54–56, surveys the probable significance in payment and duties of the varying titles "King's painter," "serjeant painter," and "Court painter" used to meet Henry VIII's expansive needs; Holbein was certainly the paramount painter, though Hilliard may acknowledge Horenbout among "for *Limning* divers others" at Henry's court (p. 19). Roy Strong's most recent examination of English miniatures traces independent court limnings to the "lost figure" Lucas Horenbout (d. 1544), whose best work is very heavily influenced by Holbein; Strong postulates Hilliard's training in limning by Levina Teerlinc (d. 1576), for whom no substantial *oeuvre* can securely be created (Roy Strong, "From Manuscript to Miniature," in Murdoch et al., *English Miniature,* 31–33, 41–49). Early seventeenth-century art historian Karel van Mander reports that Horenbout taught Holbein to paint miniatures. See also Roy Strong, *Holbein and Henry VIII* (London, 1967), 13–18 and passim.

15. For Henry VI's mission to the Court of Armagnac in 1442, see *Official Correspondence of Thomas Bekynton,* ed. Williams (Rolls Series, 1872), vol. 2, 184; for the employment of Cosimo Tura by the d'Este about 1450, see Pope-Hennessy, *Portrait in the Renaissance,* 162–64; for Antonio Mor's mission to reveal Mary Tudor to Charles V and Philip II, recorded by van Mander, see Strong, *English Icon,* 117. On Henry VIII's marital use of portraiture, see J. J. Scarisbrick, *Henry VIII* (Berkeley, Calif., 1968), 357–75.

16. Many of Holbein's later portraits—such as *Sir Richard Southwell* (1536) in the Uffizi and *De Vos van steenwijk* (1541) and *Anton The Good of Lorraine* (1543) in the Berlin Gemäldegalerie—use the flat, blue background and gold lettering that concentrate all depth in the figure; *Mrs. Pemberton* (post-1532) uses a pose and tone not unlike the Jane Seymour drawing (c. 1536) in the Royal Collection at Windsor, executed at least twice in oil, while the Anne of Cleves miniature in the Victoria and Albert Museum and the head of the Louvre three-quarter-length painting represent a single conception and composition, down to small details of costume. For the theory that Holbein drew sitters on a pane of glass, then repeatedly transferred the result to paper by means of a grid, see K. T. Parker, *The Drawings of Hans Holbein* (London, 1945), 29–32, illustrated by a Dürer woodcut.

17. The most detailed discussion of this relationship is Horst Vey, "Nicholas Hilliard and Albrecht Dürer," in *Mouseion: Studien . . . für Otto H. Förster* (Cologne, 1960), 155–68. Vey demonstrates that Hilliard could have seen Dürer's *Four Books* not in English but in French (after 1557) or Italian (1591–94), while he obviously had seen the circulating graphic reproductions of Dürer's works (including Lomazzo's illustrations) as well as those of Goltzius and others, judging them accurately. Noticing Hilliard's error in asserting (like Vasari and Lomazzo) that Dürer lacked Italian experience, Vey concludes that he misunderstood Dürer's theoretical studies and, despite his great praise, adopted little or nothing of Dürer's Renaissance ideas or technique into his treatise or miniatures.

18. The *Kleberger* is unique, its iconography perhaps drawn from Hans Burgkmair's woodcuts of Roman emperors or from medallions of twelve ancient emperors by Marcantonio Raimondi that, Vasari reports, Raphael sent to Dürer (Angela Ottino della Chiesa, *The Complete Paintings of Dürer* [New York, 1968], 114).

19. Hilliard's contemporaries found Goltzius's work appealing. See Henry Peacham, *The Compleat Gentleman* (London, 1622), sigs P4v-Ql: "For a bold touch, varietie of posture, curious and true shaddow: imitate *Golzius,* his printes commonly to be had in Popes head alley."

20. Roy Strong, "Federigo Zuccaro's Visit to England in 1575," in his *English Icon,* 346. The impact on Italians of the Ridolfi plot against the Queen's life was considerable.

21. Haydocke, *Tracte,* in good Renaissance fashion claiming kinship both with Vasari, through a brief catalogue of English painters, and with Plutarch, through a comparison of English and Italian masters.

22. Scrotes's portrait appears in Strong, *English Icon,* 72; cf. also in that volume van der Meulen's *Eric XIV of Sweden,* 122, and Zuccaro's drawing for a portrait of Leicester, 164.

23. Auerbach, *Nicholas Hilliard,* 181–93; the latter attributions are most speculative (see pp. 31–32). See also Noel Blakiston, "Nicholas Hilliard and Queen Elizabeth's Third Great Seal," *Burlington Magazine* 90 (1948):101–7.

24. *Locus classicus* for this much-studied form is G. F. Hill, *A Corpus of Italian Medals of the Renaissance before Cellini*, 2 vols. (London, 1930). See also A. Suhle, *Die deutsche Renaissance-Medaille: ein Kulturbild aus der ersten Hälfte des sechszehnten Jahrhunderts* (Leipzig, 1950); on the relation of medals to miniatures, see Torben H. Colding, *Aspects of Miniature Painting* (Copenhagen, 1953), 39–41. For the medal's appearance in Hilliard's orbit, see remarks on the Dutch medalist Steven van Harwick by Reynolds, *English Portrait Miniatures*, 8, and Auerbach, *Nicholas Hilliard*, 178–79; on Pilon, see Winter, 23.

25. Pope-Hennessy, *Portrait in the Renaissance*, 185–86, provides a brief introduction to this large field; Bronzino and François Clouet are the central figures. Strong, *Portraits of Queen Elizabeth I*, 13–14, relates the Clouets to Elizabethan style.

The Making of a Miniature

1. Jim Murrell, "The Craft of the Miniaturist," in Murdoch et al., *English Miniature*, 1–2.

2. See Auerbach, *Nicholas Hilliard*, 184–86, 196–97, 320–21, for attribution, discussion, and catalogue information.

3. Murrell, "Craft of the Miniaturist," 7–14. See also Arthur F. Kinney's introduction to the present edition.

4. Hilliard advises, "after you have proportioned the face, let the party arise, and stand" (p. 45); Norgate requires three sittings, for drawing on the carnation and dead-coloring, for particularizing the features and beginning background and costume, and for adding expression and completing costume and jewelry with precision (Murrell, "Craft of the Miniaturist," 13).

5. Reynolds, *English Portrait Miniatures*, 19.

6. Pope-Hennessy, "Nicholas Hilliard and Mannerist Art Theory," 98. When speaking as a painter, Alberti, working on a scheme that the translator Spencer believes unique, begins with four colors to match the four elements, though other colors named for gems such as jasper and porphyry are cited as mixtures (John R. Spencer, trans., *Leon Battista Alberti On Painting* [New Haven, 1966], 49–50; cf., however, p. 82). When Alberti writes in Latin as a philosopher, he allows the traditional seven. See Samuel Y. Edgerton, "Alberti's Colour Theory: A Medieval Bottle without Renaissance Wine," *Journal of the Warburg and Courtauld Institutes* 32 (1969): 109–34.

7. Hilliard's apparent candor is sometimes misleading, particularly in directions for realistic painting of jewels by glazing on silver; Norgate also keeps this secret by describing it in code (Murrell, "Craft of the Miniaturist," 7). Elements of "mystery"—or the slowly declining postmedieval guilds as possessors of private, craft-related knowledge handed down through families—are still part of limning in the sixteenth century.

8. The use of music demonstrates the aristocratic nature of Hilliard's art; after Henry VIII—an accomplished musician who took pride in composition—royal patronage of Thomas Tallis, William Byrd, Orlando Gibbons, John Dowland, and Thomas Morley made both sacred and secular music and the beginnings of serious music criticism the art form in which (alone except for drama) England was second to none.

9. See pp. 125–126 of the present edition.

10. Compare Alberti's advice that artists associate with poets and orators who have broad knowledge and share the habit of "embellishments" (Spencer, *Alberti On Painting*, 90).

11. The effortlessly elegant style was drawn from the Italian manner prescribed by Baldassare Castiglione in *Il Cortegiano* and translated into English by Sir Thomas Hoby as *The Book of the Courtier* (1561). A visitor from Antwerp, Emanuel van Meteren, observed in terms published in 1599 and gathered no earlier than 1575, "The English are a clever, handsome, and well-made people. . . . bold, courageous, ardent, . . . and having little fear of death; they are not vindictive, but very inconstant, rash, vainglorious, light, and deceiving. . . . full of courtly and affected manners and words, which they take for gentility, civility, and wisdom. They are eloquent and hospitable. . . . The English dress in elegant, light, and costly garments, but they are very inconstant and desirous of novelties, changing their fashions every year, both men and women" (William B. Rye, *England as Seen by Foreigners* [London, 1865], 69–71).

12. Thomas Hoby, trans., *The Book of the Courtier*, ed. Walter Raleigh (London, 1900), bk. 1, chap. 52; the source is Pliny, *Historia naturalis* 35.86. In the broader context of the artist's need to experience what he depicts, Horace's famous maxim *Si vis me flere, dolendum est primum ipsi tibi* (If you wish me to weep, you must first feel pain yourself, *Ars Poetica* 102–3) is echoed in Lomazzo, who extends imaginative participation from painter to observer. "A picture artificially expressing the true naturall motions . . . will cause the beholder to wonder, when it wondereth, to desire a beautifull young woman for his wife, when he seeth her painted naked," and on through seven more inspired reactions (Haydocke, *Tracte*, bk. 1, sig. Aaj).

13. Pope-Hennessy, "Nicholas Hilliard and Mannerist Art Theory," 96.

14. On conventions for female beauty as displayed in sixteenth-century painting, see Elizabeth Cropper, "On Beautiful Women, Parmigianino, *Petrarchismo*, and the Vernacular Style," *Art Bulletin* 50 (1976):374–94, and her unpublished paper "Mannerist Portraiture as Stylistic Reality," presented to the symposium "Renaissance Woman/Renaissance Man" at Yale in March 1982.

15. On grounds of realism, lest "planes shine where they ought to be dark and are dark where they ought to be light," Alberti dryly concludes, "There are some who use much gold in their *istoria*. They think it gives majesty. I do not praise it" (Spencer, *Alberti On Painting*, 85).

16. Reynolds, *English Portrait Miniatures*, 20.

17. Auerbach, *Nicholas Hilliard*, 37.

18. Murrell, "Craft of the Miniaturist," 6–8. That Hilliard's mastery in this skill was widely acknowledged is clear from the Constable sonnet (see the Epigraph).

19. Strong, in *The Cult of Elizabeth,* 47–49, argues persuasively for viewing this miniature as a depiction of "Queen of Love and Beauty." The majestic impression is confirmed by the description of Venetian Secretary Giovanni Scaramelli on February 2, 1603, within weeks of Elizabeth's death: "She was clad in taffety of silver and white trimmed with gold; her dress was somewhat open in front and showed her throat encircled with pearls and rubies down to her breast. Her hair was of a light colour never made by nature, and she wore great pearls like pears round the forehead . . . and displayed a vast quantity of gems and pearls upon her person" (Ian Dunlop, *Palaces and Progresses of Elizabeth I* [London, 1962], 192, quoting the Venetian Calendar of State Papers).

20. Lomazzo too opposes melancholy in hue and atmosphere, remarking of shadows, "there can be nothing more base and abject then they, being of so Melancholye and heavie a Nature, that the verie Kinge of shaddowes and darknesse beneath in the center of the earth, disdaines them, and cannot abide them" (Haydocke, *Tracte,* 186). The fashion for melancholy, and for depths of shadow, grew as Hilliard's career began to wane. See Roy Strong, "The Elizabethan Malady: Melancholy in Elizabethan and Jacobean Portraiture," *Apollo* 79 (1964):264–69.

The Setting for the Miniatures

1. The general sketch of Elizabethan social and cultural backgrounds presented here takes its outline from Joel Hurstfield, *Elizabeth I and the Unity of England* (London, 1961) and *The Elizabethan Nation* (London, 1964); J. E. Neale, *Queen Elizabeth I* (London, 1934) and *Essays in Elizabethan History* (London, 1958); and Conyers Read, *Mr. Secretary Cecil and Queen Elizabeth* (New York, 1955).

2. Thomas Wilson, younger son of a country gentleman, in "The State of England, *anno dom.* 1600" described the vicissitudes for aristocrats as follows: "I find great alterations almost every year, so mutable are worldly things and worldly men's affairs; as namely the earl of Oxford, who in the year 1575 was rated at £12,000 a year sterling, within 2 following was vanished and no name of him found, having in that time prodigally spent and consumed all, even to the selling of the stones, timber and lead of his castles and houses. And yet he liveth and hath the first place amongst earls" (condensed in Joel Hurstfield and Alan G. R. Smith, eds., *Elizabethan People* [London, 1972], 19).

3. Auerbach, *Nicholas Hilliard,* 19–24, 31, 37–38. Patrons also included the Queen's favorites the Earl of Leicester and, unhappily, the Earl of Essex; see Noel Blakiston, "Nicholas Hilliard at Court," *Burlington Magazine* 96 (1954):17–18.

4. Scarisbrick, *Henry VIII,* 19.

5. A major extract of the 1600 Inventory appears in John Nichols, *The Progresses*

and *Public Processions of Queen Elizabeth* (London, 1823), vol. 3. This description draws upon Janet Arnold's comprehensive "The 'Coronation' Portrait of Queen Elizabeth I," *Burlington Magazine* 120 (1978):727–41.

6. Arnold, "'Coronation' Portrait," 736nn. Aylmer Vallance, *Art in England during the Elizabethan and Stuart Periods, The Studio* (London, 1908), 56, notes that continuing use of the fleur-de-lis, first assumed by Edward III in token of claim to the crown of France, was maintained by English sovereigns until 1801.

7. James M. Osborn, ed., *The Quenes Maiesties Passage through the Citie of London to Westminster the Day before Her Coronacion* (New Haven, 1960), 27–28, 45, 53–56, 60. "How many nosegaies did her grace receive at poore womens handes? how ofttimes staied she her chariot, when she saw any simple body offer to speake to her grace?" (p. 62).

8. Neale, *Essays,* 12 and *passim.*

9. Dunlop, *Palaces and Progresses,* 117. Lupold von Wedel, a German nobleman and sophisticated traveler, described his participation in a procession of a daily sort: "On the 18th [October 1584] we walked a mile between walls which . . . reach as far as Hampton Court, where the Queen resides. . . . Before the Queen marched her life-guard, all chosen men, strong and tall, two hundred in number. . . . Then came gentlemen of rank and of the council, two of them bearing a royal sceptre each, a third with the royal sword in a red velvet scabbard. . . . Now came the Queen, dressed in black on account of the death of the Prince of Orange and the Duke of Alençon; . . . Her train was carried behind her by a countess, then followed twelve young ladies of noble birth, children of counts or lords. . . . Both sides of the gallery as far as the Queen walked through it to the chapel were lined by the guard bearing arms" (condensed in Hurstfield and Smith, *Elizabethan People,* 15–16).

10. A. H. Dodd, *Life in Elizabethan England* (London, 1961), 12 (quoting from William Harrison, *Description of England in Shakspere's Youth,* ed. F. J. Furnivall [London, 1877]).

11. See Dunlop, *Palaces and Progresses,* 128–36 on Norwich and environs, 140–48 on Kenilworth, drawing heavily on the report of Leicester's Gentleman Usher Thomas Laneham.

12. Dunlop, *Palaces and Progresses,* 121.

13. Nichols, *Progresses* 1:108–30, reprints a Roll of gifts accepted and received in 1561/2 (from BM Harleian MSS). Against receipt of £1260 in cash alone, Nichols estimates (xliv) from the Pipe Rolls that Elizabeth's total annual expenditure, early in her reign, was a little under £40,000; by the end of her reign it was £55,000.

14. Nichols, *Progresses* 1:294–95 (from Sloane MS. 814). Nichols also lists (pp. 527–28) fifteen years of Leicester's annual gifts of magnificent jewels.

15. Nichols, *Progresses* 1:117. The list excerpted is for 1562.

16. *Calendar of State Papers* 10/1, nos. 41–42, cited by Auerbach, *Tudor Artists,* 69; Nichols, *Progresses* 1:28.

17. On the dispatch of Elizabeth's portraits to foreign royalty and nobility, Roy Strong, *Portraits of Queen Elizabeth I*, 23–27, cites E. Bonnaffé, *Inventaire des Meubles de Catherine de Medicis en 1589* [Paris, 1874], 92, 128; *26th Report of the Deputy Keeper of the Public Records*, Appendix II, p. 56; and T. Goldberg, *English Silver in the State Armoury Museum in the Moscow Kremlin* (London, 1954), 442.

18. William Gaunt, *Court Painting in England* (London, 1980), 18, describes Sittow's function for Henry VIII; Strong, *Portraits of Queen Elizabeth I*, 20–24, 26, cites the exchange of portraits between Elizabeth and the Dukes of Anjou and Alençon, sons of Catherine de' Medici.

19. A. F. Steuart, ed., *Memories of Sir James Melville of Halhill, 1535–1617* (New York, 1930), 94. The exchange between Elizabeth and Mary, Queen of Scots begun in 1561 is the first recorded reference to Elizabeth's diplomatic use of limnings (Strong, *Portraits of Queen Elizabeth I*, 24).

20. Strong, *Portraits of Queen Elizabeth I*, 20, 28, and note. Unton's sentimental anecdote is flattery, for Henri IV did not then welcome an embassy from Elizabeth (Strong, *Cult of Elizabeth*, 97–98).

21. Roy Strong suggests that Lee designed the program for the "Ditchley" portrait, now in the National Portrait Gallery, to suit the tilt held there in 1592 (Strong, *The Elizabethan Image: Painting in England, 1540–1620* [London, 1969], 45 and frontispiece). On the Procession picture, see Strong, *Cult of Elizabeth*, 17–55.

22. Strong, *English Icon*, 87, 100, 118. On the connection to reliquary jewels, see Joan Evans, *English Jewellery* (London, 1921), 84–85; for jewels worn in portraits, see Strong, *Portraits of Queen Elizabeth I*, 56–64, 82, and *English Icon*, 123–28.

23. These portraits are illustrated in Strong, *English Icon*, 171–80; cf. *Lady Mary Fitton* (1595), 193, and *Mary Cornwallis* (c. 1580–85), 180, which shows an uncovered miniature.

24. The phoenix emblem—its motto *Saevis Tranquillus in Undis*—is a royal *impresa* that Elizabeth shared with the Medici and William of Nassau and Orange (d. 1584). Its usual form is the floating nest of the Halcyon bird, who approaches it while winds are becalmed for days (William S. Heckscher, "Reflections on Seeing Holbein's Portrait of Erasmus at Longford Castle," in *Essays in the History of Art Presented to Rudolf Wittkower*, ed. Douglas Fraser et al. [London, 1967], 131). Appropriately for a Protestant sovereign creating a new church in a new age, Henry VIII substituted the Ark; Elizabeth no doubt followed him.

25. See Strong, *Cult of Elizabeth*, 84–100.

26. John Buxton, *Elizabethan Taste* (London, 1963), 120 (quoting Lord Herbert of Cherbury, *Autobiography*).

27. Frances A. Yates, "Queen Elizabeth as Astraea," *Journal of the Warburg and Courtauld Institutes* 10 (1947): 27–82, is the seminal exposition of Elizabeth as pagan goddess of peace and glory; see also Yates, *Allegorical Portraits of Queen Elizabeth I*

at *Hatfield House,* Hatfield House Booklet No. 1, and *Astraea: The Imperial Theme in the Sixteenth Century* (London and Boston, 1975).

28. Strong, *Portraits of Queen Elizabeth I,* 5 (quoting *Calendar of State Papers, Domestic* 1547, 80, p. 232). In 1584, a draft patent actually reserved the right to portray Elizabeth to Hilliard and George Gower (Auerbach, *Tudor Artists,* 109, citing Cottonian Charter, iv, 26). Full monopoly was probably not achieved until the reign of James I.

29. Strong, *Portraits of Queen Elizabeth I,* 89.

30. Confirmation comes from Sir John Harington; see Arthur F. Kinney's introduction to the present edition.

31. The dazzling effect of golden hairs recurs throughout the Britomart portions of *The Faerie Queene;* cf. especially 111.ix.20.

32. William Birch, "A Songe betwene the Quene's Majestie and Englande," quoted in Elkin C. Wilson, *England's Eliza* (Cambridge, Mass., 1939), 4–6.

33. Nichols, *Progresses* 1:276.

34. Frances A. Yates, "Elizabethan Chivalry: The Romance of the Accession Day Tilts," *Journal of the Warburg and Courtauld Institutes* 20 (1957):4–25.

35. On the extensive symbolism in this limning, perhaps assimilated to Protestant scriptural symbols, see Rene Graziani, "The 'Rainbow Portrait' of Queen Elizabeth I and its Religious Symbolism," *Journal of the Warburg and Courtauld Institutes* 35 (1972):255–59. Vey, "Hilliard und Dürer," 160, 165, traces Venetian origins for the outdoor portrait; the motif had become too general by 1590, he says, for Dürer to be the source of the background landscape.

36. Leicester Bradner, ed., *The Poems of Queen Elizabeth I* (Providence, R.I., 1964), 7.

37. Roger Ascham, *The Scholemaster,* in *The Whole Works of Roger Ascham,* ed. J. A. Giles, 3 vols. in 4 parts (London, 1865), 3:165.

38. Strong, *Elizabethan Image,* 49, cites these lines. Leslie Hotson, *Shakespeare by Hilliard* (London, 1977), 13, adduces Middleton's *The Puritaine* 1.i, in which a widow weeps over the miniature of her dead husband.

39. Strong, *Cult of Elizabeth,* 56–83, conjectures identification of the "Elizabethan Gentleman" as the Earl of Essex (a suggestion first raised by David Piper). The energy and conviction of Strong's argument are persuasive, and his exposition of details of iconography and cultural setting extremely valuable. But the "frenchified" quality he sees in Hilliard's life and art of the 1570s, a decade before the "Gentleman," strains the documentary evidence rather far (p. 60). Moreover, the nose of the "Gentleman," like the nose visible in two clearly related miniatures, is notably different from the distinctive nose in portraits certainly of Essex. Cheeks may grow gaunt with age, but noses change little. Yet Hilliard says (p. 24) that "the nosse [showeth] the most favor"; he might be expected to concentrate on it, and as other pictures show, he could render greatly varying noses. Whether Strong's identification is correct, his interpretation is

surely right. Leslie Hotson, *Mr. W. H.* (London, 1964), identifies the "Elizabethan Gentleman" as Shakespeare's friend, named as Master William Hatcliffe.

40. The Latin motto translates as "Faith, though prais'd, is punish'd [that supports/ Such as good fate foresakes]." The original version, in Lucan's *Belli civilis* 8.485, appears when the death of Pompey is advised. See David Piper, "The 1590 Lumley Inventory," *Burlington Magazine* 99 (1957): 224–31, 299–392; Pope-Hennessy, *Portrait in the Renaissance,* 256.

41. Winter, *Elizabethan Miniatures,* 5.

42. Gaunt, *Court Painting,* 52–56; he notes that other painters record a similar dour expression in James I.

43. Winter, *Elizabethan Miniatures,* 3, observes this relationship.

44. Francis Bacon, "Of Beauty," in *The Works of Francis Bacon,* ed. James Spedding et al., 14 vols. (London, 1889), 6:478–79.

45. George Chapman, "Epistle to Royden," in *The Poems of George Chapman,* ed. Phyllis B. Bartlett (New York, 1962), 49.

The Artist in THE ARTE

1. William Harrison, *Description of England in Shakspere's Youth,* ed. F. J. Furnivall, 3 vols. (London, 1877), 1:144–53; Thomas Smith, *De Republica Anglorum,* ed. L. Alston (Cambridge, 1906), 38–47.

2. Auerbach, *Nicholas Hilliard,* 5–10, 28–30.

3. The Statute is condensed in Hurstfield and Smith, *Elizabethan People,* 48, 55–56.

4. Such dedication is difficult when the "needy Artificer" lacks "sufficient means" to be "not subject to [those] comon cares of the world for food and garment" (p. 15). The counsel of perfectionism is common in the literature of art theory, perhaps most eloquently offered by Leonardo: "I remind you, painter, that when, through your own judgment or another's warning, you discover some error in your works, you should correct it, so that when you show the work you do not with it show what you are made of. . . . If you say that in making corrections you lose time which, if you spent it on another work, would make you much money, you must know that the money we make over and above our cost of living is not of much worth" (A. Philip McMahon, trans., *Treatise on Painting,* 2 vols. [Princeton, 1956], 1:51–52).

5. According to Auerbach's research of Minutes of the Goldsmiths' Company— incomplete, however, for Hilliard's flourishing years 1579–92—and the Apprentice Books for 1578–1648, only six young men were apprenticed to Hilliard over forty active years, including his own son Laurence and the significant figure Rowland Lockey (Auerbach, *Nicholas Hilliard,* 6, 9–10, 18, 40).

6. The competition of "strangers"—artists of foreign origin—was a subject of much vexation throughout the Tudor era. Sir Thomas Elyot remarked as early as 1531

that failure to train young English artisans has "caused that in the said artes englishmen be inferiors to all other people, and be constrayned, if we wyll have any thinge well paynted, kerved, or embrawdred, to abandone our owne countreymen and resorte unto straungers" (*The Boke Named the Governour*, ed. H. H. S. Croft, 2 vols. [London, 1880], 1:140). A 1563 Statute attempted to exclude the import of handcrafted products of foreign artificers for financial reasons (Hurstfield and Smith, *Elizabethan People*, 63–64). Hilliard believed that England was as cold a home for native purveyors of the fine and decorative arts as Philip Sidney had found for poetry: "Of truth all the rare siences especially the arts of *Carving, Painting, Gouldsmiths, Imbroderers,* together with the most of all the liberall siences came first unto us from the Strangers, and generally they are the best, and most in number" (p. 19); Hilliard's list of "siences" adds to Elyot's only his own trade of goldsmithing. Guilds were still attempting to maintain nativist monopolies in "The Goldsmiths' Complaint against the Aliens" in 1622, regretting that "said aliens and strangers . . . make and sell many deceitful jewels, pearls, counterfeit stones, and other goldsmiths' wares of gold and silver, to the great deceit of the nobility and people of this kingdom" (Joan Thirsk and J. P. Cooper, eds., *Seventeenth Century Economic Documents* [Oxford, 1972], 236–37).

7. Auerbach, *Nicholas Hilliard*, 20–21, 31, 36–38. Not all who commissioned Hilliard even met their obligations, we may deduce from his denunciation of the "Ignoranter and basser sort" who "will never robe men of their cuning, but of their worke peradventure if they can/ for commonly wher the Witte is small, the consience is lesse" (p. 35–36). Adding insult to injury, in the new century Hilliard's patrons began to employ his own pupils. Isaac Oliver is almost certainly the object of the disdain in his 1601 complaint to Cecil, "I have taught divers, bothe straungers and Englishe, which nowe and of a long tyme have pleased the comon sorte exceeding well, so that I am myself become unable by my art any longer to keep house in London." Reynolds, *Hilliard and Oliver*, 76.

8. The text is printed in full and the balance of palette and coat of arms illustrated, in Strong, *English Icon*, 170.

9. Pope-Hennessy, "Nicholas Hilliard and Mannerist Art Theory," 92.

10. Cennini's social-philosophical comments are presented in Elizabeth G. Holt, *Literary Sources of Art Theory* (Princeton, 1947), 70–72. Alberti is quoted in Spencer, *Alberti on Painting*, 66–67, 89–90 (and Pope-Hennessy notes ["Nicholas Hilliard and Mannerist Art Theory," 92], that Haydocke cites Alberti on the status of the artist). Some of Leonardo's many assumptions of the learned or scientific basis of painting appear in McMahon, *Treatise on Painting*, 1:1–12, 111, 113.

11. Haydocke, *Tracte*, 1–2, 8. For the inclusion of painting in the education of gentlemen, see Castiglione in Hoby, *Book of Courtier*, 91–92, and Elyot, *Boke Named Governour*, 1:43–49. Elyot places painting and carving among the learned sciences, while Castiglione cautiously notes that the Greeks did so.

12. For the Dürer, see Erwin Panofsky's useful summary-essay, "Artist, Scientist,

Genius," in *The Renaissance: Six Essays* (New York, 1962), 166–67; for the Henry VIII, see Gaunt, *Court Painting*, 15.

13. A plausible source for this view and the credibility it apparently anticipates is the startling assertion about children's inclinations made by Sir Thomas Elyot, who nonetheless reaches the same rueful conclusion. "Nature . . . is to him [who can draw] benevolent," says Elyot. "Lette us folowe our owne propre natures, that thoughe there be studies more grave and of more importaunce, yet ought we to regarde the studies wherto we be by our owne nature inclined. . . . For how many men be there that havyng their sonnes in childhode aptly disposed by nature to paynte, to kerve, or grave, to embrawder, or do other lyke thynges, wherin is any arte commendable concernynge invention, but that, as sone as they espie it, they be therwith displeased, and forthwith byndeth them apprentises to taylours, to wayvers, to towkers, and somtyme to coblers, whiche have ben the inestimable losse of many good wittes" (*Boke Named Governour*, 1:43, 138–40). Dürer's *Four Books on Proportion* are dedicated not only to painters, but to goldsmiths, masons, sculptors, and cabinetmakers.

14. Elyot, *Boke Named Governour*, 1, chap. 8. Elyot knew some Italian art theory—he cites the classical art theorist Vitruvius, he knows that colors must be tempered with "good size" in order to last, and he recognizes that line, shadow, and proportion are central problems for a Renaissance painter (ibid., 1:44; 2:318, 403)—but like Hilliard he soberly commends painting as a "secrete pastime, or recreation of the wittes, late occupied in serious studies" (ibid., 1:48). In commentary probably borrowed from the *paragone* of painting and sculpture (cf. Leonardo in McMahon, *Treatise on Painting*, 1:37), Elyot disdains the soil of labor in Hilliardesque terms: "a commune painter or kerver, . . . shall present him selfe openly stained or embrued with sondry colours, or poudered with the duste of stones that he cutteth, or perfumed with tedious savours of the metalles by him yoten." To hold that gentlemen may dabble in art without dishonor is not at all the same, after all, as to insist that only gentlemen should paint professionally. Elyot is quite specific: "I intende nat, by these examples, to make of a prince or noble mannes sonne, a commune painter or kerver" nor to suggest that "they shulde put their holle studie and felicitie" therein. "The open profession of the crafte [is] but of a base estimation" (Elyot, *Boke Named Governour*, 1:48, 40–42).

15. Pope-Hennessy ("Nicholas Hilliard and Mannerist Art Theory," 91–92) has suggested that Hilliard drew the concept of noble precedent—especially Quintus Fabius, called Pictor—from Castiglione, where the appropriate passage reads, in Sir Thomas Hoby's 1561 translation, "the men of olde time, and especially in all Greece would have Gentlemens children in the schooles to apply peincting, as a matter both honest and necessary. . . . openly enacted not to be taught to servauntes and bondsmen" (*Book of Courtier*, 91). "Giovanni Santi, Raphael's father [and Castiglione's contemporary at Urbino], was not the first to maintain that the Greeks did not allow slaves to study painting" (Rudolf and Margot Wittkower, *Born under Saturn: The Character and Conduct of Artists* [London, 1963], 16). The notion, originally expressed by Pliny

(*Historia naturalis* 35), was revived by the humanist Alberti and thereafter became a commonplace. Sir Thomas Elyot, himself drawing on Castiglione, like Hilliard cites all Roman and no Greek examples.

16. The manuscript is mutilated at the Biblical reference (p. 17). A marginal note in a later hand reads "Ecclesiasticus"; there is some similarity to *Ecclesiastes* 2:12–14 and 5:18–20. But "Besaleel and Ahohas" must refer to *Exodus* 31, where God gives Bezalel and Oholiab the ability in designing, metalwork, and carving necessary to decorate the tent of the ark for the keeping of the Sabbath—a highly serious precedent. Cf. also Gethsemane as example of narrative painting (p. 30). Despite Hilliard's rehearsal of the saw about a Pope who saw Angles as angels, the treatise reflects the spread of Protestantism under the Elizabethan settlement. He cites John Bosham, a "zealious and godly persson" who was able—"upon the liberty of the gosspell at the coming in of quene *Elizabeth*"—to follow "a love of gods devine service" and become a minister (p. 18). God's principal place in the lives of limners is "election . . . in all vocations and degrees": "god caleth" men to painting through an infusion of "the sperit of god" (p. 17). A pious "god grant it" appears as a form of punctuation (p. 21), but religion plays no other spontaneous role in the treatise. On Hilliard's early Protestant connections, through the Bodley family, see Thornton and Cain, *A Treatise*, 21–22.

17. "Painting contains within itself this virtue, that any master painter who sees his works adored will feel himself considered another god" (Spencer, *Alberti On Painting*, 64–65). "What Prince . . . or ingenuous man is there, which taketh not delight, with his pencell to imitate God in Nature?" (Lomazzo in Haydocke, *Tracte*, 14). Cf. Wittkower, *Born under Saturn*, 14–16, 93–99, on the *divino artista* after Michelangelo, who gave life to stone. Sidney: "The poet, . . . lifted up with the vigour of his own invention, doth grow in effect into another nature, in making things either better than Nature bringeth forth, or, quite anew" (Philip Sidney, *An Apology for Poetry*, ed. Geoffrey Shepherd, 100).

18. Such liberality may have been a custom of Hilliard's class: "Both the artificer and the husbandman are sufficiently liberal and very friendly at their tables; and when they meet they are so merry without malice, and plain without inward Italian or French craft and subtlety, that it would do a man good to be in company among them" (Harrison, *England in Shakspere's Youth*, 151).

19. Spencer, *Alberti On Painting*, 92–96; Pope-Hennessy, "Nicholas Hilliard and Mannerist Art Theory," 93, calls the strictures on conduct northern in origin but traces them no further than van Mander.

20. Cf. Lomazzo's remark that drawing is "most agreeable and infinitely pleasant" (Haydocke, *Tracte*, 6–8, 14). Still closer in spirit to Hilliard is Alberti: "Whenever I turn to painting for my recreation, which I frequently do when I am tired of more pressing affairs, I apply myself to it with so much pleasure that I am surprised that three or four hours have passed" (Spencer, *Alberti On Painting*, 67).

21. The concept of judgment arises in Italian Renaissance art theory as a natural consequence of the rational basis for painting. In his *Ten Books on Architecture*, Alberti ascribes the perception of beauty not to mere opinion but to "a certain innate judgment" (*animis innata quaedam ratio*) common to all. In *On Painting*, he extends that faculty firmly to an educated aesthetic perception, "worthy of liberal minds and noble souls": "I certainly consider a great appreciation of painting to be the best indication of a most perfect mind, even though it happens that this art is pleasing to the uneducated as well as to the educated"; nor should the painter "disdain the judgment and views of the multitude, when it is possible to satisfy their opinions" (Spencer, *Alberti On Painting*, 66–67, 97). Leonardo, too, considering painting a science, believes that rational judgment—not taste or some mystic faculty—checks its practice at all points (Anthony Blunt, *Artistic Theory in Italy, 1450–1600* [London, 1963], 27). "For Zuccaro judgment is no longer a rational and intellectual faculty but the weapon which 'chooses that which is most beautiful to the eye' " (ibid., 145)—clearly the concept emerging in Hilliard.

22. The original source for the idea of judgment is Aristotle's *Politics*, 8.1341b, where performance at a professional level is scorned. It was transmitted to Hilliard by humanists as well as art theorists. Castiglione's courtier-candidate learns drawing not only for utility and pleasure but because "it is a helpe to him to judge of the ymages both olde and new, of vessels, buildings, old coines, cameoes, gravings, and such other matters, it maketh him also understand the beawtye of livelye bodies." Castiglione's fullest expression of the power of judgment is applied to writing, which the gentleman attempts because "by such exercise he shall be able to give his judgement upon other mennes doings" and to "tast of the sweetenes and excellencye of styles." The result of such a faculty is an abstract enjoyment; the reader is able "to pause at [a text], and to ponder it better, and he taketh a delyte in the wittinesse and learning of him that writeth, and with a good judgement, after some paines takying, he tasteth the pleaser that consisteth in harde thinges" (Hoby, *Book of Courtier*, 96, 85, 65). The concept may have passed into Hilliard's orbit equally through Elyot, who concludes his chapter on artistic pastimes: "the exquisite knowledge and understanding that he hath in those sciences, hath impressed in his ... eies an exacte and perfecte jugement, as well in desernying the excellencie of them, whiche either ... in statuary, or paynters crafte, prefesseth any counnynge" (Elyot, *Boke Named Governour*, 1:48).

23. One of Alberti's great codifications in *On Painting* is its focus on the relation between observer and painting created by lines of sight artificially projected on the picture-plane through his "visual pyramid." For example, "As soon as the observer changes his position ... planes appear larger, of a different outline or of a different colour." Equally though less intensely he directs the affective content of the *istoria* toward the viewer, as in: "The *istoria* will move the soul of the beholder when each man painted there clearly shows the movement of his own soul"; "Movements should be moderated and sweet. They should appear graceful to the observer rather than a

marvel of study" (Spencer, *Alberti On Painting*, 45, 77, 86). The sustained intellectual effort of this analysis is beyond Hilliard, whose tone is closer to Elyot's: "And where the lively spirite, and that whiche is called the grace of the thyng, is perfectly expressed, that thinge . . . persuadeth and stereth the beholder" (Elyot, *Boke Named Governour*, 1:45). See Panofsky, *Meaning in the Visual Arts*, 99n.

24. Auerbach, *Nicholas Hilliard*, 40, citing Rymer's *Foedera*, 17:15. See also George C. Williamson, "Portrait Miniatures," in *The Studio* (London, 1910), 4, on more extensive use of honorific titles.

THE ARTE OF LIMNING *as Art Theory*

1. Philip Norman, *Introduction to Treatise*; Pope-Hennessy, "Nicholas Hilliard and Mannerist Art Theory."

2. Erwin Panofsky, *The Codex Huygens and Leonardo da Vinci's Art Theory* (London, 1940), 90–92. See also McMahon, *Treatise on Painting*, 1:xxvi–xxviii.

3. See Daniel V. Thompson, Jr., trans., *The Craftsman's Handbook: The Italian "Il Libro dell'Arte" of Cennino Cennini* (New York, 1954). Recipes for colors were the "mystery" of the craft, the secret concealed from outsiders. Michelangelo—like Hilliard, perpetuating his tradition through the word rather than through apprentices—gave extensive attention to paints; in general, the greater the artist the more he is concerned with the materials of his craft. Hilliard's directions are reasonably explicit (p. 36).

4. This passage has the humanist flavor of a treatise on oratory that parses its theme. The closest analogue in art theory may lie in Leon Battista Alberti's preface to his *Ten Books on Architecture*, approaching "this Art and its Operations, from what Principles it was derived, and of what Parts it consisted: And finding them of various Kinds, in Number almost infinite, in their Nature marvellous, of Use incredible, insomuch that it was doubtful what Condition of Men, or what Part of the Commonwealth, . . . the Individual or the whole human Species, was most obliged to the Architect" (James Leoni, trans., *Ten Books on Architecture*, by Leon Battista Alberti, ed. Joseph Rykwert [London, 1955], xi).

5. Pope-Hennessy, "Nicholas Hilliard and Mannerist Art Theory," 93–94, and Erwin Panofsky, *Meaning in the Visual Arts* (Garden City, N.Y., 1955), 93, 96n, 102n, cite Lomazzo's dependence on Dürer; Hilliard's many references to Dürer are critical. Pope-Hennessy (p. 90) cites Haydocke's obliquely stated reference to such earlier theorists as Armenini; the library of the great collector Sir Thomas Bodley, with whom Hilliard probably shared a youthful exile in Protestant Switzerland and whom he certainly limned, is another possible source.

6. Hilliard may have misunderstood Dürer's intent, the exhaustive investigator Horst Vey believes; it was descriptive rather than normative or idealized toward types,

trying to discover laws in nature rather than to state canons for beauty. (Vey, "Hilliard und Dürer," 158–59). See Panofsky, *Meaning in the Visual Arts,* 99–103. Hilliard could not have read Dürer in English (see pp. 71, 131, n. 17).

7. Haydocke interrupts Lomazzo's Preface to emphasize his omission of Lomazzo's views on religious images (Haydocke, *Tracte,* 3–4). Since circumspection on religious subjects was in order in England under the Elizabethan settlement, Hilliard's passage on Judas in the garden (p. 30) can be referred to Lomazzo's discussion of artificial light, with illustrations from the mysteries of Christ and reference to history painting as the best authority (Haydocke, *Tracte,* bk. 2, chap. 7, 146–47). Hilliard gives a far more detailed version of the Biblical story.

8. Gerald M. Ackerman, *The Structure of Lomazzo's Treatise on Painting* (Ann Arbor, Mich., 1971), 17–18, 26, demonstrates Lomazzo's acquaintance with Leonardo's notebooks and other theoretical treatises circulating in Milan in the later sixteenth century, as well as his thorough knowledge of Alberti and Vasari.

9. See Rensselaer W. Lee, *Ut Pictura Poesis: The Humanistic Theory of Painting* (New York, 1967), 5–7; Neal Gilbert, *Renaissance Concepts of Method* (New York, 1960). Lomazzo declares, "the Definition of Arte it selfe, . . . is nothing els but a sure and certaine rule of things to be made" (Haydocke, *Tracte,* 13). Hilliard also uses "art" with connotations much closer to the modern, making no distinction of meaning.

10. Blunt, *Artistic Theory in Italy,* 146–48.

11. Imitation of earlier masters is a cardinal tenet of Renaissance aesthetics, in art (except for Leonardo) as in literature (see Spencer, *Alberti On Painting,* 94–95). English humanist Roger Ascham links the two: "And truly it may be a shame to good students, who having so fair examples to follow as Plato and Tully, do not use so wise ways in following them . . . as rude ignorant artificers do. . . . For surely the meanest painter useth more wit, better art, greater diligence in his shop in following the picture of any mean man's face, than commonly the best students do" (Roger Ascham, *The Whole Works,* ed. J. A. Giles, 3 vols. [London, 1865], 3:216; cf. 191, 216, 239).

12. Spencer, *Alberti On Painting,* 45, 57; cf. 81–83.

13. Haydocke, *Tracte,* 176.

14. Ibid., 167–68.

15. McMahon, *Treatise On Painting,* 70–71.

16. Panofsky, *Codex Huygens,* 35.

17. "Und von har pis zum kin in 3 teill geteilt im obersten dy stirn im andern die nas im tritten der mund mit dem kin" (William M. Conway, ed., *The Writings of Albrecht Dürer* [London, 1958], 166, 187). Hilliard appears not to know that this set of proportions is an elementary precept of painting, used since Vitruvius (Vey, "Hilliard und Dürer," 158).

18. Spencer, *Alberti On Painting,* 43, 63, 64; cf. 89, 93. Haydocke, *Tracte,* 14.

19. Haydocke, *Tracte,* bk. 2, 1.

20. On the question of idealization, see Spencer, *Alberti On Painting,* 72–80, 94,

134n; Blunt, *Artistic Theory in Italy*, 59–64, 88–93, 142–44; Philip Sidney, *An Apology for Poetry*, ed. Shepherd, p. 102.

21. Spencer, *Alberti On Painting*, 77.

22. Ibid., 25.

23. McMahon, *Treatise on Painting*, 13, 147–57. "It is true that one ought to observe decorum, and that movements should be indicative of the motions of the mover's mind" (ibid., 58). See Haydocke, *Tracte*, 13, 25–76; Lee, *Ut Pictura Poesis*, 23–26, 28.

Bibliography

I. Hilliard and Portraiture in Britain

Arnold, Janet. "The 'Coronation' Portrait of Queen Elizabeth I." *Burlington Magazine* 120 (1978):727–41.

Auerbach, Erna. "An Elizabethan Indenture." *Burlington Magazine* 93 (1951):319–23.

———. "Holbein's Followers in England." *Burlington Magazine* 93 (1951):44–51.

———. "More Light on Nicholas Hilliard." *Burlington Magazine* 91 (1949):166–68.

———. *Nicholas Hilliard*. London, 1961.

———. "Portraits of Elizabeth I." *Burlington Magazine* 95 (1953):197–205.

———. *Tudor Artists*. London, 1954.

Blakiston, Noel. "Nicholas Hilliard and Queen Elizabeth's Third Great Seal." *Burlington Magazine* 90 (1948):101–7.

———. "Nicholas Hilliard as a Traveller." *Burlington Magazine* 91 (1949):169.

———. "Nicholas Hilliard at Court." *Burlington Magazine* 96 (1954):17–18.

———. "Nicholas Hilliard in France." *Gazette des Beaux Arts* 51 (1958):297–300.

———. "Nicholas Hilliard: Some Unpublished Documents." *Burlington Magazine* 89 (1947):187–89.

Bonnaffé, Edmond. *Inventaire des Meubles de Catherine de Medicis en 1589*. Paris, 1874.

Bourgoing, Jean de. *English Miniatures,* ed. George C. Williamson. London, 1928.

Buckeridge, Bainbrigg. *An Essay towards an English School of Painting* (1706), essay accompanying translation of Roger de Piles's *Abrégé de la vie des Peintres* (1699). Rev. ed. London, 1969.

Colding, Torben Holck. *Aspects of Miniature Painting: Its Origins and Development*. Copenhagen, 1953.

Davies, Adriana. *Dictionary of British Portraiture: The Middle Ages to the Early Georgians*. New York, 1979.

Edmond, Mary. "Limners and Picturemakers: New Light on the Lives of Miniaturists and Large-Scale Portrait-Painters working in London in the Sixteenth and Seventeenth Centuries." *The Walpole Society* 47 (1978–80):60–241.

Evans, Joan. *English Art, 1307–1461*. Oxford, 1949.

————. *English Jewellery.* London, 1921.

————. *Pattern: A Study of Ornament in Western Europe from 1180 to 1900.* 2 vols. Oxford, 1931.

Farquhar, Helen. "Nicholas Hilliard, 'Embosser of Medals in Gold.' " *The Numismatic Chronicle and Journal of the Royal Numismatic Society,* 4th ser., vol. 8 (1908):324–56.

————. "Portraiture of our Tudor Monarchs on their Coins and Medals." *The British Numismatic Journal,* 1st ser., vol. 4 (1907):79–143.

Fletcher, John. "The Date of the Portrait of Queen Elizabeth I in her Coronation Robes." *Burlington Magazine* 120 (1978):753.

Foskett, Daphne. *British Portrait Miniatures: A History.* London, 1963.

————. *A Dictionary of British Miniature Painters.* 2 vols. London, 1972.

Foster, J. J. *A Dictionary of Painters of Miniatures: 1525–1850.* London, 1926.

Ganz, Paul. "Holbein and Henry VIII." *Burlington Magazine* 83 (1943):269–72.

————. "Henry VIII and His Court Painter, Hans Holbein." *Burlington Magazine* 63 (1933):146–55.

————. *The Paintings of Hans Holbein.* London, 1950.

Gaunt, William. *Court Painting in England.* London, 1980.

Goldberg, T. *English Silver in the State Armoury Museum in the Moscow Kremlin.* London, 1954.

Goodison, J. W. "George Gower, Serjeant Painter to Queen Elizabeth." *Burlington Magazine* 90 (1948):262.

Grancsay, Stephen. "A Miniature Portrait of the Earl of Cumberland in Armour." *Bulletin of the Metropolitan Museum of Art* 15 (1956–57):120–22.

Graziani, René. "The 'Rainbow Portrait' of Queen Elizabeth I and its Religious Symbolism." *Journal of the Warburg and Courtauld Institutes* 35 (1972):247–59.

Hake, Henry M. "The English Historic Portrait, Document and Myth." *Proceedings of the British Academy* 29 (1943):133–52.

Heckscher, William S. "Reflections on Seeing Holbein's Portrait of Erasmus at Longford Castle." In *Essays in the History of Art Presented to Rudolf Wittkower,* edited by Douglas Fraser et al., 128–48. London, 1967.

Holmes, Richard R. "Nicholas Hilliard," *Burlington Magazine* 8 (1905–06):229–34, 316–25.

Hotson, Leslie. *Mr. W. H.* London, 1964.

————. "Queen Elizabeth's Master Painter." *Sunday Times Magazine* (22 March 1970):46–53.

————. *Shakespeare by Hilliard.* London, 1977.

Long, Basil S. *British Miniaturists: 1520–1860.* London, 1929.

Mercer, Eric. *English Art: 1553–1625.* Oxford, 1962.

Millar, Oliver. "The Elizabethan and Jacobean Scene." *Burlington Magazine* 112 (1970):170–75.

Murdoch, John, Jim Murrell, Patrick J. Noon, and Roy Strong. *The English Miniature.* New Haven and London, 1981.

Norgate, Edward. *Miniatura: or The Art of Limning* (1650), edited by Martin Hardie. London, 1919.

Norman, Philip. Introduction to *Nicholas Hilliard's Treatise concerning 'The Art of Limning.'* *The Walpole Society* 1 (1911–12):1–14.

———. "A Few Words on the Early Art of Miniature Painting as Practised by Hilliard and Others." *The Walpole Society* 1 (1911–12):51.

Parker, K. T. *The Drawings of Hans Holbein.* London, 1945.

Piper, David. *The English Face.* London, 1957.

———. "The 1590 Lumley Inventory." *Burlington Magazine* 99 (1957):224–31, 299–302.

———. "Tudor and Stuart Painting." In *The Genius of British Painting,* edited by David Piper, 62–110. New York, 1975.

Pope-Hennessy, John. *A Lecture on Nicholas Hilliard.* London, 1949.

———. "Nicholas Hilliard and Mannerist Art Theory," *Journal of the Warburg and Courtauld Institutes* 6 (1943):89–100.

Reynolds, Graham. *English Portrait Miniatures.* London, 1952.

———. "The Painter Plays the Spider." *Apollo* 79 (1964):279–84.

———. "Portraits by Nicholas Hilliard and His Assistants of King James I and His Family." *The Walpole Society* 34 (1952–54):14–26.

Saunders, O. Elfrida. *A History of English Art in the Middle Ages.* London, 1932; reprinted New York, 1969.

Shaw, William A. "An Early English Pre-Holbein School of Portraiture." *Connoisseur* 31 (1911):1972–81.

———. "The Early English School of Portraiture." *Burlington Magazine* 2 (1934):171–84.

Strong, Roy. *The Cult of Elizabeth: Elizabethan Portraiture and Pageantry.* London, 1977.

———. "The Elizabethan Malady: Melancholy in Elizabethan and Jacobean Portraiture." *Apollo* 79 (1964):264–69.

———. *The English Icon: Elizabethan and Jacobean Portraiture.* London and New York, 1969.

———. *Holbein and Henry VIII.* London, 1967.

———. *Nicholas Hilliard.* London, 1975.

———. "Nicholas Hilliard's Miniature of Francis Bacon Rediscovered and Other Miniatures." *Burlington Magazine* 106 (1964):337.

———. *Portraits of Queen Elizabeth I.* Oxford, 1963.

———. "Queen Elizabeth, the Earl of Essex, and Nicholas Hilliard." *Burlington Magazine* 101 (1959):145–49.

———. *Tudor and Jacobean Portraits.* 2 vols. London, 1969.

Thornton, R. K. R., and T. G. S. Cain. *A Treatise Concerning the Arte of Limning.* Ashington, England, 1981.

Vey, Horst. "Nicholas Hilliard und Albrecht Dürer." In *Mouseion: Studien . . . für Otto H. Förster,* 155–68. Cologne, 1960.

Waterhouse, Ellis K. *Painting in Britain: 1530–1790.* 4th ed. London, 1978.

Williamson, George C. *The History of Portrait Miniatures.* London, 1904.

———. "A New Piece of Information about Nicholas Hilliard." *Apollo* 4 (1926):31–32.

———. "Portrait Miniatures." In *The Studio.* London, 1910.

———, and Percy Buckman. *The Art of the Miniature Painter.* London, 1926.

Winter, Carl. *Elizabethan Miniatures.* Harmondsworth, England, 1943.

———. "Hilliard and Elizabethan Miniatures." *Burlington Magazine* 89 (1947):175–83.

———. "Holbein's Miniatures." *Burlington Magazine* 83 (1943):266–69.

Yates, Frances A. *Allegorical Portraits of Queen Elizabeth I at Hatfield House.* Hatfield House Booklet No. 1.

II. Elizabethan and Continental Backgrounds

Ackerman, Gerald M. *The Structure of Lomazzo's Treatise on Painting.* Ann Arbor, Mich., 1971.

Arnold, Janet. *A Handbook of Costume.* London, 1973.

Ascham, Roger. *The Whole Works,* edited by J. A. Giles. 3 vols. in 4 parts. London, 1865.

Bacon, Francis. *The Works of Francis Bacon.* Edited by James Spedding et al. 14 vols. London, 1889.

Barasch, Moshe. *Light and Color in the Italian Renaissance Theory of Art.* New York, 1978.

Baxandall, Michael. *Painting and Experience in Fifteenth Century Italy.* Oxford, 1972.

Blunt, Anthony. *Artistic Theory in Italy, 1450–1600.* London, 1963.

Bradner, Leicester, ed. *The Poems of Queen Elizabeth I.* Providence, R.I., 1964.

Brooks, Eric St. John. *Sir Christopher Hatton.* London, 1947.

Buxton, John. "Concord of Sweet Sounds." *Apollo* 79 (1964):303–6.

———. *Elizabethan Taste.* London, 1963.

Chaffers, William. *Gilda Aurifabrorum: A History of English Goldsmiths and Plate-workers and Their Marks.* London, 1883.

Chapman, George. *The Poems.* Edited by Phyllis B. Bartlett. New York, 1962.

Clark, Kenneth. *Civilisation: A Personal View.* London, 1969.

———. "Leon Battista Alberti on Painting." *Proceedings of the British Academy* 30 (1944):283–302.

Conway, William M., ed. *The Writings of Albrecht Dürer.* London, 1958.

Cropper, Elizabeth. "On Beautiful Women, Parmigianino, *Petrarchismo,* and the Vernacular Style." *Art Bulletin* 50 (1976):374–94.

Cunnington, C. Willett and Phillis. *Handbook of English Costume in the Sixteenth Century.* London, 1954.

Della Chiesa, Angela Ottino. *The Complete Paintings of Dürer*. New York, 1968.

Dodd, A. H. *Life in Elizabethan England*. London, 1961.

Dunlop, Ian. *Palaces and Progresses of Elizabeth I*. London, 1962.

Edgerton, Samuel Y. "Alberti's Colour Theory: A Medieval Bottle without Renaissance Wine." *Journal of the Warburg and Courtauld Institutes* 32 (1969):101–34.

Elyot, Sir Thomas. *The Boke Named the Governour*. Edited by H. H. S. Croft. 2 vols. London, 1883.

Englefield, W. A. D. *The History of the Painter-Stainers Company of London*. London, 1923.

Gilbert, Neal. *Renaissance Concepts of Method*. New York, 1960.

Harley, Rosamond D. *Artist's Pigments, c. 1600–1835: A Study in English Documentary Sources*. London, 1970.

Harrison, William. *Description of England in Shakspere's Youth*. Edited by F. J. Furnivall. 3 vols. London, 1877.

Haydocke, Richard, trans. *A Tracte Containing The Artes of Curious Paintinge Carvinge & Buildinge,* by John Paul Lomatius (Giovanni Paolo Lomazzo). London, 1598.

Hayward, John F. *Virtuoso Goldsmiths and the Triumph of Mannerism*. New York, 1976.

Hazard, Mary E. "The Anatomy of 'Liveliness' as a Concept in Renaissance Aesthetics." *Journal of Aesthetics and Art Criticism* 30 (1975):407–18.

Heal, Ambrose. *The London Goldsmiths, 1200–1800: A Record of the Names and Addresses of the Craftsmen*. Cambridge, 1935.

Hill, G. F. *A Corpus of Italian Medals of the Renaissance before Cellini*. 2 vols. London, 1930.

Hoby, Thomas, trans. *The Book of the Courtier,* by Baldassare Castiglione, edited by Walter Raleigh. London, 1900.

Hogrefe, Pearl. *The Life and Times of Sir Thomas Elyot, Englishman*. Ames, Iowa, 1967.

Hollander, Anne. *Seeing through Clothes*. New York, 1978.

Holt, Elizabeth G. *Literary Sources of Art Theory*. Princeton, 1947.

Huizinga, Johan. *Erasmus of Rotterdam*. Translated by F. Hopman. Rev. ed. London, 1952.

Hurstfield, Joel. *Elizabeth I and the Unity of England*. London, 1961.

———. *The Elizabethan Nation*. London, 1964.

———, and Alan G. R. Smith, eds. *Elizabethan People*. London, 1972.

Ivins, William M. *On the Rationalization of Sight; with an Examination of Three Renaissance Texts on Perspective*. New York, 1975.

Javitch, Daniel. *Poetry and Courtliness in Renaissance England*. Princeton, 1978.

Kinney, Arthur F. *Elizabethan Backgrounds*. Hamden, Conn., 1974.

Kipling, Gordon. *Triumph of Honour: Burgundian Origins of the Elizabethan Renaissance.* Leiden, 1977.

Lee, Rensselaer W. *Ut Pictura Poesis: The Humanistic Theory of Painting.* New York, 1967.

Leoni, James, trans. *Ten Books on Architecture,* by Leon Battista Alberti, edited by Joseph Rykwert. London, 1955.

Lomazzo, Giovanni Paulo. *Trattato dell'arte della pittura, scoltura, et architettura.* Milan, 1584.

Lippmann, Friedrich. *Zeichnungen von Albrecht Dürer in Nachbildungen.* Rev. ed. Berlin, 1929.

Maiorino, Giancarlo. "Linear Perspective and Symbolic Form: Humanistic Theory and Practice in the Work of Leon Battista Alberti." *Journal of Aesthetics and Art Criticism* 34 (1976):479–86.

Martindale, Andrew. *The Rise of the Artist.* New York, 1972.

McMahon, A. Philip, trans. *Treatise on Painting,* by Leonardo da Vinci. 2 vols. Princeton, 1956.

Nahm, Milton C. *The Artist as Creator: An Essay in Human Freedom.* Baltimore, 1956.

Neale, J. E. *Essays in Elizabethan History.* London, 1958.

———. *Queen Elizabeth I.* London and Toronto, 1934.

Nichols, John. *The Progresses and Public Processions of Queen Elizabeth.* 3 vols. London, 1823.

Osborn, James M., ed. *The Quenes Maiesties Passage through the Citie of London to Westminster the Day before Her Coronacion.* New Haven, 1960.

Panofsky, Erwin. "Artist, Scientist, Genius." In *The Renaissance: Six Essays,* 123–82. New York, 1962.

———. *The Codex Huygens and Leonardo da Vinci's Art Theory.* London, 1940.

———. *Meaning in the Visual Arts.* Garden City, N.Y., 1955.

Peacham, Henry. *The Art of Drawing.* 1606 (STC 19500).

———. *The Compleat Gentleman.* 1622 (STC 19502).

———. *Graphice; or the Most Auncient And Excellent Art of Drawing and Limning.* 1612 (STC 19507).

Plowden, Alison. *Marriage with My Kingdom: The Courtships of Queen Elizabeth.* London, 1977.

Pope-Hennessy, John. *The Portrait in the Renaissance.* New York, 1966.

Read, Conyers. *Mr. Secretary Cecil and Queen Elizabeth.* New York, 1955.

Reddaway, Thomas F. *The Early History of the Goldsmiths' Company, 1327–1509.* London, 1975.

Richter, Jean Paul, ed. *The Literary Works of Leonardo da Vinci.* 2 vols. 3rd ed. London, 1970.

Rye, William B. *England as Seen by Foreigners.* London, 1865.

Santayana, George. "On the Epitaph of Raphael." *Journal of Aesthetics and Art Criticism* 35 (1976):5–6.

Scarisbrick, J. J. *Henry VIII.* Berkeley, Calif., 1968.

Shepherd, Geoffrey. Introduction to *An Apology for Poetry,* by Philip Sidney, edited by Shepherd, 1–91. London, 1965.

Shearman, John. *Mannerism.* London, 1967.

Smith, Thomas. *De Republica Anglorum.* Edited by L. Alston. Cambridge, England, 1906.

Spencer, John R., trans. *Leon Battista Alberti On Painting.* New Haven, 1966.

———. "Ut Rhetorica Pictura: A Study in Quattrocento Theory of Painting." *Journal of the Warburg and Courtauld Institutes* 20 (1957):26–44.

Squire, Geoffrey. *Dress, Art, and Society, 1560–1970.* New York, 1974.

Steuart, A. Francis, ed. *Memories of Sir James Melville of Halhill, 1535–1617.* New York, 1930.

Suhle, Arthur. *Die deutsche Renaissance-Medaille: ein Kulturbild aus der ersten Hälfte des sechszehnten Jahrhunderts.* Leipzig, 1950.

Thirsk, Joan, and J. P. Cooper, eds. *Seventeenth Century Economic Documents.* Oxford, 1972.

Thompson, Daniel V., Jr., trans. *The Craftsman's Handbook: The Italian "Il Libro dell'Arte" of Cennino Cennini.* New York, 1954.

———. *The Materials and Techniques of Medieval Painting.* London, 1936.

Vallance, Aylmer. *Art in England during the Elizabethan and Stuart Periods.* In *The Studio.* London, 1908.

Williams, T., ed. *Official Correspondence of Thomas Bekynton,* Rolls Series, 1872.

Wilson, Elkin C. *England's Eliza.* Cambridge, Mass., 1939.

Wittkower, Rudolf and Margot. *Born Under Saturn: The Character and Conduct of Artists.* London, 1963.

Yates, Frances A. *Astraea: The Imperial Theme in the Sixteenth Century.* London and Boston, 1975.

———. "Elizabethan Chivalry: The Romance of the Accession Day Tilts." *Journal of the Warburg and Courtauld Institutes* 20 (1957):4–25.

———. "Queen Elizabeth as Astraea." *Journal of the Warburg and Courtauld Institutes* 10 (1947):27–82.

III. Catalogues, Reviews, and Notices

Brett, E. *A Kind of Gentle Painting: An Exhibition of Miniatures by Elizabethan Court Artists Nicholas Hilliard and Isaac Oliver.* Scottish Arts Council, Edinburgh, 1975.

Cust, Lionel. "Elizabethan Art at the Burlington Fine Arts Club." *Apollo* 4, no. 1 (1926):1–6.

[Fell, H. Granville] "A Constellation of Elizabethan Art." *Connoisseur* 120 (1947):55–56.

Foskett, Daphne. *British Portrait Miniatures: An Exhibition Arranged for the Period of the Edinburgh International Festival.* Scottish Committee, Arts Council of Great Britain, Edinburgh, 1965.

Furst, Herbert. "English Miniaturists." *Connoisseur* 93 (1934):221–25.

Greenblatt, Stephen. Review of *The Cult of Elizabeth,* by Roy Strong. *Renaissance Quarterly* 31 (1978):642–44.

Howard, Deborah. "The Elizabethan Image Painting in England, 1540–1620." *Revue de l'Art* 11 (1971):97–99.

J. K. Review of *The English Icon,* by Roy Strong. *Connoisseur* 173 (1970):276.

Kennedy, H. A. *Early English Miniatures in the Collection of the Duke of Buccleuch.* In *The Studio.* London, 1917.

"Miniature Masterpieces from the Nicholas Hilliard Show." *Illustrated London News* 1 (1947):584–85.

Noon, Patrick J. *English Portrait Drawings and Miniatures.* Yale Center for British Art, 1979.

Piper, David. "Tudor Portraits at Burlington House." *Apollo* 64 (1956): 194–99.

Pope-Hennessy, John. Review of *Elizabethan Miniatures,* by Carl Winter. *Burlington Magazine* 83 (1943):259–60.

Reynolds, Graham. "The Elizabethan Image." *Apollo* 91 (1970):138–43.

———. *Nicholas Hilliard and Isaac Oliver.* Catalogue of the Loan Exhibition at the Victoria and Albert Museum, 1947. Rev. ed. London, 1971.

———. *Tudor and Jacobean Miniatures.* London, 1973.

Rowse, A. L. "The Elizabethan Exhibition," in *The English Spirit,* 97–110. New York, 1946.

Strong, Roy. *The Elizabethan Image: Painting in England, 1540–1620.* The Tate Gallery, London, 1969.

———. "Shakespeare's Patrons: Portraits in the Shakespeare Exhibition at Stratford on Avon." *Apollo* 79 (1964):293–98.

———, and Julia Trevelyan Oman. *Elizabeth R.* London, 1971.

Vaughan, William. "Elizabethan Portraits at the Tate." *Connoisseur* 173 (1970):1–9.

Vey, Horst. Review of *Nicholas Hilliard,* by Erna Auerbach. *Kunstchronik* 15 (1962):120–29.

Watson, F. J. B. "The Hilliard Exhibition." *Phoenix* 2 (1947):202–4.

Williamson, George C. [Pierpont Morgan Collection] London, 1906.

Index